Henry Moore

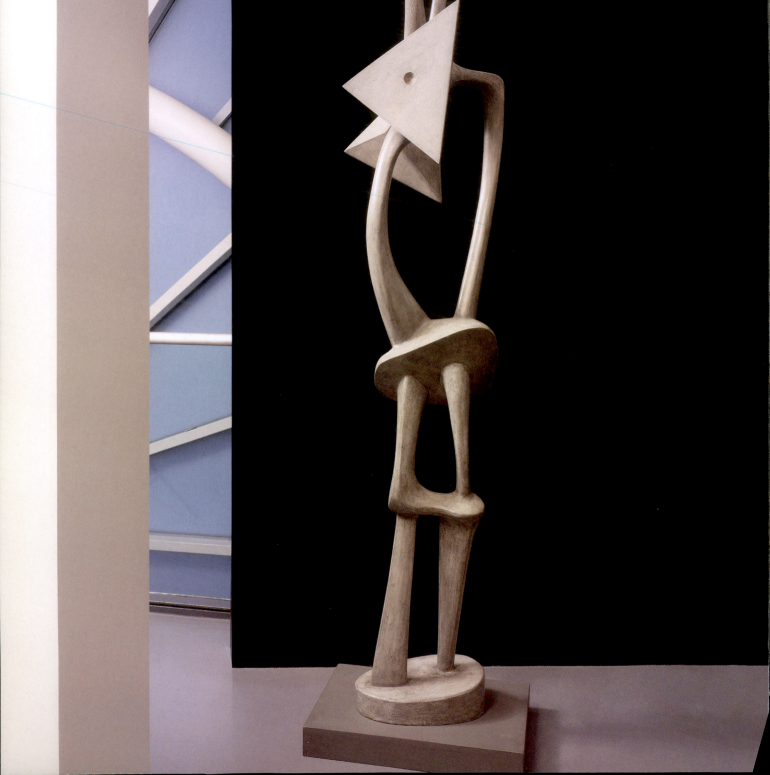

Henry Moore

War and Utility

IMPERIAL WAR MUSEUM

Foreword

Henry Moore's shelter drawings caught a public mood of community and defiance at the height of the London Blitz. Their commissioning and production were remarkable at a time when artistic practice was fraught and national priorities lay elsewhere, but through them Moore's popular reputation was established. Since that time his established presence in public galleries and civic spaces has almost deceived us. Our expectations of his art have perhaps been dulled and a veil drawn over the complexity and fluidity of his working methods; the excitement and bravery of his exploration of form and structure; and the constant engagement in the contemporary events of his day. On the twentieth anniversary of Moore's death, Imperial War Museum London is delighted to be able to host *War and Utility*, and through it offer the opportunity to review and reassess his artistic practice during the Second World War and the immediate surrounding years.

Thirty years ago, when Moore visited his first and only major exhibition at the Museum, he was able to discuss each drawing in great detail, recalling the circumstances and events of the time. Alas, the tape recorder was not turned on! Today, we are indebted to The Henry Moore Foundation for its resources and investment in understanding his work. The Foundation has been hugely supportive and generous, allowing the Museum to review and reshape a project that it originally developed for its galleries in Perry Green. Anita Feldman Bennet laid the groundwork for re-creating the exhibition at Imperial War Museum London; David Mitchinson extended his original essay to give the necessary overview of Moore and the development of his sculpture during this period; Charlotte Booth, Malcolm Woodward and John Farnham all ensured their exceptional numbers of loans were delivered and installed safely. Public and private lenders alike have been generous with their collections and time. James Campus's catalogue design is sympathetic to both text and image. Production has been co-ordinated by Gemma Maclagan. The context of the exhibition has been highlighted in Roger Tolson's essay and supported by the photography of Damon Cleary and Matt Gonzalez, who were assisted by Richard Ash. The exhibition has been co-ordinated by the Department of Art with assistance from the Exhibitions team.

Robert Crawford CBE
Director-General
Imperial War Museum

Contents

Lenders
The Henry Moore Foundation
The British Council
The British Museum
Harlow Arts Trust
The Henry Moore Family Collection
Huddersfield Art Gallery
Robert and Lisa Sainsbury Collection,
University of East Anglia
Tate
The Whitworth Art Gallery, University of
Manchester
Private collections

FRONTISPIECE:
Standing Figure 1950
LH 290
fibreglass, height 221cm
The Henry Moore Foundation:
transferred from the Henry Moore Trust, 1978

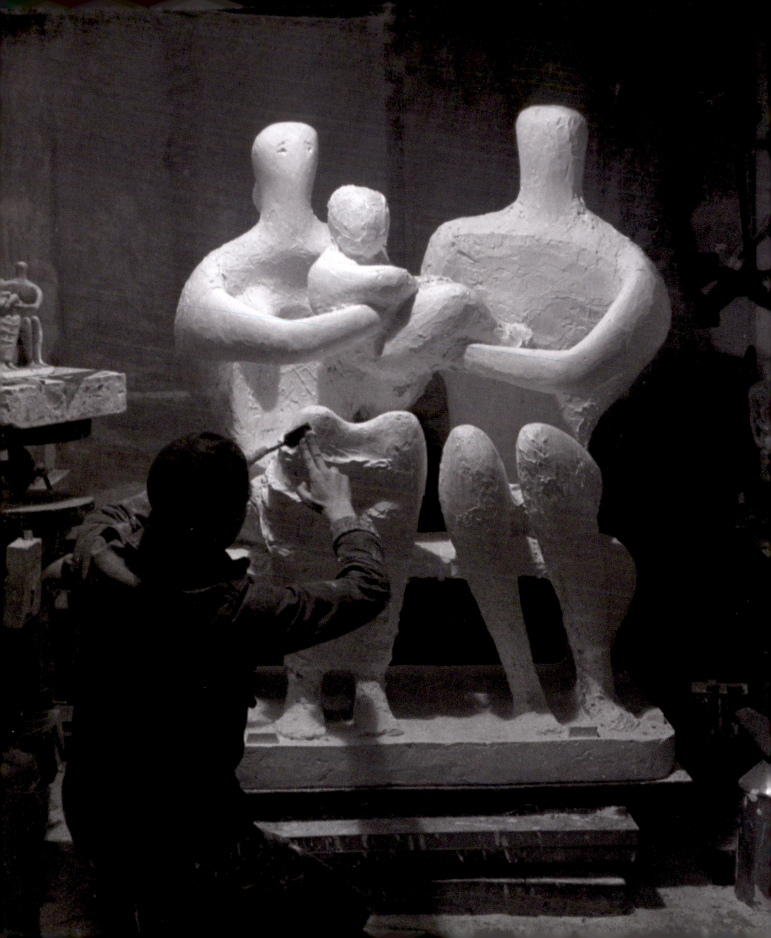

This exhibition looks at Moore's achievement between 1938 and 1954 by trying to show in a visual manner the historical context in which the changes and developments in his work came about. In no way does it attempt to give a chronological survey of the period, or for that matter of his life. Space would prevent the former and biographical histories on the latter abound.

Some of the events of this period which moved or influenced Moore were personal, for example the birth in 1946 of his daughter Mary; others, such as the Festival of Britain in 1951, were national; while others again, most obviously the Second World War, were international. Each was to have its effect on what Moore made and how he made it. Also significant was Moore's experimentation with new materials and processes, or with those he had made little use of earlier – terracotta, plaster, concrete and bronze casting – as well as lithography, collographic printing and textile design. An increased awareness of new formats for creative expression led Moore to produce drawings for textiles in 1943, to illustrate Edward Sackville-West's radio play *The Rescue* in 1946 and provide lithographs for André Gide's translation of Goethe's *Prometheus* four years later.[1] Other involvement with projects of a literary nature included cover designs for *Poetry London*, beginning in 1942;[2] the cover for *A Map of Hearts*, edited by Stefan Schimanski and Henry Treece in 1944;[3] and drawings to illustrate *A Land*, a geological study of Britain by Jacquetta Hawkes, published in 1951.[4]

Moore was 40 years old in 1938, mature, respected and well established. Work, teaching, friends and family, and the short journey between his home and studio in Hampstead and his cottage at Burcroft in rural Kent, where he could carve in the open-air, dominated his world. By 1954 everything had changed. Moore and his wife Irina had left their bombed Hampstead studio in 1940 for the hamlet of Perry Green in Hertfordshire, where their house, Hoglands, would remain home for the rest of their lives [fig.1]. He had become internationally famous, well travelled and successful and had held the first of many one-man exhibitions abroad, won sculpture prizes, accepted honorary degrees and been appointed to endless committees. The Tate Gallery for example, whose director, J B Manson, had told Robert Sainsbury in 1938, 'Over my dead body will Henry Moore ever enter the Tate', made Moore a Trustee only three years later and gave him his first London retrospective in 1951.[5]

Moore's work too had changed. In his drawings the subject became more pictorial and less dominated by ideas for sculpture. The war drawings were entirely figurative – even if some retained surreal elements in their depiction of human form [fig.2]. This changing style did not

FIG.9. *Family Group* 1948–49 (cat.181), in progress.

1. Edward Sackville-West, *The Rescue*, Martin Secker and Warburg, London 1945; Johann Wolfgang Goethe, *Prométhée*, translated by André Gide, Henri Jonquières/P A Nicaise, Paris 1950.

2. Moore produced cover designs for *Poetry London* vols. 7, 8 in 1942, 11, 12 in 1947, 13, 14 in 1948 and 15, 16 in 1949.

3. Stefan Schimanski and Henry Treece, (eds.), *A Map of Hearts*, Lindsay Drummond, London 1944.

4. Jacquetta Hawkes, *A Land*, Cresset Press, London 1951.

5. Roger Berthoud, *The Life of Henry Moore*, Giles de la Mare, London 2003, p.183.

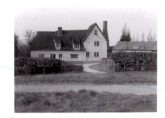

FIG.1. Hoglands, the Moores' Hertfordshire home, purchased in 1940 with a deposit of £300 paid by the surrealist painter, Gordon Onslow-Ford, for *Reclining Figure* 1939–40 (LH 210).

6. *La Planète affolée, Surréalisme: Dispersion et influences 1938–47*, exhibition cat. La Vieille Charité, Marseilles 1986, p.169, translated in Claude Allemand-Cosneau and Catherine Ferbos-Nakov, 'Form: The Seeing Eye', *Henry Moore: From the Inside Out*, Prestel, Munich 1996, p.41.

7. Moore had joined the Civil Service Rifles in February 1917 (at the suggestion of his Yorkshire friend, Douglas Houghton, later MP for Sowerby), and was gassed at the Battle of Cambrai the following November.

8. Moore to Herbert and Ludo Read, 9 October 1939, see Alan Wilkinson (ed), *Henry Moore: Writings and Conversations*, Lund Humphries, London 2002, p.60.

9. Alan G. Wilkinson, *The Drawings of Henry Moore*, Tate Gallery, London/Art Gallery of Ontario, Toronto 1977, p.36.

go unnoticed. On 1 May 1938 the British Surrealists, including Moore and his friend, Roland Penrose, took part in anti-government demonstrations in Hyde Park in support of Republican Spain. Two years later Moore was associated with the Third International Surrealist Exhibition, taking place in Mexico City. In the same year he also exhibited in *Surrealism Today* at the Zwemmer Gallery in London, the final show held by the British Surrealists as a coherent group. By 1947, when a further International Surrealist Exhibition was held in Paris, Moore was missing – an absence condemned by some of those taking part: 'The most surprising case is still Henry Moore, the sculptor, leaping straight from Surrealism to making religious ornaments and then plunging into the monotonous serial production of sketches done in the air raid shelters, a miserable popularisation of his pre-war reclining figures'.[6] Such criticism was unwarranted and rather missed the point, as Moore had been profoundly affected by his own involvement in the First World War and realised at an early date the likely consequences of the Second.[7]

The times were uncertain and Moore, writing in October 1939 to the art critic and historian, Herbert Read, noted:

I'm a couple of months over the present military service age limit. But if the war goes on for long, the limit won't stay at 41, I'm sure. Having been in the trenches in the last war, not for anywhere near as long as you were, but long enough not to want it twice in a lifetime – I hope it won't come to that. But I hate Fascism & Nazism so much that if the war gets closer & more intense, & grows into a main issue, the state of mind to go on quietly working might not be possible to keep up, & apart from necessity one might willingly seek to take some part in it.[8]

Summing-up how the war had affected him, he later recalled: 'Without the war, which directed one's direction to life itself, I think I would have been a far less sensitive and responsible person ... The war brought out and encouraged the humanist side in one's work.'[9]

For the first few months of war, work continued normally but this period of relative calm was not to last. Moore had taught for two days a week at Chelsea School of Art since 1931, but with the school's evacuation to Northampton in the summer of 1940 teaching came to an end. At the same time the inability to move freely in and out of Burcroft, now in a restricted military zone, meant an end to carving in the open-air. Back in London, he applied to Chelsea Polytechnic for training in precision-tool making, but training classes were few in number to the proportion of applicants. 'Several weeks went by and I heard nothing', he recalled, 'so I

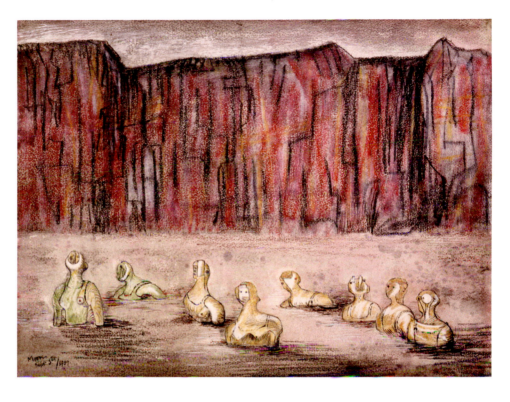

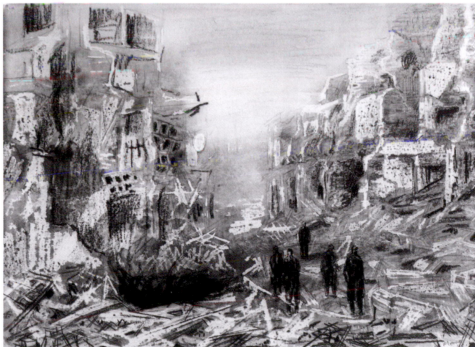

FIG.2. *September 3rd, 1939*
1939 (HMF 1551), The Moore Danowski
Trust.

FIG.3. *Early Morning after the Blitz 1940*
(HMF 1557a), one of a group of drawings
showing the devastation above ground,
formerly in the collection of Moore's
friend, Jacquetta Hawkes.

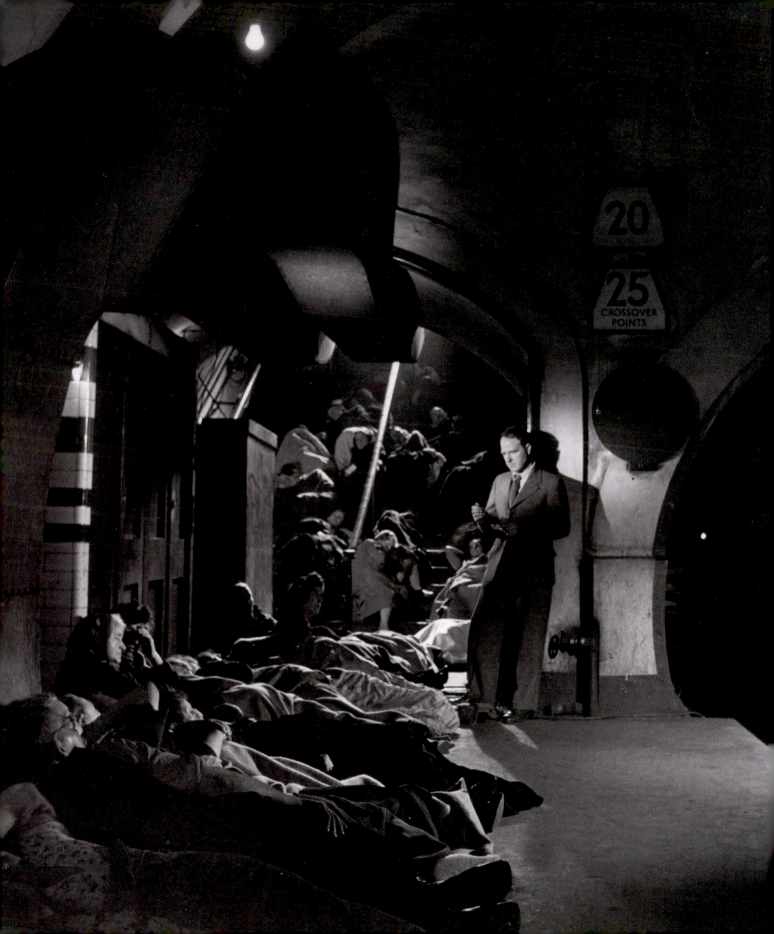

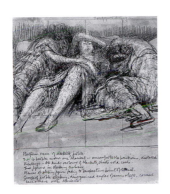

Three Figures Sleeping: Study for 'Shelter Drawing' 1940–41. Second Shelter Sketchbook p.7. HMF 1632. pencil, wax crayon, watercolour, pen and ink. The Henry Moore Foundation: gift of Irina Moore 1977

took up drawing. Months went by, waiting; I went on drawing. Then the air raids began – and the war from being an awful worry became a real experience',[10] [fig.3]. Writing to Arthur Sale in October 1940, he explained:

> The night-time in London is like another world … the unreality is that of exaggeration like in a nightmare. But what doesn't seem like a cinematograph to me are the queues, before four o'clock outside some of the Tube stations, of poor looking women & children waiting to be let in to take shelter for the night – & the dirty old bits of blankets & clothes & pillows stretched out on the Tube platforms – it's about the most pathetic, sordid, & disheartening sight I hope to see.[11]

Moore began sketching the devastation caused above ground by the bombing but quickly became focussed on those taking refuge underground; later, at the instigation of Kenneth Clark, he developed these sketches to produce his Shelter drawings.[12] One small casualty of the

above:
Three Figures Sleeping: Study for 'Shelter Drawing' 1940–41
Second Shelter Sketchbook p.7
HMF 1632
pencil, wax crayon, watercolour, pen and ink.
The Henry Moore Foundation: gift of Irina Moore 1977

right:
Grey Tube Shelter 1940
HMF 1724
pencil, wax crayon, coloured crayon, watercolour, wash, pen and ink
279 x 381 mm
The Trustees of the Tate Gallery, London: presented by the War Artists' Advisory Committee 1946

left:
FIG.4. Moore in Holborn underground station, London, September 1943, during the filming of Out of Chaos, a documentary about war artists, directed by Jill Craigie.

10. James Johnson Sweeney, 'Henry Moore', *Partisan Review*, New York March–April 1947, p.184.

11. Moore to Arthur Sale, 10 October 1940; the scholar and poet Arthur Sale corresponded with Moore throughout the early war years, see Wilkinson, p.60.

12. Clark was appointed Director of the National Gallery, London, in 1934 and Chairman of the War Artists' Advisory Committee five years later.

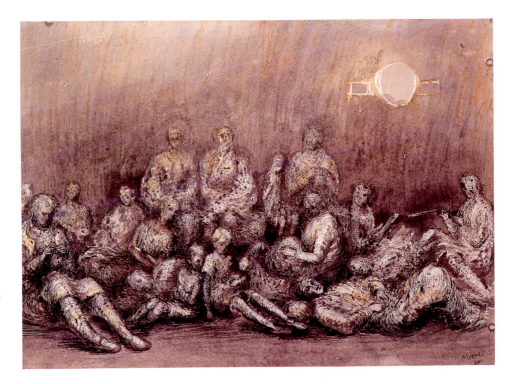

air raids was the Moores' home and studio in Hampstead, superficial damage to which led to the move to Hertfordshire. International events thereafter had less immediate impact on their tranquil world amidst the English countryside, but Moore's work mirrors the tensions of the times. The inhabitants of the shelters may have been observed in London but the drawings themselves were made in Perry Green. A social consciousness is obvious both in the treatment of the subject and through Moore's own observations that he could not intrude upon the shelterers' privacy by taking his drawing materials with him underground. Night after night he silently observed, noting:

> Instead of drawing, I would wander casually past a group of people half a dozen times or so, pretending to be unaware of them. Sometimes I climbed a staircase so that I could write down a note on the back of an envelope without being seen. A note like "two people sleeping under one blanket" would be enough of a reminder to enable me to make a sketch next day.'[13] 'I began filling a notebook with drawings ... I drew from memory on my return home. But the scenes of the shelter world, static figures asleep – reclining figures – remained vivid in my mind, I felt somehow drawn to it all. Here was something I couldn't help doing [14] [fig.4].

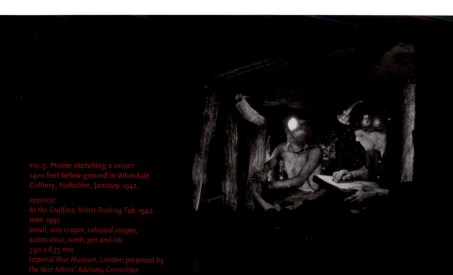

FIG.5. Moore sketching a miner 1400 feet below ground in Wheldale Colliery, Yorkshire, January 1942.

opposite:
At the Coalface: Miner Pushing Tub 1942
HMF 1991
pencil, wax crayon, coloured crayon,
watercolour, wash, pen and ink
330 x 635 mm
Imperial War Museum, London: presented by
the War Artists' Advisory Committee

By the summer of 1942, the authorities had begun to institutionalise the shelters. No doubt the provision of bunk beds and sanitation proved a benefit to the shelterers but with the changes came a waning of Moore's interest in the subject. At Herbert Read's suggestion he undertook to return to his Yorkshire birthplace, Castleford, to draw miners at work – Britain's Underground Army – as they were called, choosing Wheldale Colliery where his father had worked half a century earlier. At the time, sketching the coalminers had less emotional impact on him than drawing the shelterers, as he viewed the experience as 'a commission coldly approached,'[15] though later he remembered the conditions below ground as the nearest thing to Hell he could imagine. Wheldale pit 'is one of the deepest in the Castleford area', he explained,

13. Henry Moore, 'Introduction', *Shelter-Sketchbook*, Marlborough Fine Art, London 1967.

14. Sweeney, p.184.

15. *ibid.*

16. Henry Moore, Auden poems/Moore lithographs: An exhibition of a book dedicated by Henry Moore to W H Auden with related drawings, British Museum Publications London 1974.

When the pit-cage reaches the bottom of the shaft there is still close on a mile to walk, and finally one has to crawl on hands and knees to reach the coal face where the roof is only three feet high. The thick choking dust, the noise of the coal-cutting machines and the men shovelling and pickaxing, the almost unbearable heat and the dense darkness hardly penetrated by the faint light from the miners lamps, the consciousness of being nearly a mile below ground, all made it seem at first like some terrible man-made inferno [16] [fig.5].

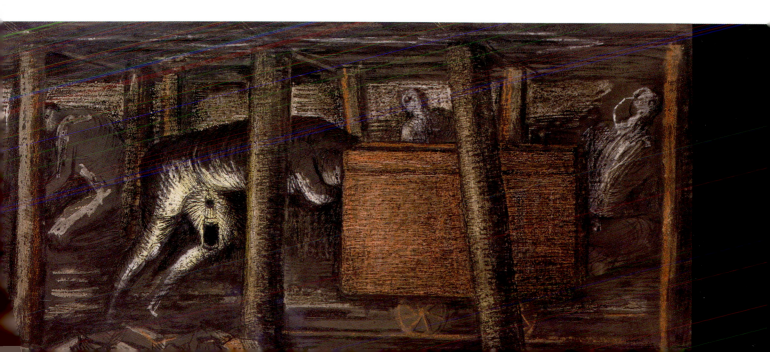

Moore paid tribute to the miners and the shelterers for being the catalysts that brought drapery and the male figure to greater prominence in his post-war sculpture.

Drawings from the end of the 1940s were much concerned with domestic scenes connected with members of his family, though new sculptural motifs such as the internal/external form and the rocking chair also appeared. All these works had one thing in common – a greater build-up of pigment on the page than had been seen in the drawings of the 1930s, when pencil or pen and ink, allowing the whiteness of the paper to show through, had been paramount. When colour was used it had been as delicate strokes or thin layers of pastel; lightness had been important. Now wax crayons in conjunction with pencils, watercolour wash and pen and ink produced a dense, rich surface, usually, though not always, dark and sombre in tone, with heavily contrasting streaks of white and yellow.

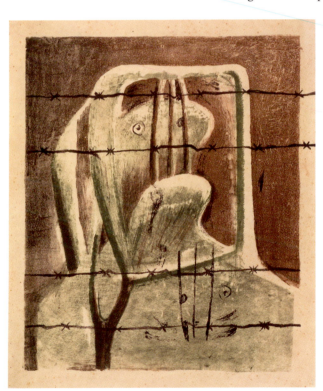

FIG.6. *Spanish Prisoner c.*1939 (CGM 3), lithographic proof, The Henry Moore Foundation.

Moore started printmaking in a tentative manner during 1931 with two woodcuts made for inclusion in the first edition of *The Island*, a quarterly journal of texts, poems and illustrations.[17] The medium did not appeal to him and he never returned to it, the blocks remaining uneditioned until 1966. Only one further print was proofed before the Second World War, a lithograph [fig.6] made to help raise funds for Spanish prisoners of war held in French detention camps. This was never produced, as the outbreak of war caused the evacuation of Camberwell School of Art where it was to have been editioned.

After this hesitant start, Moore's interest in printmaking developed slowly during the 1940s with his recognition that the medium could be used to reach a large audience. Encouraged by the painter and graphic artist Merlyn Evans, who had exhibited with the Surrealists in the 1930s and taught at the Central School of Art in London, he made his first etching in 1948. Coincidentally, a lightening and brightening in his colour palette after the sombre tones used in the Coalmine drawings, led to his experimenting with lithography. For his first major album of lithographs, *Prométhée* 1950 (CGM 18–32), he used drawing as a preparatory means to compose each subject, a method of working he remained happy with for the remainder of his life. All the individual colours for his lithographs were

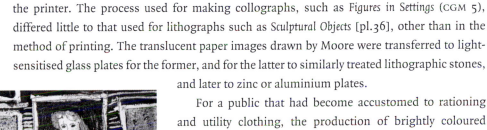

Textile Design: Framed Heads 1943
Page from Textile Design Sketchbook 2
HMF 2127
pencil, wax crayon, coloured crayon,
watercolour
The Henry Moore Foundation:
gift of the artist 1977

drawn on separate sheets of translucent paper on to which he wrote instructions as a guide for the printer. The process used for making collographs, such as *Figures in Settings* (CGM 5), differed little to that used for lithographs such as *Sculptural Objects* [pl.36], other than in the method of printing. The translucent paper images drawn by Moore were transferred to light-sensitised glass plates for the former, and for the latter to similarly treated lithographic stones, and later to zinc or aluminium plates.

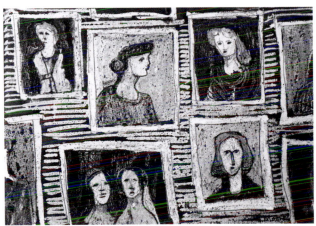

For a public that had become accustomed to rationing and utility clothing, the production of brightly coloured fabrics must have come as a welcome surprise. At the request of Zika Ascher, a Czech refugee who had arrived in London via Oslo in 1940 and set up a workshop to produce material for the fashion industry, Moore, along with other artists, was asked to collaborate in a printing project to help revitalise that most important article of wartime style, the headscarf. Moore filled three sketchbooks with ideas and, in addition to producing two headscarf designs, collaborated with Ascher in the making of four wall panels and at least 20 dressmaking fabrics.[18]

Moore's sculpture also developed in a different direction to that which he had been following during the early 1930s. By 1938 he was moving away from a preoccupation with direct carving towards the practice of making small three-dimensional sketch models, or maquettes as many later became known. These were modelled in white clay or terracotta, and subsequently cast as individual leads or small editions in bronze. Later, around 1950, he would switch to plaster, a material he continued using for the remainder of his career. At the end of the 1930s came the stringed figures and the earliest helmet – the first manifestation of an internal/external form. The years of the war drawings, from October 1940 until the end of 1942, were the only period of Moore's working life in which he produced no three-dimensional work. When he returned to sculpture with the terracotta Madonna and Child maquettes, the change in concept, material and subject was striking. Gone are the stringed and slightly mechanical figures of the late 1930s, to be replaced with figurative, draped and highly modelled forms. At this time he continued drawing, still working out ideas on paper that could later be realised in three dimensions, but from the start of the 1950s, more or less coinciding with his switch to using plaster, the 'idea for sculpture' on paper was finally abandoned.

17. See CGM 1, 2 in Josef Bard et al, *The Island*, Vol.1 No.1, London 15 June 1931.

18. Little as yet has been published on Moore's textile designs; for illustrations see *Henry Moore Volume 3 Complete Drawings 1940–49*, The Henry Moore Foundation in association with Lund Humphries, Aldershot 2001, pp.174–189; see also Margaret Reid, 'Henry Moore's Textiles and Tapestries', *An Introduction to Henry Moore*, The Henry Moore Foundation, Perry Green 2002, pp.23–25.

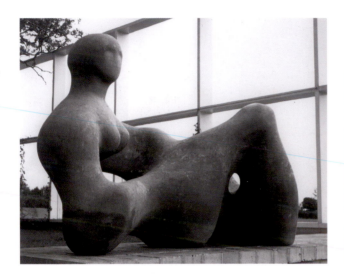

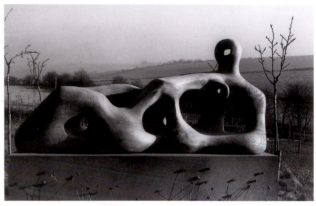

FIG.7. *Recumbent Figure 1938* (LH 191), sited at Serge Chermayeff's house at Halland in Sussex; now in the Tate collection.

FIG.8. *Reclining Figure 1939* (LH 210), the last sculpture to be carved in the open-air at Burcroft, near Dover; formally in the Onslow-Ford collection, now in the Detroit Institute of Arts.

Like the two immediate pre-war carvings, *Recumbent Figure 1938* [fig.7] and *Reclining Figure 1939* [fig.8], the large sculptures from the post-war period remained life-sized or just a little over. None were monumental in size even if many appeared monumental in scale. Some were carved; others, starting with *Family Group 1948–49* [pl.27], were modelled in plaster over a wood and wire armature with the help of assistants and cast in bronze [fig.9]. Another wartime legacy, arising this time from the Coalmine drawings, was the occasional appearance of the male figure in Moore's sculpture. Only six life-sized works contained recognisable male forms – three as parts of groups and three as warriors. In chronological order these were *Family Group, King and Queen 1952–53* [pl.19], *Warrior with Shield 1953–54* [pl.24], *Harlow Family Group 1954–55* [fig.10], *Falling Warrior 1956–57* (LH 405), and the much later *Goslar Warrior 1973–74* (LH 641). Moore's treatment of male subjects followed a clear pattern. In sculpture, as in his drawings and lithographs, they were never aggressive, militaristic, or bombastic. In the Family Groups they appeared as supportive figures and in *King and Queen* as stoical, contemplative, even domestic. All three of Moore's warriors have shields, a classic item of defence, but no weapons of attack such as swords or spears. The shields when viewed as a traditional form of protection can be compared to the helmets in the helmet heads, or the exterior elements of the internal/external forms – hard defensive barriers safeguarding what lies beneath.

Most of the major post-war sculptures were made for British clients or sponsors. The first cast of *Family Group* is in Stevenage; Moore's other life-sized sculpture of the subject was made for Harlow [fig.10], both pieces sited in response to requests for works to be placed in New Towns. International demand stimulated by his American dealer Curt Valentin had started, but its extent was nothing approaching the level it was later to reach. At home the two full-size

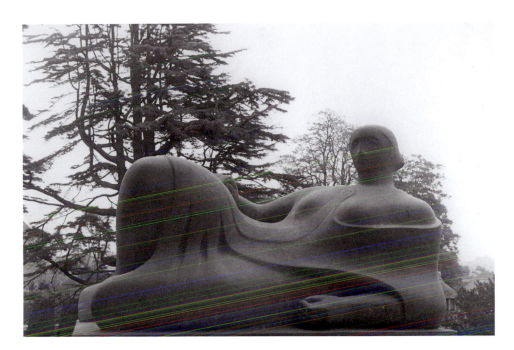

below right:
FIG.11. *Madonna and Child 1943–44* (LH 226), Church of St Matthew, Northampton.

below left:
FIG.12. *Claydon Madonna and Child 1948–49* (LH 270), sited in its original position in the Church of St Peter, Claydon; now in St Mary, Barham.

right:
FIG.13. *Memorial Figure 1945–46* (LH 262), Dartington Hall, Devon.

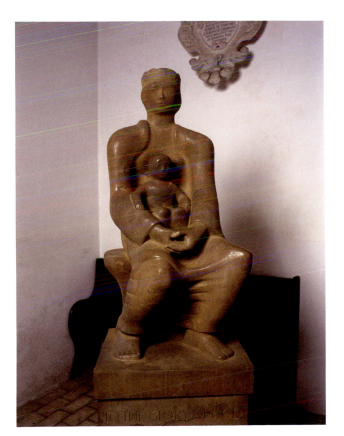

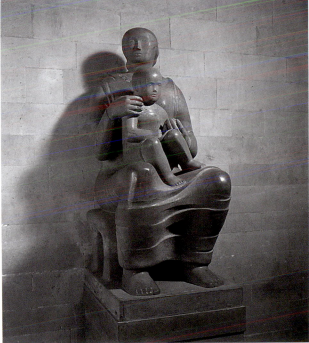

18)

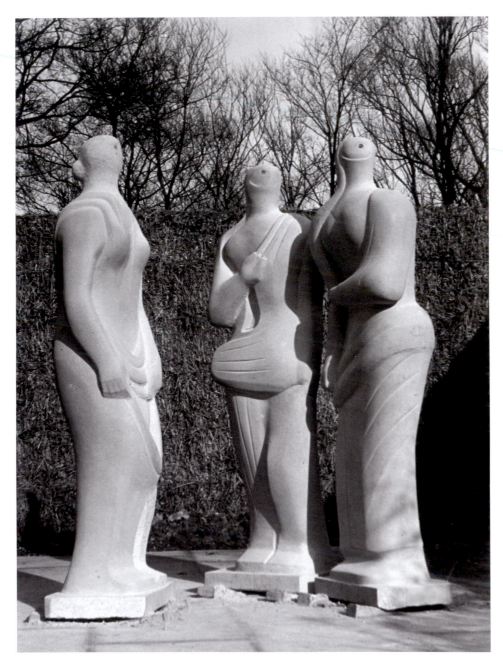

left:
FIG.14. *Three Standing Figures 1947–48*
(LH 268), nearing completion outside
Moore's studio at Hoglands, Perry Green.

above:
FIG.15. *Reclining Figure: Festival 1951*
(LH 293), in position at the Festival of
Britain, 1951.

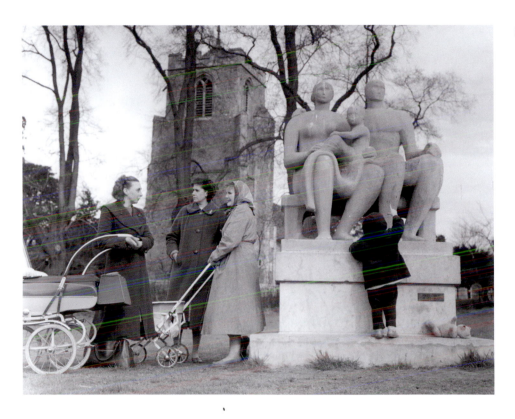

FIG.10. *Harlow Family Group* 1954–55
(LH 364), sited in its original position,
Old Harlow.

Madonna and Child carvings were made for private patrons and placed inside churches in
Northampton [fig.11] and Claydon [fig.12], not it might be noted in any of England's great
cathedrals. *The Memorial Figure* 1945–46 [fig.13], carved as a monument to his friend
Christopher Martin, was sited in the landscape of Dartington Hall, in Devon, where Martin had
for ten years been head of the Arts Department. *Three Standing Figures* 1947–48 [fig.14], went
into Battersea Park in London and the first cast of *Reclining Figure: Festival* 1951 [fig.15], was
sited on the South Bank of the Thames during the Festival of Britain, a celebration of
modernity and the post-war government's attempt at painting a picture of a better future. The
influence of the drapery that Moore had studied when making his Shelter drawings – a feature
of the Greek art whose influence he had tried to avoid as a student in the 1920s – can be seen
in *Draped Reclining Figure* 1952–53 (LH 336). The first bronze cast of this work was sited on a roof
terrace above Bond Street, albeit for an American client, Time-Life, who also commissioned
Moore's most ambitious carving to date [fig.16a, see fig.16b for its working model].

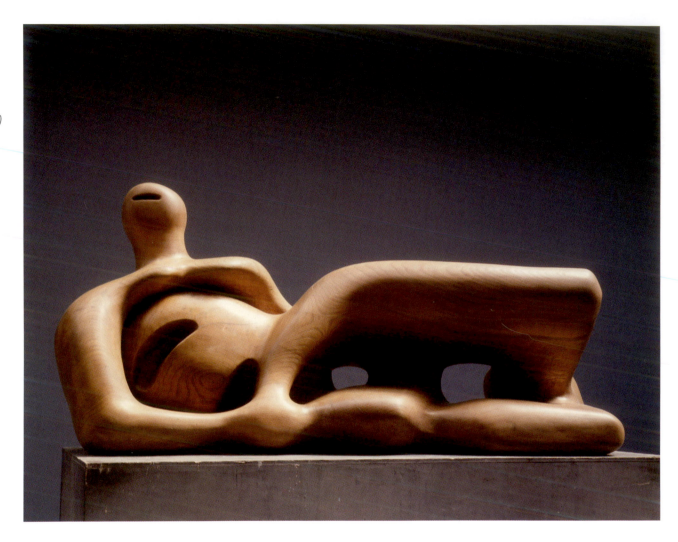

FIG.17. *Reclining Figure* 1945–46
(LH 263)

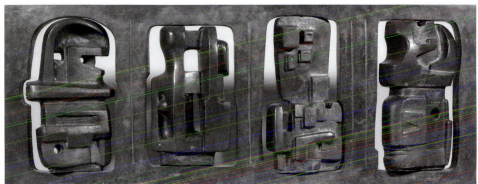

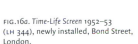

FIG.16a. *Time-Life Screen* 1952–53 (LH 344), newly installed, Bond Street, London.

FIG.16b. Working model for *Time-Life Screen* 1952 (LH 343), bronze. Arts Council Collection, Hayward Gallery, London

Other works did go overseas, notably the two great post-war wood carvings, *Reclining Figure* 1945–46 [fig.17], and *Upright Internal/External Form* 1953–54 (LH 297) to America and the first cast of *King and Queen* to the newly opened sculpture park at Middelheim outside Antwerp. How symbolic the sculpture's purchase was for Belgium only a year after that country had narrowly voted in a referendum to retain its monarchy would be interesting to know.

Moore's growing recognition oversees, from his one-man show at the Museum of Modern Art, New York, in 1946, his award of the international sculpture prize at the Venice Biennale in 1948 and the first of a long series of British Council backed exhibitions that followed, needs to be seen in the context of problems abroad. These ranged from the implications of the atomic bomb and the descent of the Iron Curtain across Europe to the retreat from Empire and British involvement in the Korean War. The Government's efforts to improve people's lives through reform in education, health and housing after the war, and its support for better standards in design, are reflected in Moore's commitment to outdoor public sculpture, something he was little concerned with during the 1930s.

David Mitchinson
Head of Collections and Exhibitions
The Henry Moore Foundation

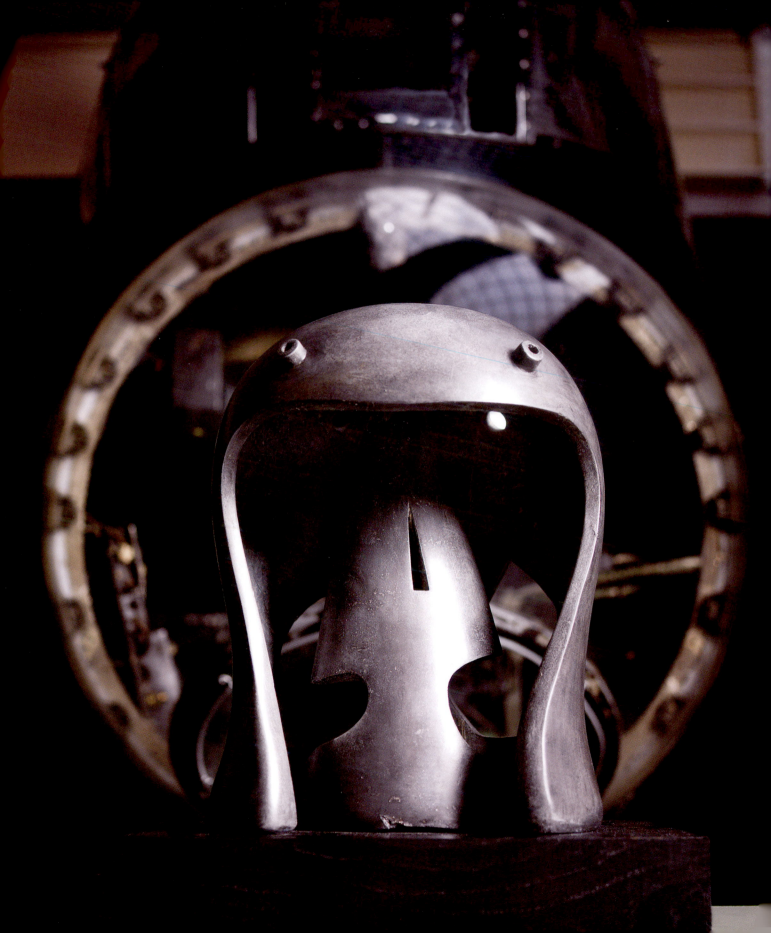

Moore and the Machinery of War

The atrium at Imperial War Museum London, filled with the modern machinery of war, stands
as a hymn to the technology that shaped and fulfilled the requirements of modern warfare.
The strategic need to know more, to see further and to penetrate defences was matched by
technological and operational requirements to simplify form, to compact and stabilise power
that reaches its apotheosis in the disarmingly small and simple shell of the atomic bomb.
These concerns with form, force and engineering would have been understood by Henry
Moore whose own exploration of the structural possibilities of materials was fundamental in
the development of his sculpture, and it is therefore no surprise that this arena has been
described as a sculptural space even though such a definition implies a limit to the function of
the weapons.[1] Indeed, it is a strange aspect of the atrium that although arranged as a Medusa's
Head, with its guns ranged and aircraft swooping to threaten and petrify, it is a safe, controlled
and managed environment, one which visitors enter as an act of leisure.

Moore's own preference was to see his works displayed in a neutral setting: 'There is no
better background than the sky, because you are contrasting solid form with its opposite –
space. The sculpture then has no competition, no distraction from other solid objects.'[2] An
attempt to fence off the car park at the Tate Gallery, Millbank, for his 1968 exhibition is surely
indicative of the extent he was prepared to go to create an appropriate environment. The
measure of his success in promoting this sort of display is the degree to which his work now
belongs to a pastoral setting in the popular imagination, an understanding reinforced by its
landscape-like form. However, such displays not only remove visual conflicts – Moore partic-
ularly hated the idea of seeing his work against cars – but it also gives a setting that deliberately
disassociates itself from the context in which it was made. Indeed, Moore regularly invoked
historic precedents and the natural world in order to promote an art that was in practice
radically new and modern. Placing the work of one of the greatest sculptors and draughtsman
of the twentieth century into the atrium of Imperial War Museum London and its adjacent
galleries gives the opportunity to re-imagine this context and see how his work of the period
both defies and draws inspiration from the modern age, most notably in the Shelter drawings,
but also in his wider sculptural practice.

London life sits at the heart of Moore's work during this period, with all its contrivances,
constructions and contradictions. The British Museum's displays of Pre-Columbian sculpture
were Moore's self-acknowledged source for the evolving forms that developed during the
1930s. Furthermore, the museum itself was part of a cultural milieu that was to feed Moore just
as it had artists before and after: the art schools, companionship, shared working
environments, dealers, exhibitions, galleries' patrons all centred on the capital. His own

FIG.23. *Helmet Head No.1* 1950
LH 279
lead, height 34cm
*The Henry Moore Foundation: gift of
Irina Moore 1977*

1. Tom Lubbock, 'Orders of Battles',
The Independent, Monday, 17 July 1989.
2. Moore to David Sylvester, Tate catalogue,
1951, (RB p.228).

moves to Kent and, later, to Hoglands in Hertfordshire, were made possible by easy train and road links to the centre that supported his regular visits. All this was to be changed by the war. His drawings of the blitzed city are essays in bewilderment and disorientation [fig.18], his letters pictures of a fading life where friends were 'dulled and deadened' and meeting them bereft of pleasure.[3] In addition, his studio in Hampstead was damaged, marking a temporary end to sculpting.

The possibility of aerial attacks on civilians pre-dated the First World War and was part of the popular imagination from even earlier.[4] They were not openly acknowledged as military possibilities until the 1920s when the Italian author, Guilio Douhet, recognised that the civilian was now as vulnerable as the military in the face of new technology.[5] The Spanish Civil War, with its widespread use of bombing, was to prove the accuracy of his predictions. Within the atrium, the Spitfire, the Lancaster bomber, the V1 and V2 are all part of the narrative of the underground shelterers. The surprise for Moore was the similarity between his own work and the groups of shelterers he first saw at Belsize Park tube station, driven underground by aerial onslaught to the tube and purpose-built shelters.

Reclining Warrior 1953
LH 358b
bronze, length 19.7cm
The Henry Moore Foundation:
gift of the artist 1977

opposite:
FIG.24. *Maquette for Mother and Child* 1952
LH 314
bronze, height 21.6cm
The Henry Moore Foundation:
gift of Irina Moore 1977

3. Moore to Arthur Sale, 30 April 1939, , Imperial War Museum, War Artists Archive, IWM ART 16597 1.

4. See Sven Lindquist, *A History of Bombing*, (translated by Linda Haverty Rugg), London 2002.

5. *Il dominio dell'aria* (Dominion of the skies), 1921.

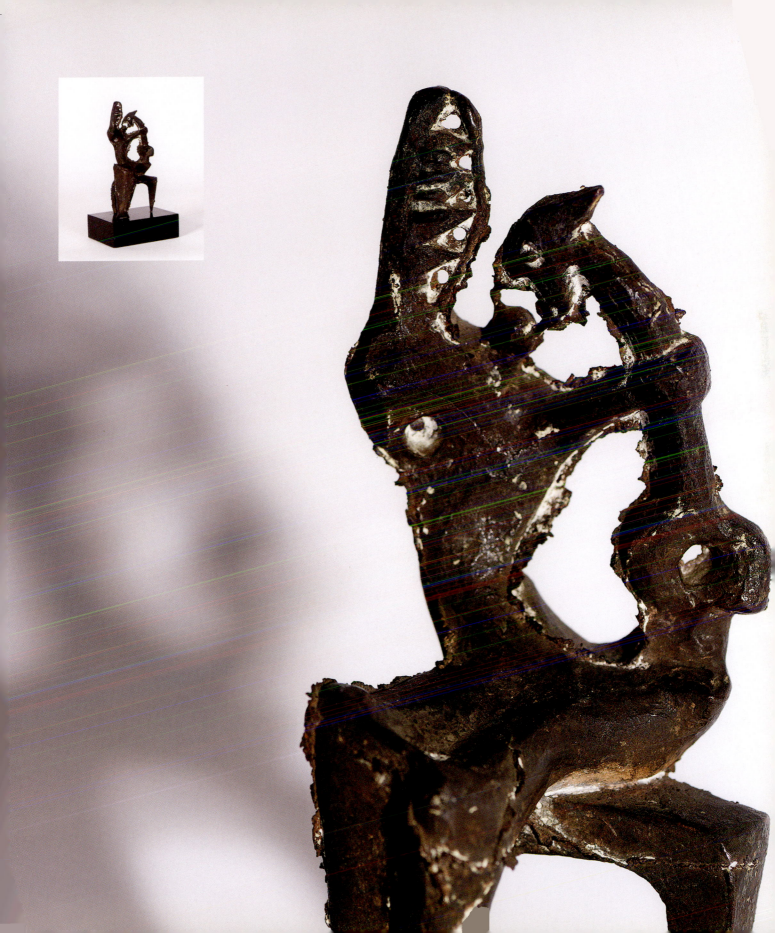

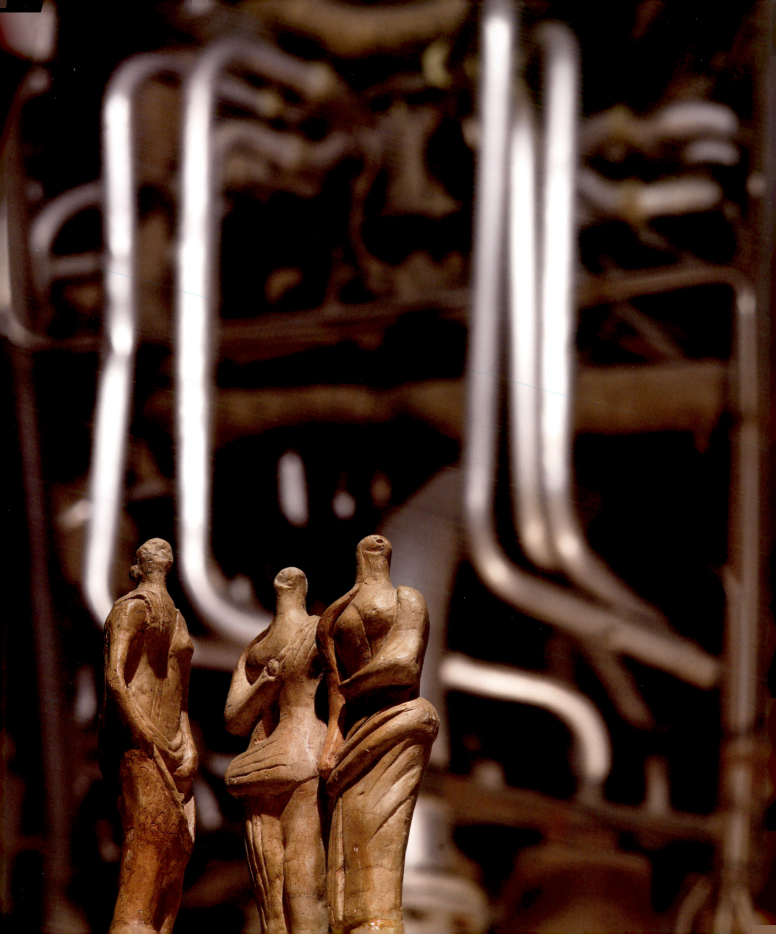

Three Standing Figures 1945
LH 258
plaster with surface colour, height 21.6cm
The Henry Moore Foundation: gift of
the artist 1977

near right:
FIG.18. *Falling Buildings:*
The City 30 December 1940 1940–41
Second Shelter Sketchbook p.61
HMF 1686
pencil, wax crayon, coloured crayon,
watercolour, wash, pen and ink
The Henry Moore Foundation: gift of
Irina Moore 1977

far right:
FIG.19. *Wrecked Omnibus and Figures in*
Underground Shelter 1940–41
First Shelter Sketchbook p.20
HMF 1578
pencil, wax crayon, coloured crayon,
watercolour, wash, pen and ink
The British Museum, London: bequest of
Jane Clark 1977

below:
Seated Torso 1954
LH 362
plaster, length 49.5cm
The Henry Moore Foundation: gift of
the artist 1977

6. Moore, *Shelter-Sketchbook*, Marlborough Fine Art, London 1967.

7. Julian Andrews, *London's War: The Shelter Drawings of Henry Moore*, London 2002.

8. Kenneth Clarke to Duncan Grant, 7 July 1941, Imperial War Museum, War Artists Archive ART /WA2 /3 /68, p.25.

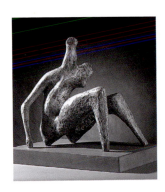

(27

I was fascinated by the sight of the people camping out deep under the ground. I had never seen so many rows of reclining figures and even the holes out of which the trains were coming seemed to me to be like the holes in my sculpture. [And there were intimate little touches. Children fast asleep, with trains roaring past only a couple of yards away. People who were obviously strangers to one another forming tight little intimate groups.] They were cut off from what was happening up above, but they were aware of it. There was tension in the air. They were a bit like the chorus in a Greek drama telling us about the violence we don't actually witness.*⁶*

In the Shelter sketchbooks, Moore frequently juxtaposes scenes from above and below ground, making explicit these tensions: a crashed bus balances by a hole in the road whilst below, aware of danger but not of a specific threat, figures sit amongst mechanical-like forms and stare out at the viewer [fig.19]; a figure is trapped under debris and, above, shelterers sleep and tend each other; the drawing of a bomb held above a sculptural object is inset into sketches of a tube platform and destroyed homes. Julian Andrews has drawn comparisons between Moore's survivors and images of ashen figures recently excavated from Pompeii.⁷ Indeed, Kenneth Clark, chair of the War Artists Advisory Committee and an important patron and friend of Moore's, described London as a 'latter-day Pompeii'⁸ during the Blitz, and the classical imagery extends in Moore's work to the toga-like dresses [pl.6]. Some pages read as

Black bearded jews, men with shawls, women handkerchief on heads women sit

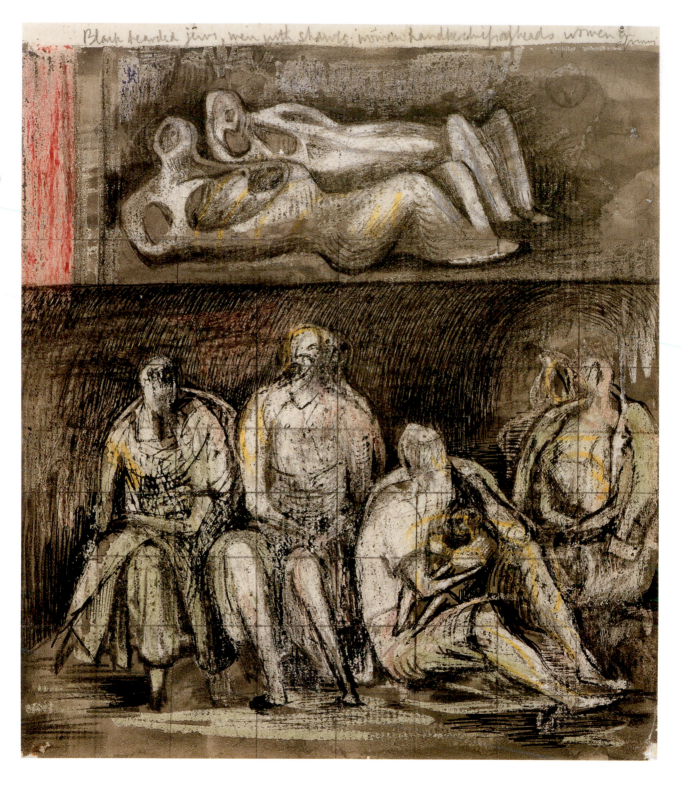

28)

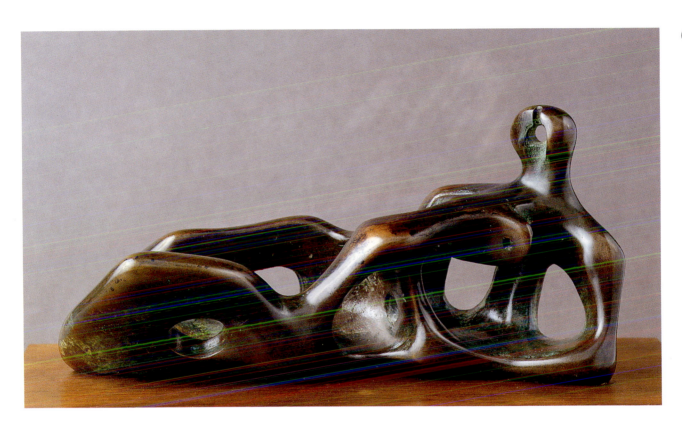

2. *Reclining Figure 1938*
LH 185
bronze, length 21.6cm
unsigned, unnumbered
The Henry Moore Foundation:
gift of the artist 1977

1. *Study for 'Group of Shelterers during*
an Air Raid' 1940–41
Second Shelter Sketchbook p.17
HMF 1642
pencil, wax crayon, coloured crayon,
watercolour, wash, pen and ink
The Henry Moore Foundation:
gift of Irina Moore 1977

below left:
FIG.21. Study for 'Shelter Drawing' 1940–41
Second Shelter Sketchbook p.77
HMF 1702
pencil, wax crayon, coloured crayon,
watercolour, wash, pen and ink
The Henry Moore Foundation:
gift of Irina Moore 1977

below right:
FIG.22. Miner with Tupping Machine in
Flocton Colliery 1942
Coalmining Subjects Sketchbook p.[41]
HMF 1944
pencil, wax crayon, watercolour, wash,
pen and ink
The Henry Moore Foundation:
gift of the artist 1977

dreams – cattle burn [fig.20]; blankets become shells; crowds converge into waves, with seal-like heads only just above the water; faces are replaced by shattered fragments of buildings – as the external world becomes an extension of private concerns and the personal, absorbing the shock of its surroundings, morphs and fossilises [pl.1]. At times the passive resolve of the figures, their completeness and fullness of form, is in contrast to the surrounding chaos, at others their own fragility exposed with the destruction [fig.21]. If Moore sought the neutral and abstract for the display of his sculpture, these images explore a very different set of possibilities. Family groups, their form and mass beautifully described with sculptural qualities, sit amidst the collapsed facades and burnt-out machines, an opening to a narrative that would see Moore's work in the open squares and spaces of the post-war towns. (Moore's own sister, her daughter and his elderly mother were all forced to move to Hoglands in October 1940 from Burnham-on-Crouch where a landmine had destroyed 80 houses, possibly influencing Moore's own artistic preoccupations of the time.) Not only are the drawings templates for a display, but also statements of faith of what values would survive the war.

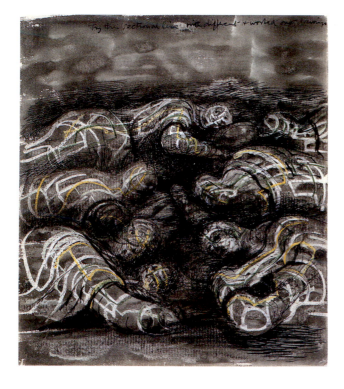

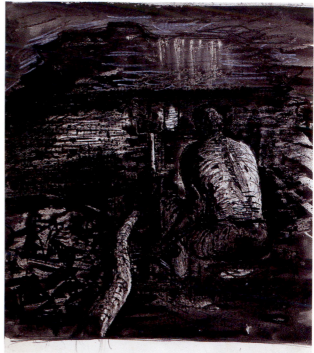

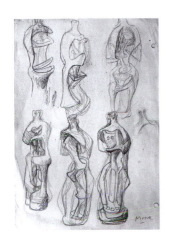

Upright Internal/External Forms 1939
HMF 1472
pencil, crayon
276 x 190mm
The Henry Moore Foundation: gift of
the artist 1977

Depictions of the individual within the created spaces of technology extended into other areas of Moore's work. The tunnelled environments of the mines might be similar to the underground stations, but now the individual, and it is usually individuals rather than groups, reacts to the tight constrictions by exploring and violently re-shaping it [fig.22]. Here, there is little evidence of the external world, and the unfamiliarity of the claustrophobic spaces perhaps reduces the viewer's ability to engage in these drawings as easily as with the Shelter works. It is the miner-type figure that is seen in work such as *Helmet Head No.1* [fig.23] and *Upright Internal/External Form* [pl.28], where a fluid and dynamic inner figure is constrained within an outer shell. These works carry ambiguous messages of threat and engagement, of external hostility and defence, of internal entrapment and protection. They have their roots in the punctured reclining female figures [pl.2] and can be read as studies of the parent-child relationship, a theme also explored in surprising ways in more figurative pieces [fig.24]. However, in form and in detail they also include explicit mechanical elements, from the rivets of *Helmet Head No.1* [fig.23] and works such as *Reclining Figure* [pl.26], whose form appears to draw on mechanical components as much as the human figure, to the streamlined shapes of the internal/external forms which draw physical and psychological comparisons with aircraft and their cockpit crew. Who is master of the machine? Who directs its path and purpose? Can the individual survive outside of this engineered shell?

Contemporary responses to Moore's work emphasise these relationships. Critics reviewing Moore's first exhibition in Hamburg in 1950, drew connections between Moore's work and the technological age that had moulded his subject matter. Hamburg had been devastated by Allied bombs and at the time of the exhibition, the British were still in control and attempting to demolish its largest dock, potentially threatening a tunnel under the Elbe. The reviewer from *Die Welt* wrote that Moore's work represented 'all of us in our Western impotence against mass and the machine' and 'man hunted by the machine taking refuge in the earth.'[9] *The Rheinische Post* wrote 'Henry Moore tries to find a away out of our age of robots, to win back lost nature with a new creative intensity.'[10] Moore's acceptance by the German critics and the purchase of work by European civic institutions is notable because of their willingness to reconnect its values with recent events. The acquisition of a cast of *Warrior with Shield* by the city of Arnhem was specifically to commemorate the failed Allied attempt to secure the town in 1944 when German Panzers destroyed the houses sheltering British parachutists.

Moore's notion that the shelterers were a Greek chorus, messengers of events elsewhere, is one that could be applied to his own work. His engagement with the politics and events of his day was deeply rooted in his life and his sculptures, in their engineered and elastic forms,

9. *Die Welt*, 22 March 1950 (RB p.222).
10. *Rheinische Post*, 3 April, 1950.

For I believe good painting & sculpture is opening not shutting your eyes to the outside world. [11]

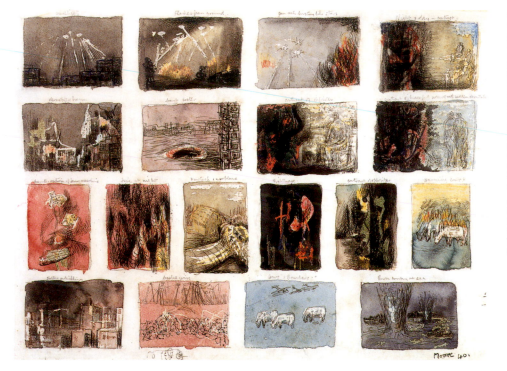

FIG.20. *Eighteen Ideas for War Drawings* 1940
HMF 1553
*pencil, wax crayon, coloured crayon,
watercolour wash, pen and ink
274 x 376 mm
inscription: (u.l.) searchlights; (u.c.) flashes
from ground; gunshells bursting like stars;
(u.r.) night & day – contrast; (u.c.l.)
devastated houses; bomb crater; (u.c.r.)
contrast of opposites; contrast of peaceful
normal with sudden devastation; (c.l.)
disintegration of farm machine; fire at night;
(c.) haystack & airplane; nightmare; (c.r.)
contrast of opposites; burning cows; (l.c.l.)
spotters on buildings; barbed wire; (l.c.r.)
cows & bombers; bombs bursting at sea.
The Henry Moore Foundation: gift of the
artist 1977*

right:
Family Group 1945
LH 239
*terracotta, height 12.7cm
The Henry Moore Foundation: gift of the
artist 1977*

tell of a world of testing and shaping, of dependence and fragility. Their incorporation of mechanical function and form reveals the technological threats and forces that imposed themselves into the daily life of society and the individual. To bring components of that age together in an exhibition is necessarily a contrived exercise but one that can create new insight into deeper interdependencies within cultures between art and invention, humanity and science. With Moore's assistance we can start to re-imagine the fears and dangers of the crew in the cockpits and turrets of the atrium machines; we can question again the creeping dominance of the machine over the individual; and to see the tube shelterers in such close proximity to the weapons of fear and destruction, we can be reminded that this is unfinished business, carried on in cities and communities across the globe.

Roger Tolson
Head of the Department of Art
Imperial War Museum

11. Moore to Arthur Sale, ibid.

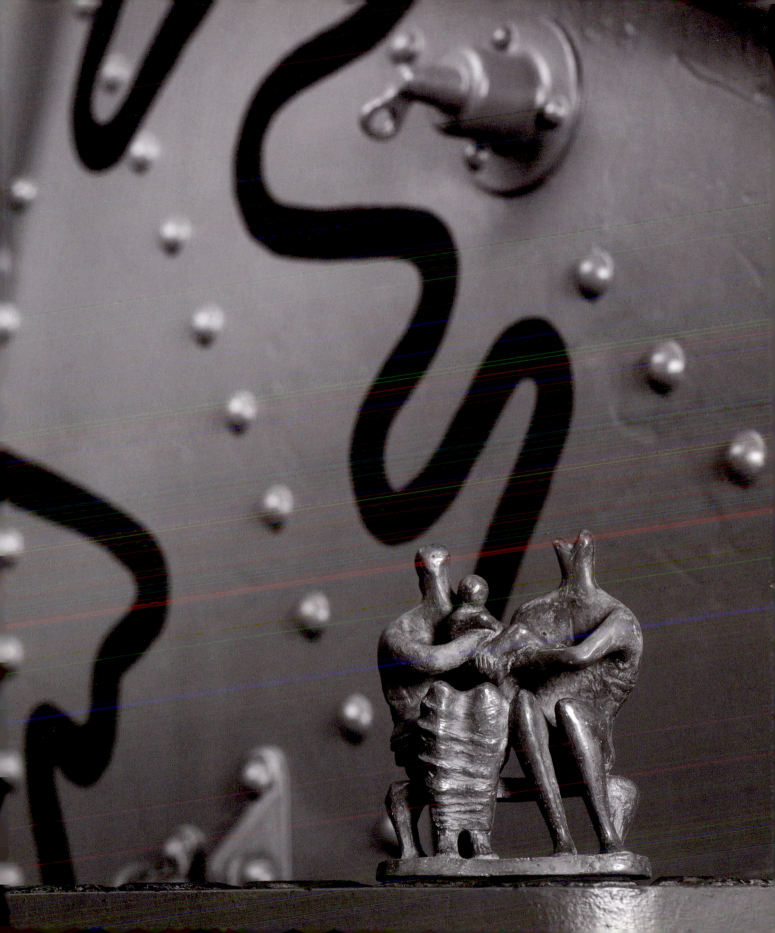

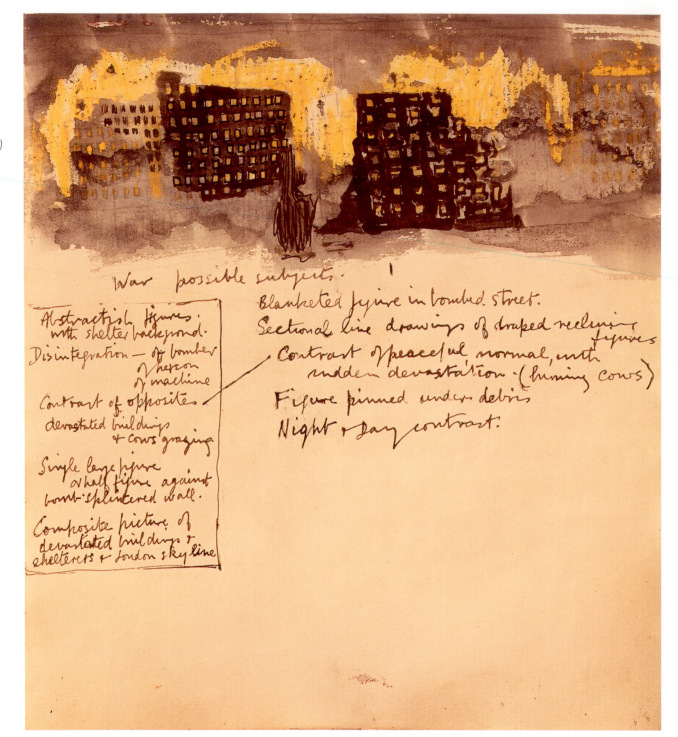

34)

War possible subjects.

Abstractish figures
 with shelter background.
Disintegration — of bomber
 of person
 of machine
Contrast of opposites
 devastated buildings
 + cows grazing

Single large figure
 or half figure against
bomb-splintered wall.

Composite picture of
 devastated buildings +
shelters + london sky line

Blanketed figure in bombed street.
Sectional line drawings of draped reclining
 figures
Contrast of peaceful normal, with
 sudden devastation · (burning cows)
Figure pinned under debris
Night + Day contrast.

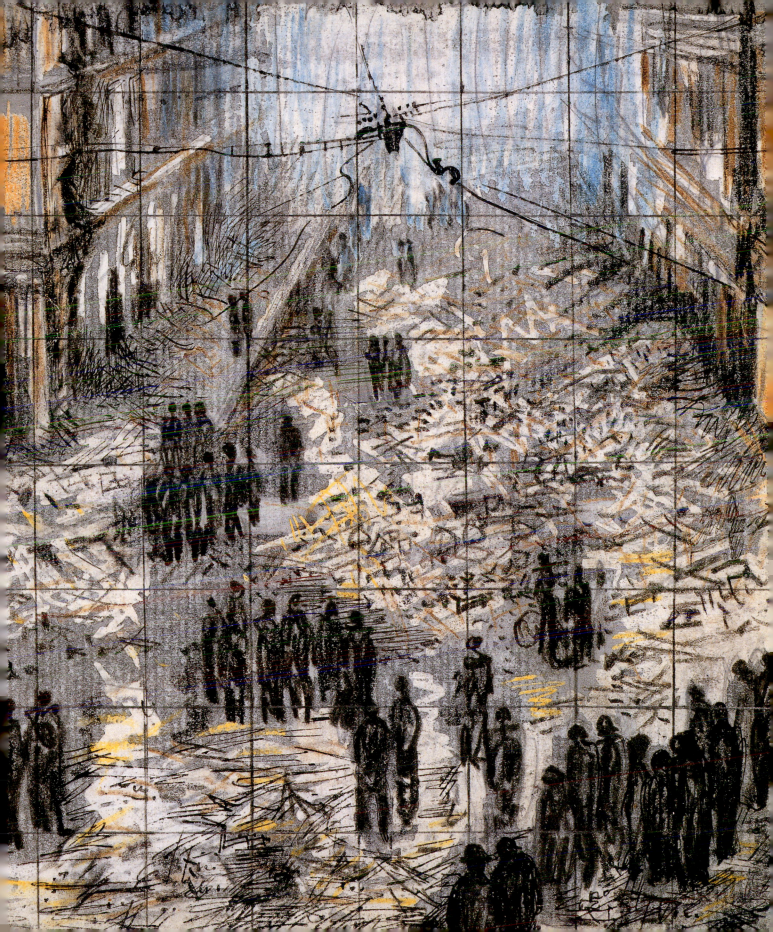

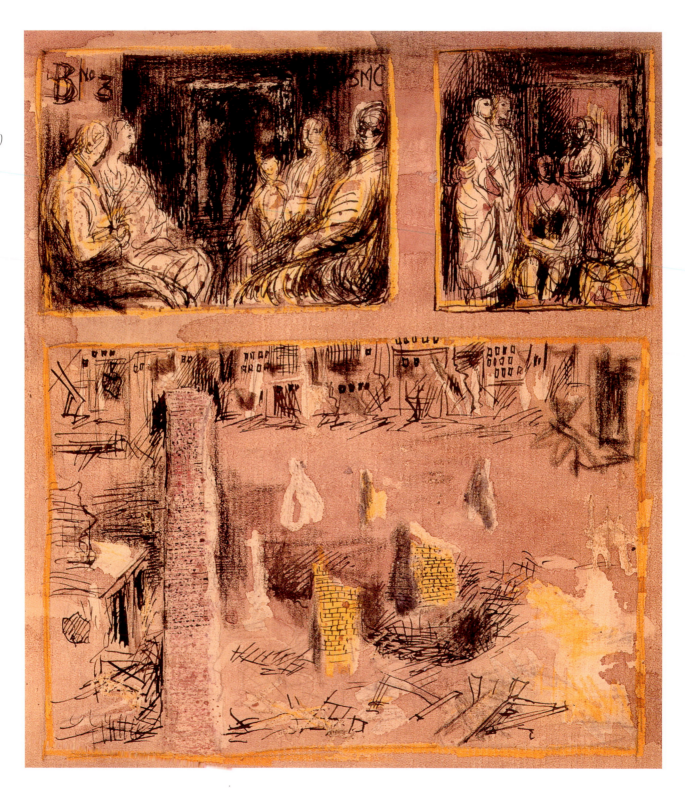

previous pages left:
3. *War: Possible Subjects* 1940–41
First Shelter Sketchbook p.45
HMF 1603
pencil, wax crayon, watercolour, wash,
pen and ink
The British Museum, London:
bequest of Jane Clark 1977

previous pages right:
4. *Study for 'Morning after the Blitz'*
1940–41
Second Shelter Sketchbook p.60
HMF 1685
pencil, wax crayon, coloured crayon,
watercolour, wash, pen and ink
The Henry Moore Foundation:
gift of Irina Moore 1977

left:
5. *Two Studies of Sheltering Groups*
and Blitzed Buildings 1940–41
First Shelter Sketchbook p.33
HMF 1591
pencil, wax crayon, watercolour, wash,
pen and ink
The British Museum, London:
bequest of Jane Clark 1977

right above:
6. *Two Women in a Shelter* 1940–41
First Shelter Sketchbook p.66
HMF 1624
pencil, wax crayon, watercolour, wash,
pen and ink
inscription: two women in a shelter/two
half figures
The British Museum, London:
bequest of Jane Clark 1977

right below:
7. *Two Seated Women in a Shelter*
1940–41
First Shelter Sketchbook p.56
HMF 1614
pencil, wax crayon, watercolour, wash,
pen and ink
inscription: two seated women in a shelter
The British Museum, London:
bequest of Jane Clark 1977

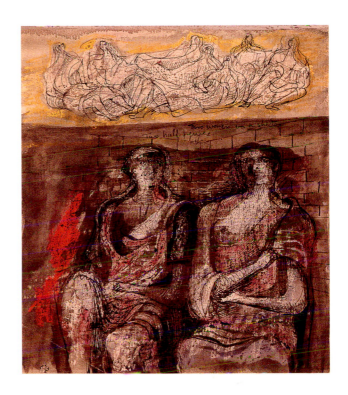

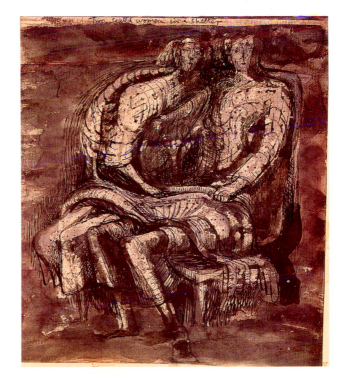

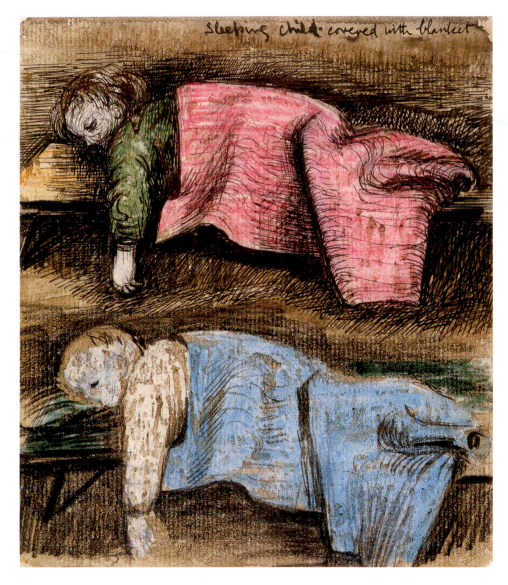

sleeping child covered with blanket

8. *Sleeping Child covered with Blanket*
1940–41
Second Shelter Sketchbook p.63
HMF 1688
pencil, wax crayon, coloured crayon,
watercolour wash, pen and ink
inscription: sleeping child; pen and ink
covered with blanket
The Henry Moore Foundation:
gift of Irina Moore 1977

9. *Sleeping Figures* 1940–41
Second Shelter Sketchbook p.86
HMF 1711
pencil, wax crayon, pastel, watercolour,
wash, pen and ink
The Henry Moore Foundation:
gift of Irina Moore 1977

overleaf left:
10. *Group of Shelterers: Sleeping
Figures* 1940–41
Second Shelter Sketchbook p.23
HMF 1648
pencil, wax crayon, coloured crayon, pen
and ink
The Henry Moore Foundation:
gift of Irina Moore 1977

overleaf right:
11. *People wrapped in Blankets*
1940–41
First Shelter Sketchbook p.61
HMF 1619
pencil, wax crayon, watercolour, wash,
pen and ink
The British Museum, London:
bequest of Jane Clark 1977

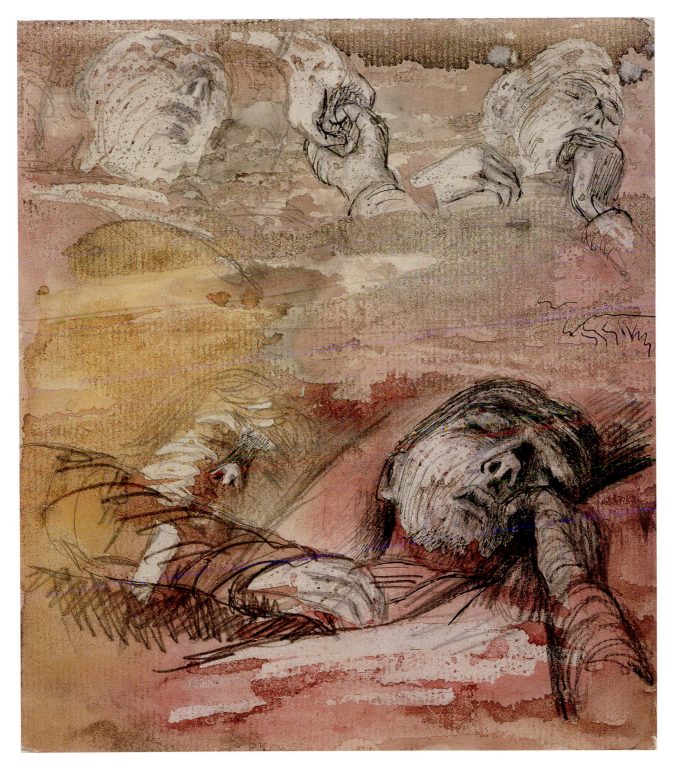

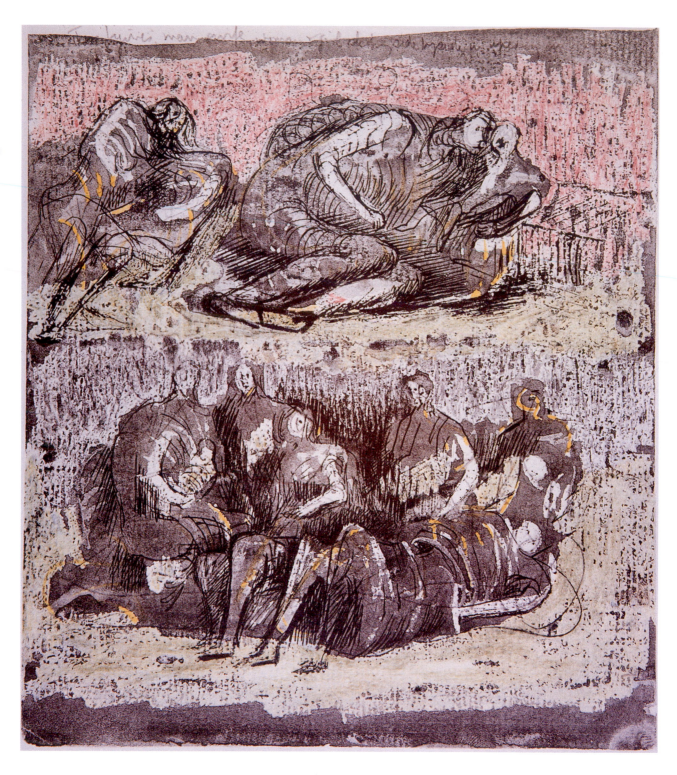

People wrapped in blankets.

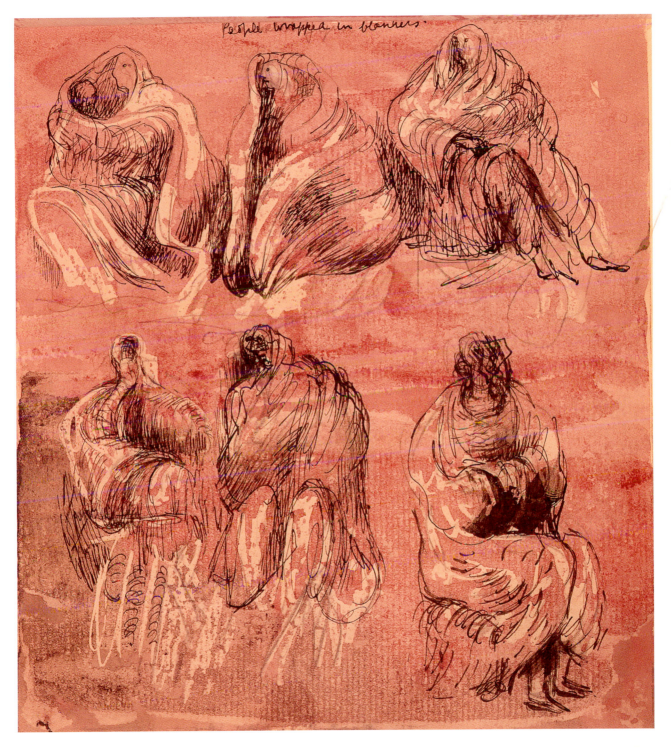

(41

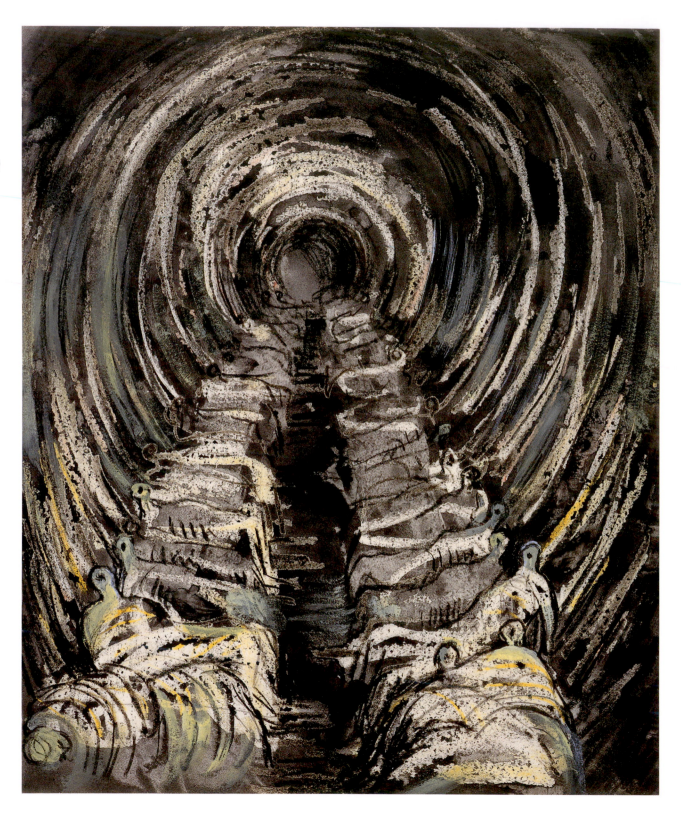

12. *Tube Shelter Perspective* 1941
Page from Large Shelter Sketchbook 1941
HMF 1773
pencil, wax crayon, coloured crayon,
watercolour wash, gouache
292 x 242mm
The Henry Moore Foundation:
gift of the artist 1977

right:
13. *Tube Shelter Scenes* 1940–41
Second Shelter Sketchbook p.54
HMF 1679
pencil, wax crayon, coloured crayon,
watercolour, wash, pen and ink
inscription: *do abstract drawing (...)*
of scene (...)/draw these in pen before
colouring
The Henry Moore Foundation:
gift of Irina Moore 1977

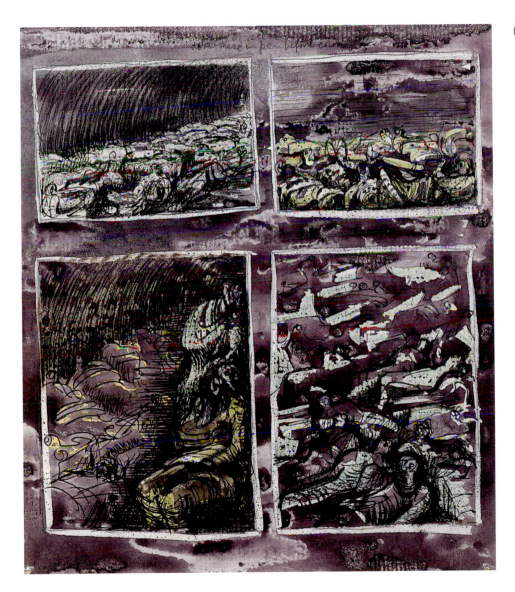

14. *Pointed Reclining Figure* 1948
LH 268a
bronze, length 24.2cm
The Henry Moore Foundation:
gift of the artist 1977

15. *Studies for 'Tube Shelter Scene' and*
'Figure in a Shelter' 1940–41
Second Shelter Sketchbook p.51
HMF 1676
pencil, wax crayon, coloured crayon,
watercolour, wash, pen and ink
inscription: woman lying down/reading
newspaper
The Henry Moore Foundation:
gift of Irina Moore 1977

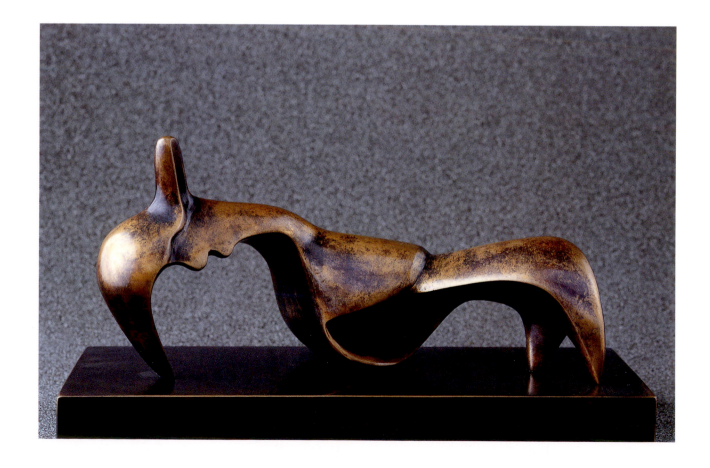

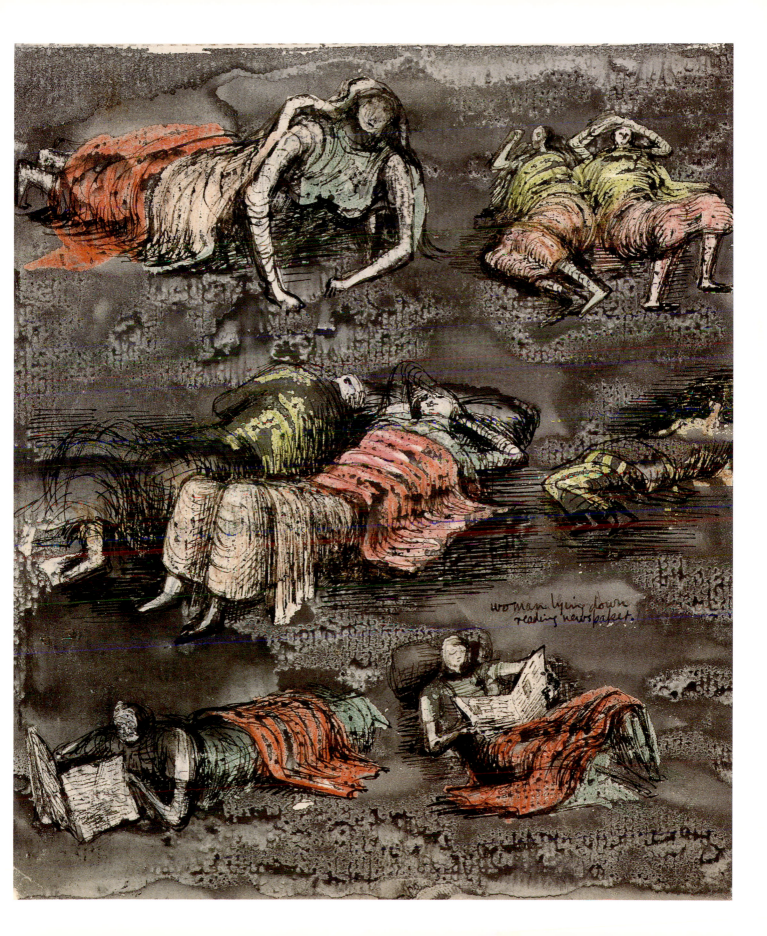

woman lying down
reading newspaper.

46)

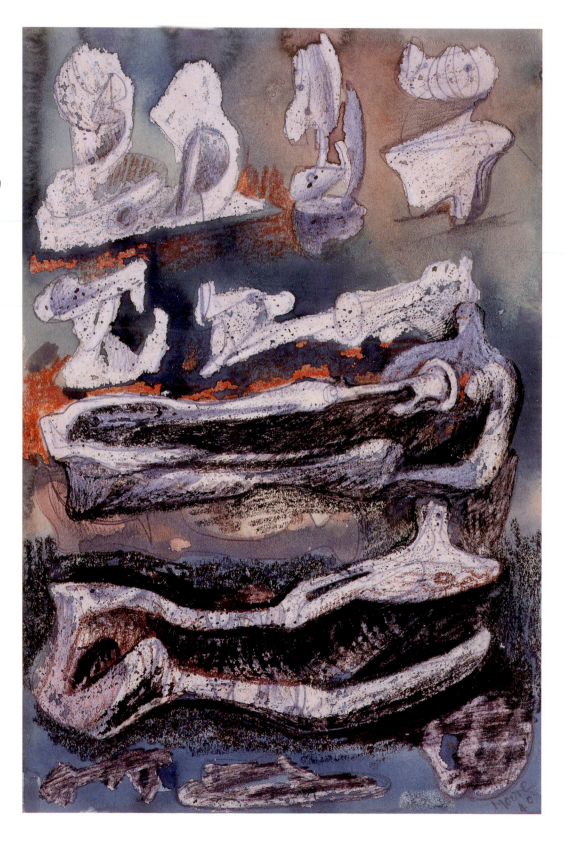

17. *Reclining Figure* 1945
LH 251
bronze, length 19.4cm
The Henry Moore Foundation:
gift of the artist 1977

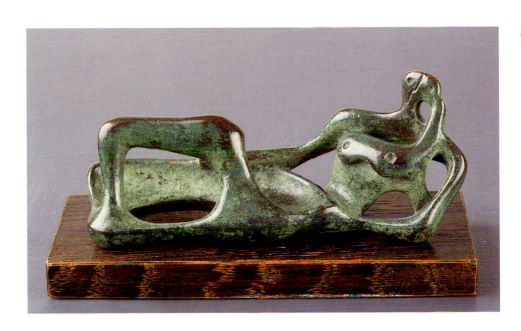

18. *Reclining Figure* 1945
LH 250
bronze, length 16.5cm
The Henry Moore Foundation:
gift of the artist 1977

left:
16. *Reclining Figures: Studies for Sculpture* 1940
HMF 1534
pencil, wax crayon, coloured crayon,
watercolour wash, pastel, pen and ink
274 x 181mm
The Henry Moore Foundation:
acquired 1980

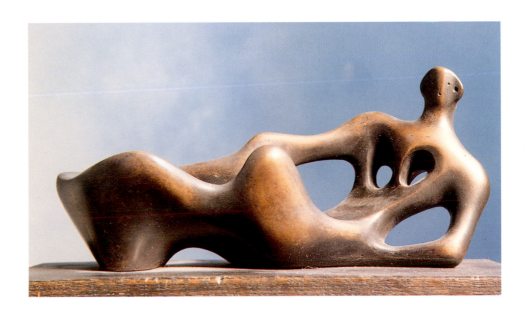

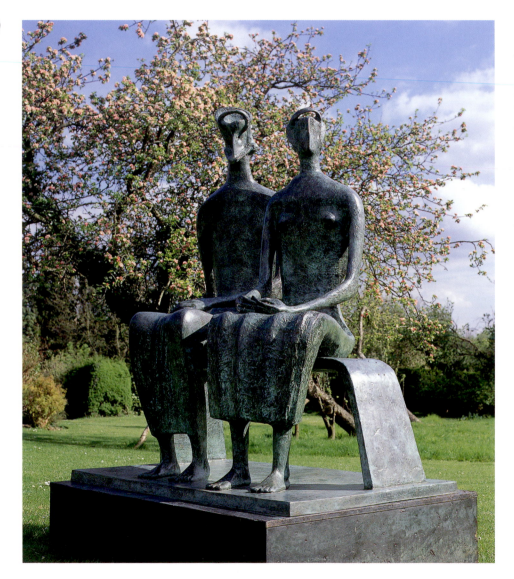

19. King and Queen 1952–53
LH 350
bronze, height 164cm
Tate

In one of Moore's early sale record books
this sculpture is rather prosaically called
Two Seated Figures. What, one is tempted
to ask, would its fame and reputation
have been if that title had remained.
Tam Miller, Moore's secretary at the time,
explained recently that she modelled for
the hands of the queen and that one of
his assistants, Alan Ingham, did the same
for the feet of the king.

 The two figures, even with the
concession to royalty apparent in their
crowns, seem quietly domestic in their
poise and scale. Some observers have
thought them autobiographical, which
seems unlikely. Others have noticed
their date and assumed that they were
associated with the Coronation of Her
Majesty The Queen in 1952, or were a
statement of some unknown kind about
the British Royal Family. There may be
some truth in these connections as far
as the title is concerned but not for the
work itself.

20. *Group of Seated Figures in front of
Ruined Buildings* 1940–41
First Shelter Sketchbook p.26
HMF 1584
*pencil, wax crayon, coloured crayon,
watercolour, wash, pen and ink*
The British Museum, London:
bequest of Jane Clark 1977

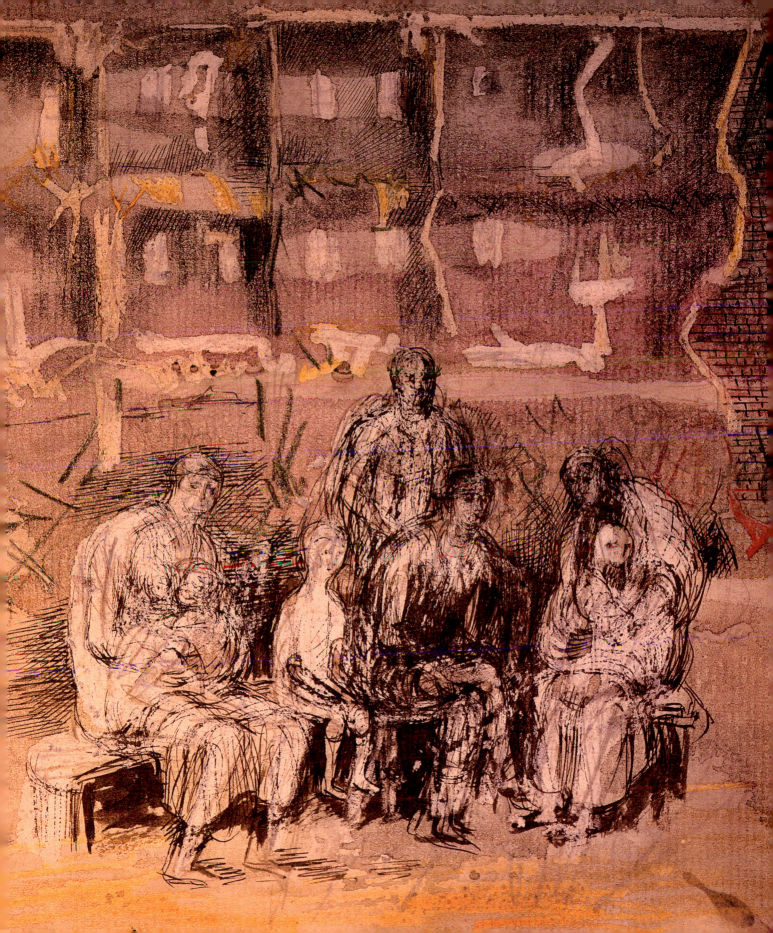

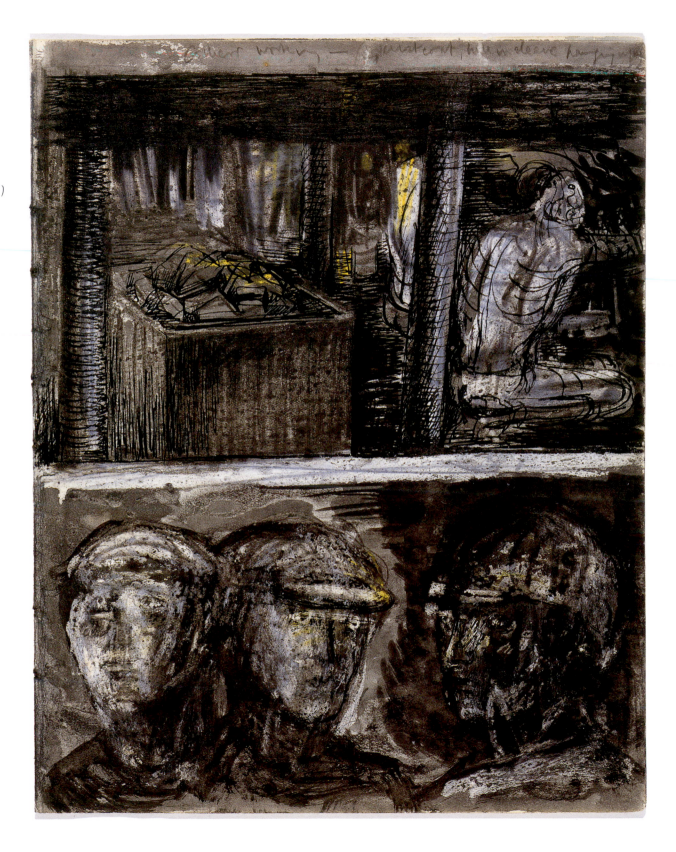

22. *Maquette for Strapwork Head*
1950
LH 289a
bronze, height 10cm
The Henry Moore Foundation:
gift of the artist 1977

(51

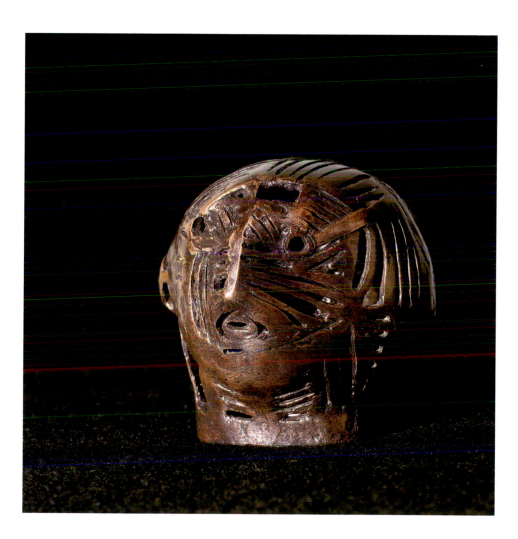

left:
21. *Miners' Heads 1942*
Coalmining Subjects Sketchbook p.[7]
HMF 1927
pencil, wax crayon, coloured crayon,
watercolour wash, pen and ink
inscription: collier working – waistcoat,
(...) in sleeve hanging
The Henry Moore Foundation:
gift of the artist 1977

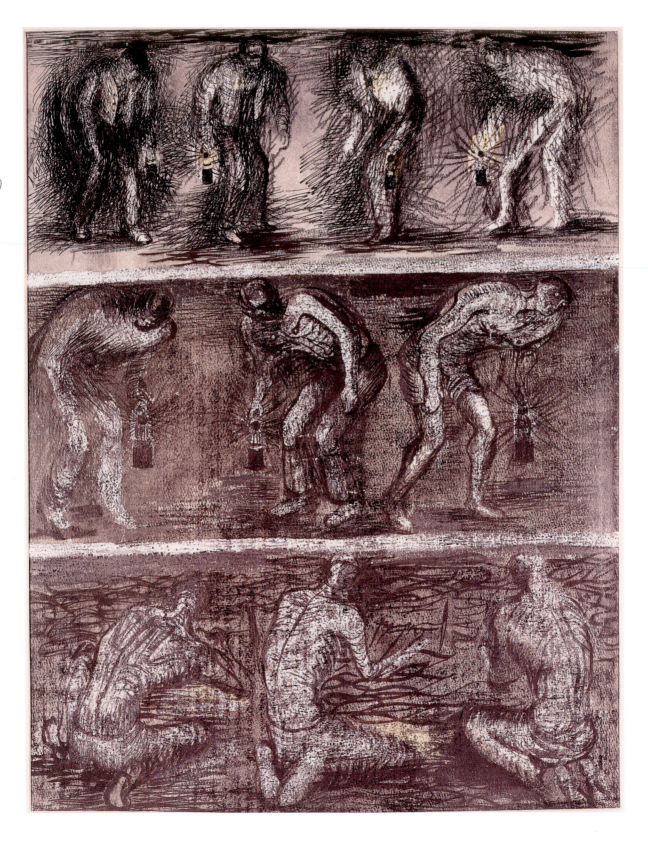

52)

24. *Warrior with Shield* 1953–54
LH 360
bronze, height 155cm
The Henry Moore Family Collection

More male figures exist in Moore's œuvre than are commonly recognized – family groups, life drawings, helmet heads, coalmine drawings and warriors – but not in a large size.

In a letter from 1955 he wrote: 'The idea for the warrior came to me at the end of 1952 or very early in 1952. It evolved from a pebble I found on the seashore in the summer of 1952, and which reminded me of the stump of a leg, amputated at the hip. Just as Leonardo says somewhere in his notebooks that a painter can find a battle scene in the lichen marks on a wall, so this gave me the start of the warrior idea. First I added the body, leg, and one arm and it became a wounded warrior, but at first the figure was reclining. A day or two later I added a shield and altered its position and arrangement into a seated figure and so changed it from an inactive pose into a figure which, though wounded, is still defiant. The head has a blunted and bull-like power but also a sort of dumb animal acceptance and forbearance of pain.'

left:
23. *Miners at Work* 1942
HMF 2003
pencil, wax crayon, coloured crayon,
watercolour, wash, pen and ink
566 x 430 mm
Whitworth Art Gallery, Manchester: presented by the War Artists' Advisory Committee

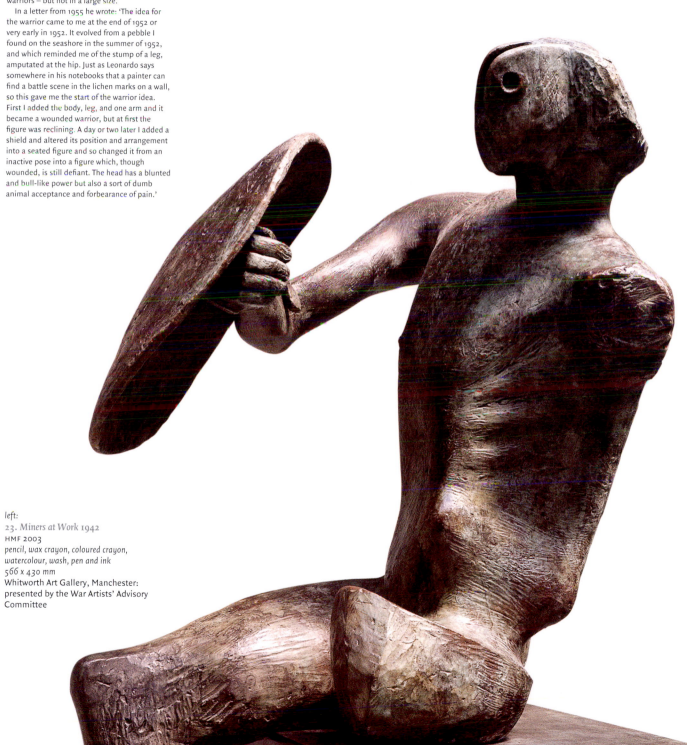

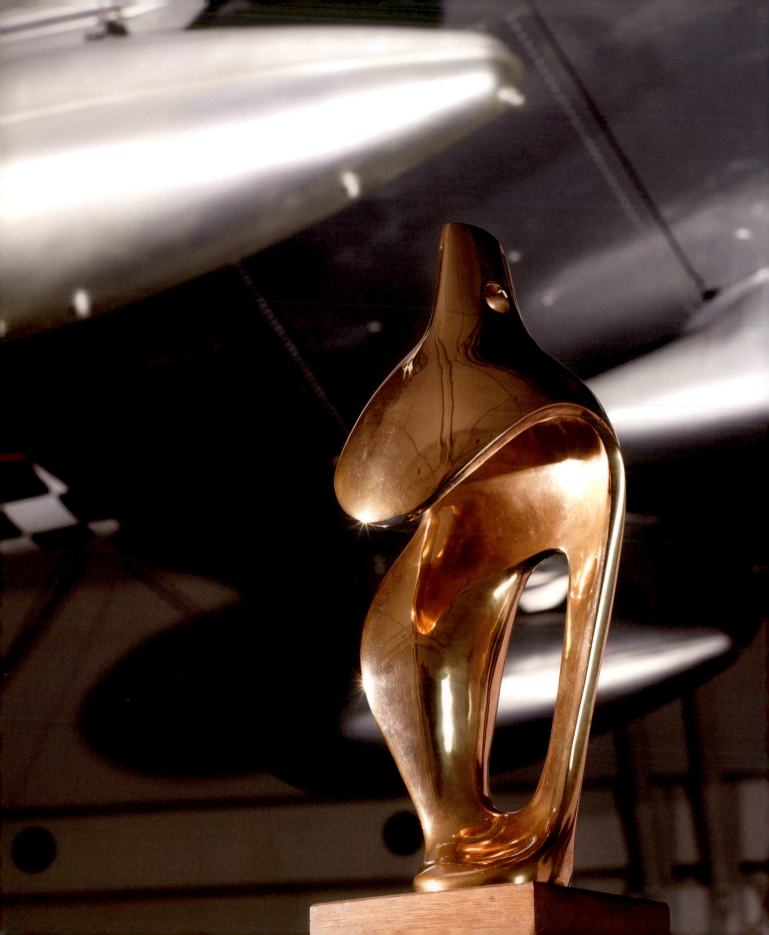

26. *Reclining Figure 1945*
LH 252
bronze, length 18.4cm
The Henry Moore Foundation:
gift of the artist 1977

left:
25. *Figure 1939*
LH 209
bronze, height 40.7cm
The Henry Moore Foundation:
gift of the artist 1977

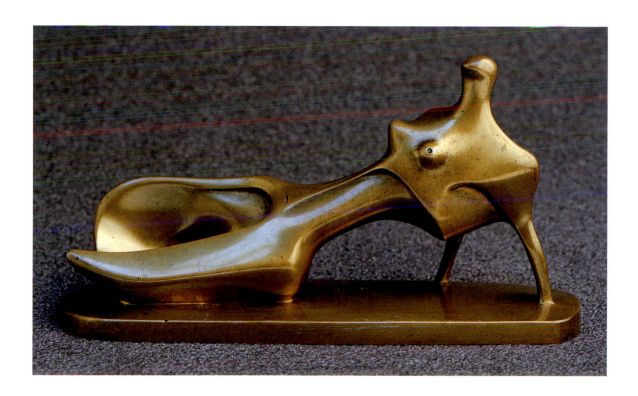

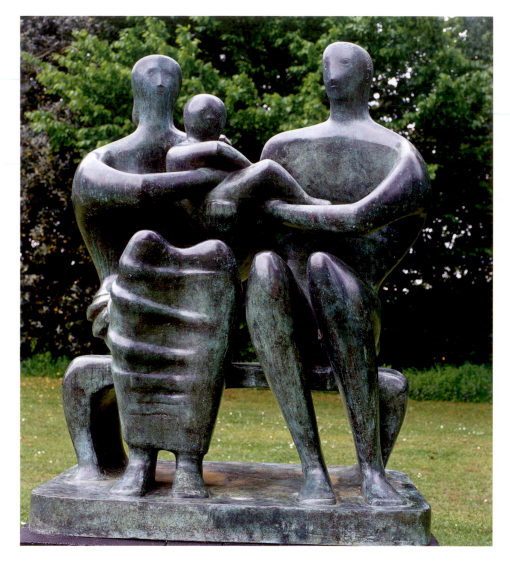

27. *Family Group* 1948–49
LH 269
bronze, height 152cm
Tate

28. *Working Model for Upright
Internal/External Form* 1951
LH 295
bronze, height 63.2cm
The Henry Moore Foundation:
gift of Irina Moore 1977

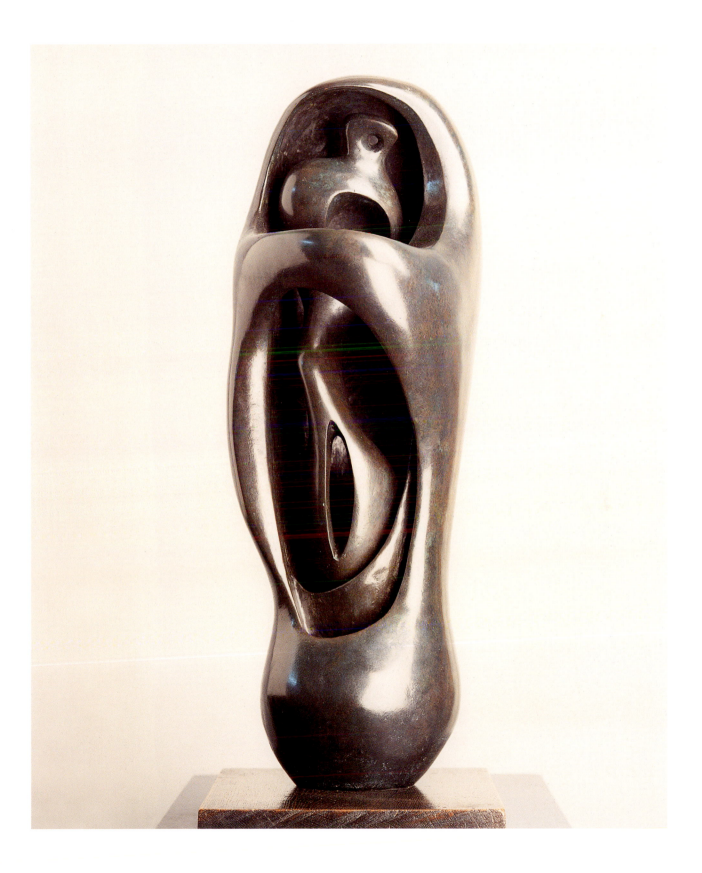

58)

29. *Mother and Child* 1939
LH 201
bronze and string, length 19cm
The Henry Moore Foundation:
gift of Irina Moore 1977

right:
30. *Reclining Stringed Figure* 1939
LH 199a
plaster with surface colour, yellow string
added 1999
length 25.7cm
The Henry Moore Foundation:
acquired 1993

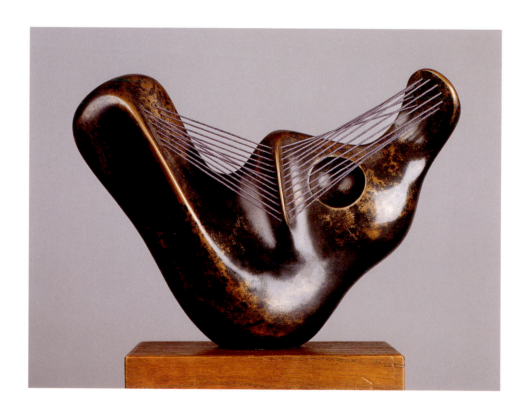

31. *Figures on Ladder Background*
c.1944
TEX 2:2
serigraphic printing on cotton 865 x
890mm produced as a headscarf in an
unlimited edition by Zika Ascher
*from a drawing of 1943 (*HMF 2131*)*
The Henry Moore Foundation:
gift of the artist 1977

32. *Three Standing Figures c.1944*
TEX 1:1
serigraphic printing on rayon 889 x
826mm produced as a headscarf in an
unlimited edition by Zika Ascher
*from a drawing of 1943 (*HMF 2147*)*
The Henry Moore Foundation:
gift of the artist 1977

34. *Barbed Wire c.1945*
TEX 4:3
serigraphic printing on rayon produced by
Zika Ascher from an unidentified drawing
The Henry Moore Foundation:
acquired 1990

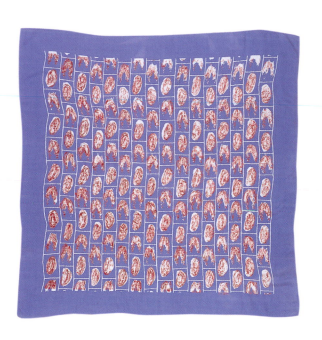

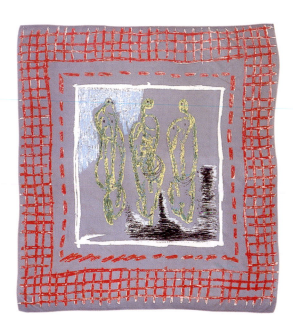

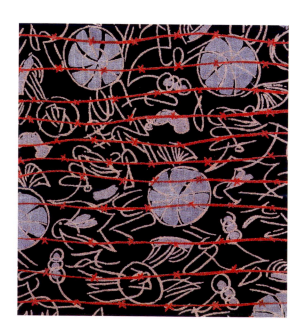

33. *Barbed Wire c.1945*
TEX 4:2
serigraphic printing on rayon produced by
Zika Ascher from an unidentified drawing
The Henry Moore Foundation:
gift of the artist 1977

It is possible that about 20 samples of this
design were printed in various colour-
ways on rayon or artificial silk. According
to Ascher about 100 metres were made as
dress material, including a length used by
the fashion designer Barbara Mosca for a
dressing gown in the film *They Made Me a*
Fugitive, released in 1947.

35. *Study for 'Sleeping Figures'* 1940–41
Second Shelter Sketchbook p.41
HMF 1666
pencil, wax crayon, wash
inscription: people under different coloured
coats & blankets – one or two sat up
The Henry Moore Foundation: gift of
Irina Moore 1977

37. *Stringed Figure: Bowl 1938*
LH 186c
bronze and string, height 54.6cm
The Henry Moore Foundation:
gift of the artist 1979

62)

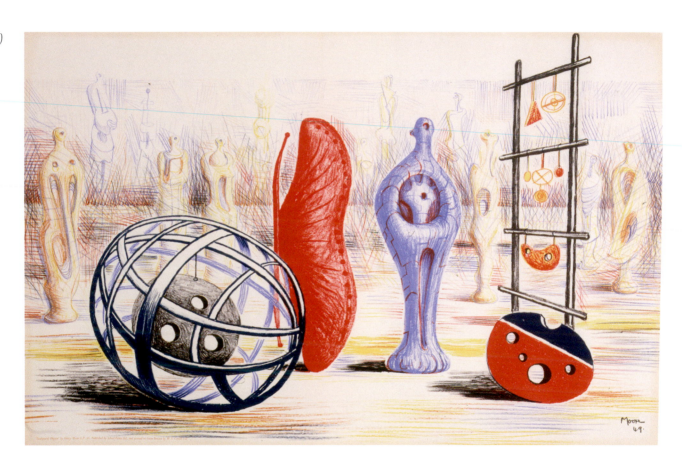

36. *Sculptural Objects 1949*
CGM 7
lithograph in six colours
495 x 762mm
publisher: School Prints, London
The Henry Moore Foundation: gift of
the artist 1977

School Prints, described as 'one of the bravest experiments in the history of modern art in this country', was founded in 1937 by Derek Rawnsley who had already initiated a 'picture lending library scheme' in 1935 which included work by Moore. The purpose was to circulate sets of colour reproductions between schools to further art education. Rawnsley was killed in the war, but in 1945 his widow Brenda decided to carry on his work as a memorial to him, expanding the circulation scheme and also publishing contemporary original graphics, mainly for use in primary schools. The prints were bought by annual subscription and four subjects were distributed each term.

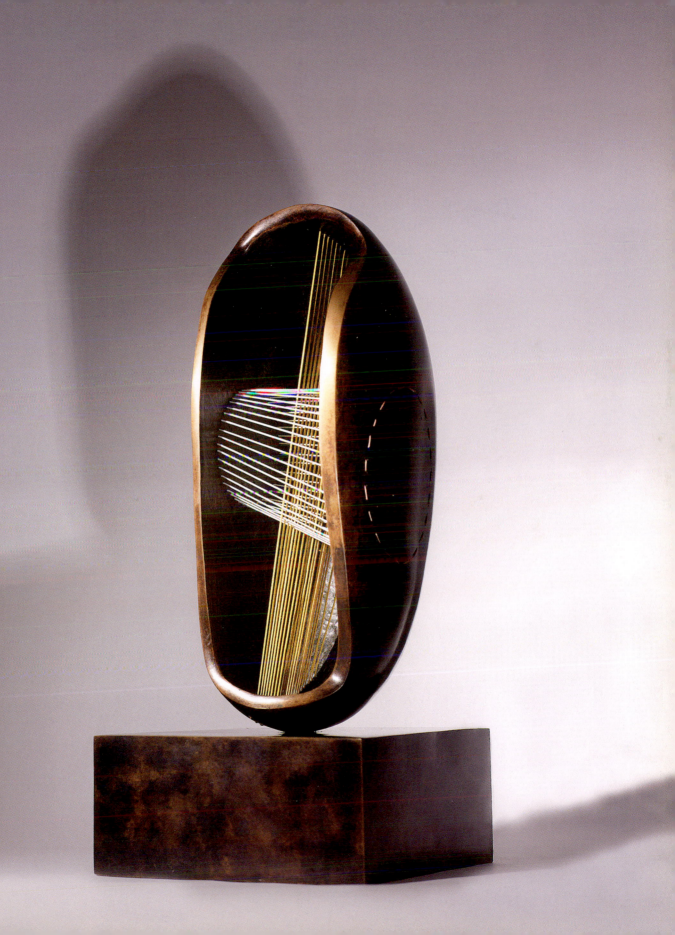

38. Sheet of Heads showing Sections 1940
(detail)
HMF 1508
wax crayon, coloured crayon, watercolour
wash, pen and ink
279 x 381 mm
The Henry Moore Foundation:
acquired 2002

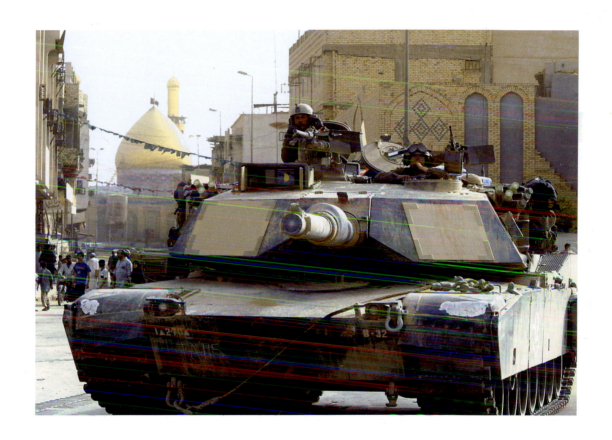

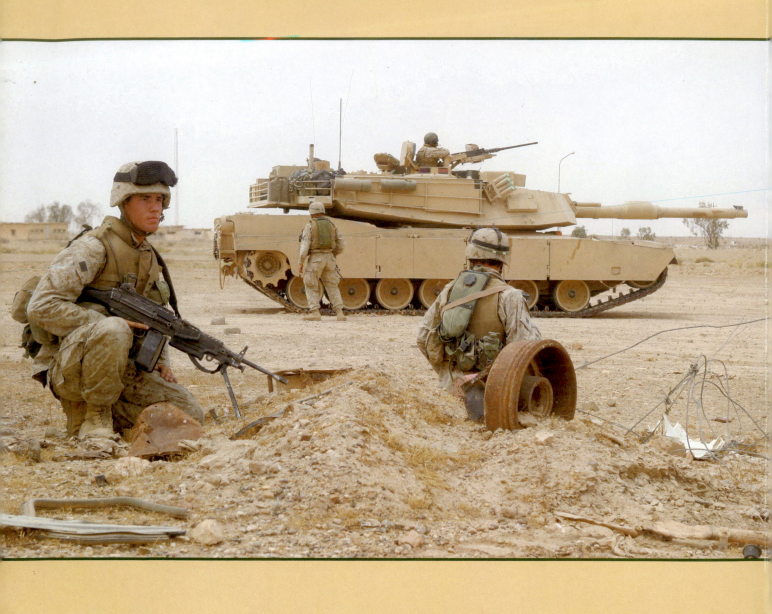

M1 ABRAMS
AT WAR

MICHAEL GREEN &
GREG STEWART

ZENITH
PRESS

DEDICATION

To all the U.S. Army and Marine Corps Abrams tankers fighting in Iraq that have upheld the proud traditions of Armor and their Service.

First published in 2005 by Zenith Press, an imprint of MBI Publishing Company, Galtier Plaza, Suite 200, 380 Jackson Street, St. Paul, MN 55101-3885 USA

Zenith Press titles are also available at discounts in bulk quantity for industrial or sales-promotional use. For details write to Special Sales Manager at MBI Publishing Company, Galtier Plaza, Suite 200, 380 Jackson Street, St. Paul, MN 55101-3885 USA.

ISBN-13: 978-0-7603-2153-9
ISBN-10: 0-7603-2153-1

Editor: Steve Gansen

Printed in China

On the frontispiece: U.S. Army M1A1 Abrams on patrol in an Iraqi city. U.S. Army

On the title page: May 2004, outside Falujah, Iraq. *Lance Corporal Kevin Quishuis Jr.*

On the front cover: U.S.Army M1A1 on the road in Iraq

Credit: Staff Sergeant Shane A Cuomo

Inset: A dramatic fireball erupts from the muzzle end of an M1 tank as a main gun round is fired. *Greg Stewart*

About the authors:
Michael Green is a freelance writer, researcher, and photographer who specializes in military, transportation, and law enforcement subjects, with more than 50 books to his credit. In addition, he has written numerous articles for a variety of national and international military-related magazines. He lives in Northern California.

Greg Stewart is a freelance photographer specializing in military subjects, who has collaborated with Michael Green on a number of book projects. He lives in Southern California.

CONTENTS

ACKNOWLEDGMENTS

SPECIAL THANKS ARE DUE TO THE U.S. ARMY AND MARINE CORPS PUBLIC affairs officers whose support and help made this book possible. Thanks also go to the various program managers and their staffs at the Tank Automotive and Armament Command (TACOM) that took the time to answer questions about the Abrams tank. Peter Keating, director of communications at General Dynamics Land Systems (GDLS), and his assistant, Elizabeth Buscemie, also provided valuable assistance in the completion of this book. As always, the helpful staff at the Patton Museum of Cavalry and Armor also went out of their way to assist the authors.

Besides the individuals mentioned in the text, others who made an extra effort to assist the authors include Ron Hare, Bruce Heron, Richard Pearce, Dean and Nancy Kleffman, Dave Latson, Fred Pernell, Russ Bryant, Dick Hunnicutt, Jacques Littlefield, John Magnusso, Bob and Trish Fleming, Richard Cox, Jim Mesko, Michael Purnell, Jim Lewis, Kenneth Estes, and especially Randy Talbot.

INTRODUCTION

IN A FAMOUS PHOTOGRAPH OF THEN-LIEUTENANTS GEORGE PATTON and Dwight Eisenhower, taken between World War I and World War II, the future of U.S. Army armored forces is proudly displayed. The key to this important photograph, however, is not the two young officers who would later come to define U.S. military leadership and success, but the tank that was pictured in the background—a U.S. M1917 light tank, a U.S.-produced version of the French Renault FT17 light tank of World War I fame. The M1917 marked the true beginning of tanks in the U.S. Army. Unfortunately, it also established a pattern in the United States of reliance on foreign expertise and technology, and of conservative thinking that would hinder the application of advancing tank technology to American tanks. This pattern would keep the development of American tanks behind that of many other countries and force the United States into a position of playing catch-up both on and off the battlefield.

During World War II, the U.S. Army fielded a series of tank designs that history has labeled as important and successful. What many observers overlook, however, is that the instrumental factor in this success was not the quality of the tanks themselves, but the massive production and logistic support system that was put in place to support American tanks in combat. Two of the most important American tanks of the war were the M3 Grant/Lee and the ubiquitous M4 Sherman medium tanks. Through the unparalleled lend-lease program, M3 Grant tanks were supplied to both the British and Russian forces, which were fighting superior German tanks. While the arrival of the first Allied 75mm tank gun of the M3 was an important event for the British fighting in North Africa, the M3 was actually an outdated design when it arrived. The Russians were not fond of the M3 and actually referred to it by its earned nickname, "a grave for six brothers."

The M4 Sherman is regarded by many as a successful design, and in many ways it performed well in combat in World War II. An evaluation of the M4, however, cannot be considered without including the fact that it was produced in such large numbers that it invariably outnumbered its German opponents on the battlefield. This enabled small groups of M4s to go after individual heavier and slower German tanks and kill them. While the M4s soldiered on throughout the war, perhaps the best evaluation of the tank's design and performance is the one that comes from those American M4 tank crewmen who fought against superior German tanks. Known as the "Ronson" (after the famous cigarette lighter of the day—"lights on the first try every time") to its U.S. crews and as the "Tommy Cooker" to the Germans, the M4's tendency to burn after being hit by enemy fire made it unpopular with its crews. Perhaps Belton Cooper said it best when he described M4 Sherman tanks as "Death Traps" in his 1998 book of that title.

In 1945, the U.S. Army fielded the M26 Pershing heavy tank. For the first time the U.S. Army had a heavily armored tank that mounted a powerful main gun. Unfortunately, only a few M26s actually saw combat before the end of World War II. While the M26 was a very successful design, its impact was over-shadowed by a new Russian tank that was displayed for the first time during the military parade in Berlin on September 7, 1945. The parade included 52 new IS-3 heavy tanks, better known to most as the Stalin tank. The appearance of the advanced Stalin tank not only shocked Western observers, it also began what would be a long-standing pattern of American tank developments as mere responses to Russian/ Soviet tank designs.

While the arrival of the American M26 Pershing (now reclassified as a medium tank) and the new M46 Patton medium tank (an improved version of the M26 Pershing) during the Korean War success-fully dealt with the venerable North Korean T34/85 medium tanks and cured what was described as the "T34 disease," the Cold War was marked by United States and NATO forces reacting to superior Soviet tanks. There were a few attempts to develop new and advanced tank designs, such as the T95 tank project, the joint American/German MBT70 main battle tank (MBT) project, and the slightly more conventional American XM803 MBT project (an austere version of the MBT70), but these development efforts were doomed to unresolved political, economic, and technological challenges. In the end, the American tanks that would have fought the Soviets had the Cold War turned hot were very much like their predecessors. The American M60 MBT series, for example, consisted of capable tanks, but they were not as capable as the Soviet MBTs they faced across the former Inter-German Border (IGB). The Soviet T64A MBT would have been able to penetrate the M60A1's and M60A3's thickest frontal armor with its 125mm main gun, while being frontally immune to the M60's 105mm main gun. There is no doubt that had World War III erupted in Western Europe prior to 1981 or 1982, American tank crews would have been in the same situation that confronted M4 Sherman tank crews in World War II.

The decision to put the new, experimental XM1 MBT into full-scale production in 1981 as the M1 Abrams MBT simply changed everything. The impact of the M1 tank cannot be overstated; while applying lessons learned from mistakes of the past, this new tank defined tanks and armored warfare for the foreseeable future. It redefined how the U.S. Army thought, planned, trained, and fought. The M1 carried the army into an order-of-magnitude change that ran the gamut of ground warfare. The speed that the army moved across the battlefield was increased, the methods used to supply this faster-moving force were redefined and mastered, the methods used to provide supporting fire from artillery and close-air-support aircraft were redefined and mastered, and the decision-making process used by the leadership at virtually all levels was accelerated. For the first time in history, the U.S. Army had the best tank in the world. The M1 Abrams became the yardstick for foreign countries potential enemies, and friends alike, to measure the capabilities of their own tanks. While the M1 embodied what arguably may be the ultimate balance of the three classic tank design criteria—firepower, mobility, and protection—it also was a crewman's tank. It incorporated a unique fightability that empowered its crews to fight at their utmost, which gives American tank crews even more of an advantage. More than any other tank in the world, the M1 was designed to keep its crewmen alive. On battlefields ranging from the deserts of Kuwait and Iraq to Baghdad itself, it has done just that.

As the initial version of the M1 Abrams MBT evolved into the improved IPM1, M1A1, M1A1 Heavy, M1A2, and the latest version, the M1A2 SEP, America had maintained and further advanced its leadership in tank technology and capabilities. The M1's established leadership position is frequently challenged by observers and military analysts seeking to compare its capabilities with those of other modern tanks from around the world. While several other advanced and very capable tanks are used by other countries (for example the German Leopard 2A6, the Israeli Merkava Mk 4, the British Challenger 2, and the Russian T90M), none of them have the capabilities of the latest versions of the M1. As the U.S. Army looks to the future and embraces the advanced technology it offers, the history of American armor must not be forgotten. The leadership position of the M1 must not be compromised; allowing that to happen would position U.S. Army forces to take a step backward and repeat the mistakes of history.

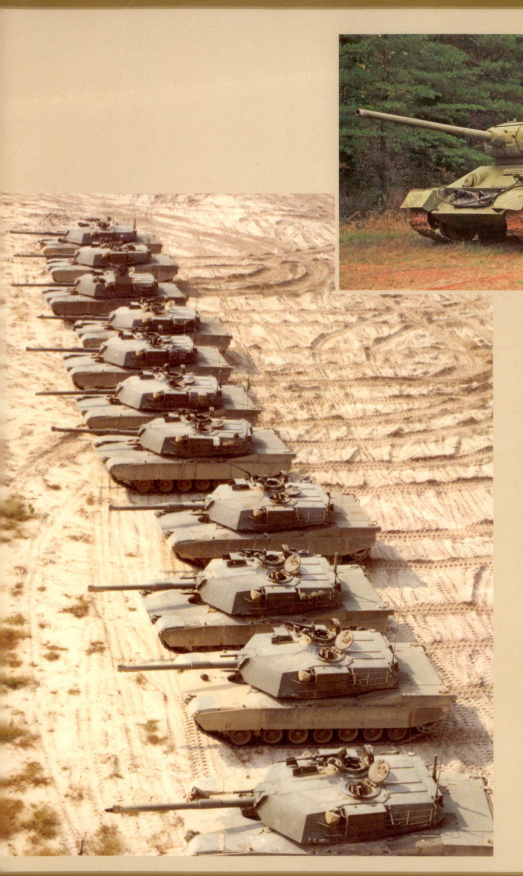

Forming part of the impressive collection of the Virginia Museum of Military Vehicles is the roughly 35-ton (32 metric tons) Russian-designed, diesel-powered T34/85 medium tank armed with an 85mm main gun. It first entered into Red Army service in 1944. Soviet production of the tank ended in the late 1940s. However, Polish and Czech factories continued production of the vehicle until the 1950s. *Michael Green*

Visible in this lineup of M1 tanks at a U.S. Army base are the tank's turret bustles, which contain most of their main gun rounds. On the top of the tank's turret bustles, one can see the three blow-off panels that will vent any explosion of the main gun rounds stored within upon detonation by an antitank weapon. *General Dynamics Land Systems*

CHAPTER ONE
BACKGROUND

TO REPLACE ITS LARGE INVENTORY of diesel-powered T34/85 medium tanks, first introduced into service late in World War II (1939–1945) and armed with an 85mm main gun, the Soviet army embarked upon the design of a new medium tank that would boast thicker armor and a more powerful main gun. As an interim measure, the Soviet army began series production of the diesel-powered T44 medium tank right after World War II. While it had a new, advanced, and more compact hull design, featuring a transverse engine layout, the turret remained very similar to that of the T34/85 and even worse, retained the same 85mm main gun.

To correct the firepower and armor protection shortcomings of the T44 medium tank turret, Russian tank designers came up with a new, larger, better armored turret capable of mounting a 100mm main gun. By installing this new turret on a T44 medium tank hull, which featured an improved diesel engine, Russian engineers came up with a new tank, designated the T54 Model 1946. As they worked the bugs out of the tank's design, progressively improved versions appeared, including the T54 Model 1949, the T54A Model 1951, and the T54A version in 1954.

To counter the threat posed by the new Russian medium tank in as short a time as possible, the U.S. Army had to come up with a stopgap vehicle that would be equal, if not superior, to the new Soviet medium tank. The army chose the roughly 50-ton (45.4 metric tons) gasoline-powered M48 Patton medium tank series, which first entered service in 1953, to be the interim vehicle to respond to the T54 threat. The Patton tank received its name from General George S. Patton, who led American tanks to victory in World War II as commander of the Third U.S. Army.

To defeat the 200mm (7.9 inches) thick frontal armor on the turret of the T54 series, the M48, originally armed with a 90mm main gun, would need a more powerful weapon. Fortunately for the U.S. Army, the British army had begun development of a new 105mm main gun for their medium tank, designated the L7. This newly designed weapon proved so superior to all other contenders that the United States produced a slightly modified version of the weapon designated the M68 105mm gun. Best of all, the new weapon could be incorporated into the M48 Patton medium tank turret.

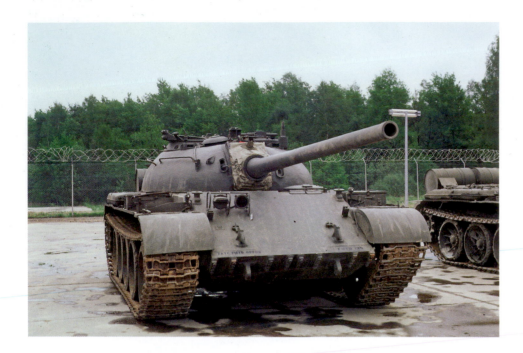

A Russian-designed, diesel-engine-powered T54-series medium tank armed with a 100mm main gun sits on display at a U.S. Army base in the mid-1980s. In addition to the main gun, the roughly 40-ton (36.3 metric tons) vehicle came equipped with up to three machine guns: one mounted on the front hull; another, known as a coaxial (or coax) machine gun, mounted alongside the main gun; and a third roof-mounted, but not seen fitted in this picture. *Michael Green*

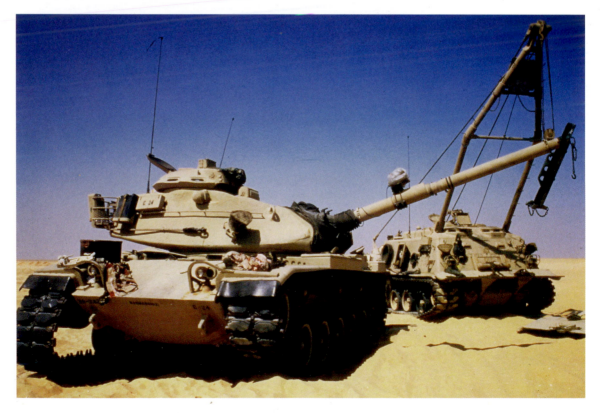

In a training exercise conducted in Egypt during the early 1970s, a U.S. Army diesel-powered, 57-ton (51.7 metric ton) M60A3 main battle tank has broken down and awaits repair. A diesel-powered, 55-ton (49.9 metric ton) M88A1 armored recovery vehicle stands by to fix any problems. A spotting feature of the M60A3 was the addition of a thermal sleeve around the gun tube, which thickens its profile when compared to the slimmer gun tube on the M60A1 tank, which lacks the thermal sleeve. *U.S. Army*

To reflect the up-gunning of the M48 Patton medium tank, along with a host of other major improvements, such as the fitting of a diesel engine into the chassis, the army designated what had become almost a brand-new tank by this time as the XM60. (Within the army, the letter *X* in front of a designation refers to experimental. When approved for series production, the *X* drops from the designation.)

Pleased with its testing of the XM60, the army accepted the vehicle into service in 1959 as the M60. Since the new tank mounted an M68 105mm main gun that was almost as potent as the much larger 120mm main gun on the M103 series heavy tank, the U.S. Army quickly ended production of the long-running M48 medium tank series and pawned off the troublesome M103 heavy tank series to the Marine Corps. Since medium tanks and heavy tanks would no longer form part of the army's frontline strength, the term *main battle tank* was applied to the M60. Unlike many other American-designed and -built tanks, the original 51-ton (46.3 metric tons) M60 never received an official army nickname, although it did form part of the Patton tank series.

This head-on picture shows the first pilot model of the diesel-powered MBT70, which weighed in at 57 tons (51.7 metric tons) combat loaded. Unlike most tanks, where the driver of the vehicle is located in the front of the vehicle's hull, the MBT70's driver sat in a counter-rotating sub-turret that allowed him to face forward no matter what direction the tank's turret was turning. The periscopes for the driver's counter-rotating capsule appear on the left side of the main gun in this picture. *U.S. Army*

THE GUN AND ARMOR RACE CONTINUES

Once the Soviet army became aware of the M60 and the threat it posed to its inventory of T54 medium tanks, it reacted by upgrading the T54's successor, the T55 medium tank. The Soviets then went on to lengthen the T55's chassis and installed a new turret armed with a high-velocity 115mm main gun superior to the 105mm main gun on the M60. The new vehicle received the designation T62 and first rolled off the production lines in July 1962. It served alongside the Soviet's inventory of heavy tanks.

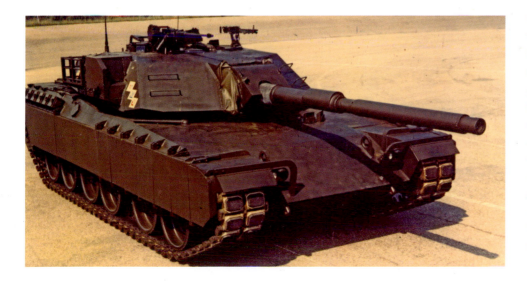

Visible on the left side of the turret of this General Motors' XM1 prototype is the gunner's side-mounted primary sight. The original General Motors prototype tank submitted to the U.S. Army, in competition with Chrysler, came with a Continental AVCR-1360 diesel engine, which drove the vehicle through a General Motors X-1100 transmission. *Patton Museum*

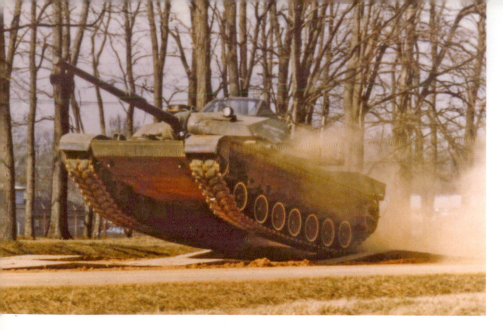

From the beginning, Chrysler decided that the gas turbine engine was the more logical choice for their version of the XM1 tank, because it was less complex than the diesel engine mounted in the General Motors prototype XM1 and had far fewer parts. This photograph shows the Chrysler automotive test rig taking air as it hurdles itself across a small bump on a test track. *Patton Museum*

That same year, a new version of the M60 tank appeared and was designated the M60A1. It featured an elongated turret, which moved the main gun trunnions farther forward. This came about for a couple of different reasons. First, the vehicle's loader now had more room between the breech and the turret ring for manhandling a new longer main gun round. Second, it allowed for the storage of additional main gun rounds in the enlarged turret bustle. The additional number of ready rounds offset the disadvantage of having main gun ammunition stowed above the tank's turret ring. American tank crews at the time reasoned that the Soviets' numerical superiority in tanks made the larger ammunition capacity a good tradeoff.

The thickness of the frontal hull armor on the 52.5-ton (47.6 metric tons) M60A1 also increased. The M60

At Fort Knox, Kentucky, the home of the U.S. Army Armor School, is a right-side view of an early production example of the roughly 60-ton (54 metric ton) gas-turbine-powered M1 tank belonging to the 2nd Battalion of the 6th Cavalry Regiment. The three-tone camouflage scheme on the vehicle was typical in the early 1980s. *Defense Visual Information Center*

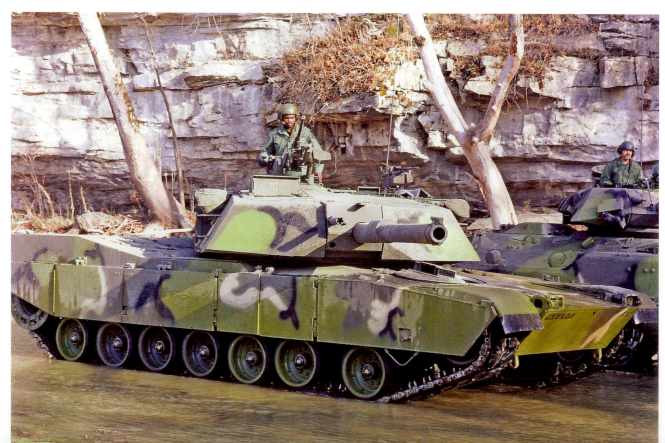

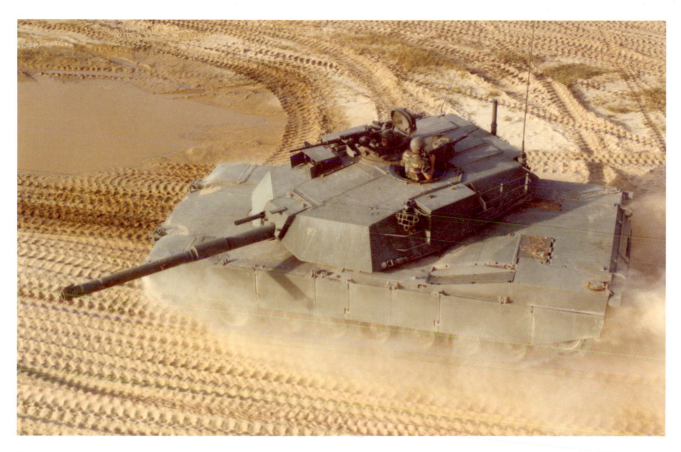

This overhead view of an M1 at running at high speed shows the tank commander's and loader's positions. On the very rear of the tank's turret is the slender two-foot, stalk-like wind sensor. It informs the vehicle's digital fire-control computer of any crosswinds that may influence the path of a projectile in flight. *General Dynamics Land Systems*

series would go on to serve for over two decades with the U.S. Army and even longer with the Marine Corps. The first tank in Soviet service considered an MBT (like the American M60) proved to the T64. It first entered into series production in the late 1960s. It featured an impressive 125mm high-velocity main gun and armor protection that was superior to its American counterpart. In response to the improvements in Soviet tank designs, the U.S. Army began upgrading its fleet of M60A1 tanks to the M60A3 standard beginning in 1979. While the roughly 57-ton (51.7 metric tons) M60A3 retained the improved M68A1 105mm main gun of the M60A1, it came with a more advanced fire-control system that incorporated a laser rangefinder and a thermal (heat-based) sighting device. The last of the army's M60A3 tanks were pulled from U.S. Army National Guard service in 1997. The Marine Corps did not replace its M60A1s until 1991, when it began receiving the M1A1 Abrams tank.

THE ORIGINAL REPLACEMENT FOR THE M60

Even as the U.S. Army began accepting the original version of the M60 tank into service, in the early 1960s it began looking for a new main battle tank. After testing a number of experimental concepts on its own, the army found itself pushed by Secretary of Defense Robert McNamara to join with the West German army in designing a new main battle tank that would be ready for service by 1970. The Americans would refer to the proposed vehicle as the main battle tank-1970 (MBT70) and, according to McNamara, it would cost less than the M60, operate at a higher speed, and be more maneuverable.

Trying to design a new state-of-the-art main battle tank on the cheap—for two very different types of armies with different organizations and ways of fighting—was not an easy task. An issue that cropped up between the Germans and the Americans was the selection of the new

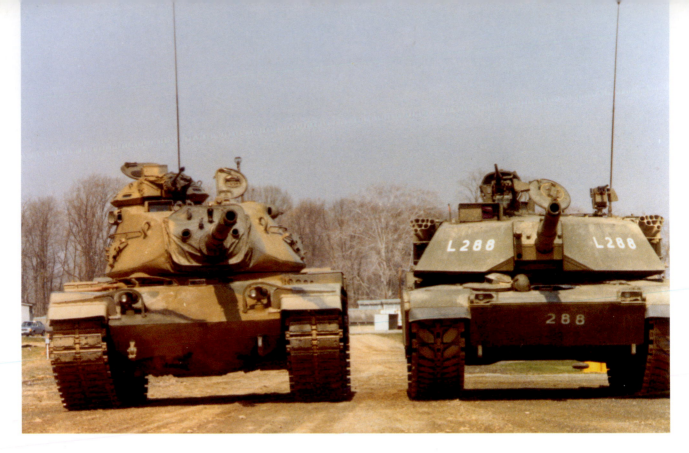

In this photograph is a side-by-side comparison of the M1 tank on the right and the M60A3 tank on the left. The reduction in height achieved by the Chrysler designers is evident. Including the tank commander's .50-caliber machine gun on the Abrams, the vehicle had a height of just over 9 feet (2.745 meters). The M60A3 topped out with a height of almost 11 feet (3.36 meters). *Patton Museum*

tank's main armament. After some debate with the West German army, which preferred a conventional high-velocity main gun for the 57-ton (51.7 metric tons) MBT70, a mutual decision was made to adopt a new 152mm main gun that could fire both a long-range anti-tank missile as well as conventional shorter-range non-missile rounds, including high-explosive, armor-piercing, antipersonnel, and white phosphorus.

By 1969, the spiraling cost of the MBT70 and continuing development problems began to attract congressional attention. Additionally, the Vietnam War was draining the army's coffers. These factors began to take a dramatic toll on the project. In September 1969, Deputy Secretary of Defense David Packard requested a review of the MBT70 project and cost estimates for production examples of the vehicle. The final report foretold that each series-production MBT70 would cost as much as $1.2 million to build. This figure sounded the death knell of the MBT70. In January 1970, the Department of Defense (DOD) officially ended the program.

In an effort to save some of the time, money, and effort that went into the MBT70 project, the army talked

Congress into letting it proceed with a simplified version of the tank. The army hoped that this new version would come in at a more reasonable price range. This simplified MBT70 concept originally bore the name Austere MBT70. That was later changed to the MBT70/XM803 and finally just to XM803. Unfortunately, this 57-ton (51.7 metric tons) vehicle remained rather pricey, and Congress quickly pulled the plug on it in December 1971.

A NEW START

While the MBT70 and the XM803 failed to meet the cost constraints imposed by Congress, the army still needed a replacement for the now nearly obsolete M60A1. Despite the belief by many inside and outside the army at the time the main battle tank was dead, Congress directed the army to renew its development of a suitable MBT to meet the threat of the 1980s and beyond, with a design-to-cost threshold. This became the XM1 tank program.

The idea that the tank had no future proved somewhat premature. The 1973 Yom Kippur War between Israel and

its various Arab opponents showed just the opposite: the tank still had a very significant role to play in modern combat. Many of the lessons learned from that conflict would go on to heavily influence specific design features on the future Abrams tanks, such as survivability and nuclear, biological, and chemical (NBC) protection.

Having learned some painful lessons from the demise of the MBT70 and the XM803, the army worked hard at getting it right on the third go-around. To keep costs down, the army dropped some of the design features that had driven up the cost and complexity of the MBT70 and the XM803. These included the combination main gun/missile launcher, the automatic loader, driver placement in the tank's turret, and the hydro-pneumatic suspension system.

Because of some controversy within the army regarding what form the new main battle tank was to take, the army established the Main Battle Tank Task Force (MBTTF) in early February 1972. Its job was to define the characteristics of the XM1 by preparing a series of concept studies that were to be completed between February 1972 and March 1973. On June 28, 1973, the army awarded contracts to the Detroit Diesel Allison Division of General Motors Corporation and the Defense Division of the Chrysler Corporation to conduct their own concept studies on the characteristics of a new main battle tank, to support the work of the MBTTF.

The most important characteristic of the American-designed XM1 was the level of armor protection required. The problem that has confronted all tank designers is the fact that thick armor makes a tank very heavy. What the army wanted was a new tank with a very high level of armor protection that weighed no more than 52 tons (47.2 metric tons), something that was impossible with existing technology. Many in the army's armor community were willing to sacrifice some level of armor protection for the many advantages of a lighter tank, including improved mobility over a wider variety of terrain and ease of transport. Others believed that the XM1 needed the highest level of armor protection available, despite the resulting weight penalty.

Eventually, the decision about tank weight fell to General Creighton W. Abrams, chief of staff of the army, in September 1972. In a 1988 interview with TACOM historian Lieutenant General Robert J. Baer (retired), program manager for the MBT70 and the Abrams tank (1972–1977), Baer responded to a question on how General Abrams decided on the 58-ton (52.6 metric tons) ceiling for the XM1. The interviewer asked whether it was a gut feeling on Abrams' part that the army would be better off with a heavier tank.

Well, no, it wasn't a "gut feeling." From the outset, General Abrams had pretty much agreed with the people at Knox [Fort Knox, Kentucky] that we should go to a lighter tank or we should drive the weight of the tank down What convinced General Abrams to go to the 58 tons was a briefing presented by [Lieutenant] General Bill DePuy [the army's assistant vice chief of staff] in

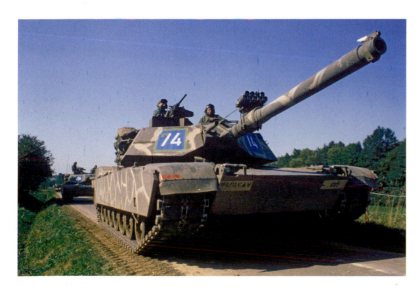

Waiting for the word to move out is an M1 tank parked on the side of a West German road, sometime in the early 1980s. The hull and turret of the M1 consist of sections of rolled homogeneous armor (RHA) plates welded together. An American version of the British-developed Chobham armor resides inside the RHA within certain areas, primarily the front hull and turret regions. *Defense Visual Information Center*

This picture shows the gunner's position on an M1 tank. In the bottom center of the picture is the gunner's primary sight (GPS). To the left of the GPS is the gunner's auxiliary sight, used when the GPS goes down. *General Dynamics Land Systems*

which he argued the case, that by going to 58 tons, we would substantially increase the survivability of the tank through the incorporation of some new technology which at the time was very hush-hush, but it, of course, was the Chobham armor. General Abrams was then convinced that, if we went to the 58 tons, we would capture the real benefits from the new armor, and that was the basis on which he made his decision.

Chobham armor was a British military invention, discovered by accident in the early 1960s. It consisted of layers of conventional steel armor and spaced ceramic armor tiles that could protect a tank from a much wider variety of battlefield weapons than just conventional steel armor alone could. The official British military code name for the product was "Burlington." The U.S. Army's Ballistic Research Laboratories later produced an American version of the Chobham armor for the XM1.

Since the adoption of an improved, American version of Chobham armor for the XM1, the army has referred to the combination of steel and non-steel armor found on the entire series of Abrams tanks with the generic term *special armor*. This may have had something to do with the fact that this type of armor protection remains in a special-access program and is classified due to the fact that releasing information about it would impact the survivability of the tank crews and comprise security.

TESTING OF THE XM1

When the various concept studies on the XM1 were completed in June 1973, the army awarded contracts to General Motors and Chrysler, calling for each company to provide a fully equipped prototype vehicle and a single automotive test rig. They were also required to supply an additional hull and turret for ballistic evaluation.

The testing of the prototype vehicles and components would show which of the contractors had best managed to incorporate the desired characteristics specified by the MBTTF into a working vehicle. Once that was determined, the winning firm would be awarded another contract to build pilot versions of the XM1, one stage away from building series-production vehicles.

In December 1974, the U.S. Army signed a memorandum of understanding with the West German government in which it promised to test a modified version of their army's new main battle tank, called the Leopard II, for possible consideration as America's new main battle tank. The stated goal of this agreement was to achieve maximum standardization between the West German army's tank fleet and the U.S. Army's fleet.

The prototypes and automotive test rigs from General Motors and Chrysler were tested at Aberdeen Proving Ground, Maryland, between January and May 1976. General Motors used a conventional diesel engine in their test vehicles. Chrysler powered their prototype vehicle and automotive test rig with gas turbine engines. Chrysler chose the gas turbine engine because it offered a number of advantages over existing diesel tank engines. Accord-

Based on the converted and upgraded hulls of surplus M1 tanks is the M104 Wolverine bridge-launching vehicle. It can carry, launch, and re-cover a 12-ton (10.9 metric ton) portable bridge that can cover a gap of almost 80 feet (24.4 meters) when fully extended. The portable bridge is able to support a 70-ton (63.5 metric ton) tracked vehicle. *General Dynamics Land Systems*

ing to Dr. Phillip W. Lett, Chrysler's point man for their version of the XM1, "The turbine's biggest advantage was its reliability, with some thirty percent fewer parts than the competitor's diesel engine." Other advantages pro-vided by fitting a gas turbine into the XM1 included lighter weight, smaller size, and the ability to use a wider range of fuels.

In July 1976, the U.S. government signed a letter of understanding with the British government affirming that the XM1 would mount the same British-designed 105mm main gun that armed the U.S. Army's and Marine Corps' inventory of M60 series main battle tanks. That letter also stated that an XM1 armed with a larger and more powerful 120mm main gun was a long-term goal of the army.

The army's original plans had called for the secretary of the army, Howard Callaway, to announce on July 20, 1976, the winner of this first phase of testing between Chrysler and General Motors. But on that day, Secre-tary of Defense Donald Rumsfeld, with the support of Secretary Callaway, postponed the event for at least one more day. Both men indicated to the army that they

Taken from the loader's seat inside an M1 tank is a view of both the tank com-mander's position in the foreground and the gun-ner's position in the back-ground. The upper sight is used by the tank com-mander when he wishes to aim and fire his .50-caliber machine gun. The white metal arm behind the breech of the 105mm main gun is the spent-case ejec-tion guard. *Michael Green*

wanted to see the new tank powered by a gas turbine engine and armed with a German-designed 120mm tank gun. The army protested, for fear that the Congress might become upset about any delays in the project and cancel the XM1 tank program. The secretaries of the army and defense prevailed, however, and the next day the army announced that both XM1 contractors would be going back to the drawing board to make needed changes to their vehicle designs. They would present new bids for the army's consideration by mid-November of that year.

Adding to the army's unhappiness with this unexpected turn of events, the secretary of the army insisted that, in the name of U.S. and German interoperability, they also test a modified version of the new West German army Leopard II tank for possible consideration as America's next main battle tank. Not everybody was happy with Rumsfeld's decision to include a German tank in the competition. The U.S. Congress Armed Services Committee stated in September 1976 that the "XM1 program must take precedence over standardization or interoperability of components."

The modified version of the Leopard II tank submitted to the army for testing came with the designation Leopard II Austere Version (AV). It mounted the same M68A1 105mm main gun as originally picked for the XM1 tank. In West German army service, the Leopard II tank mounted a 120mm main gun.

The Leopard II AV tank demonstrated that it met or surpassed most of the U.S. Army's requirements. However, despite its designation as the austere version of the Leopard II tank, the vehicle turned out to be heavier and more expensive than its American counterparts. In January 1977, the West German government withdrew the Leopard II AV tank from the competition to be America's next main battle tank. Instead, the U.S. Army agreed to use some of the Leopard II's major components in a future version of the XM1.

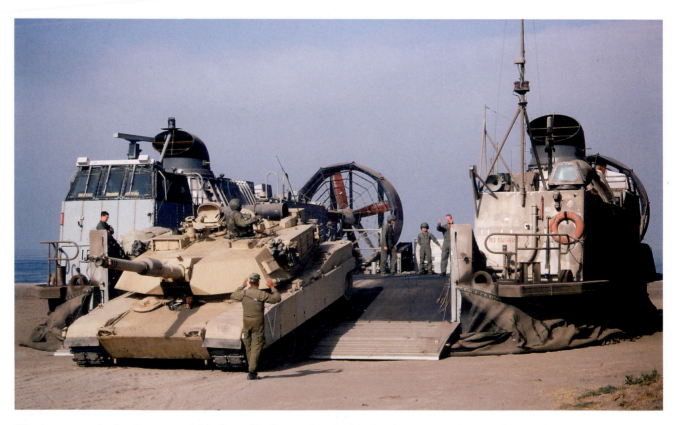

When a secure harbor is not available for unloading tanks, the Marine Corps depends on U.S. Navy landing craft, air-cushioned (LCAC) machines to get its M1A1 tanks from ship to shore and back again. The LCAC is a large hovercraft that rides across the sea and land on a cushion of air contained by a large rubber skirt. In this picture, a Marine Corps M1A1 moves slowly backward onto the deck of an LCAC. *Greg Stewart*

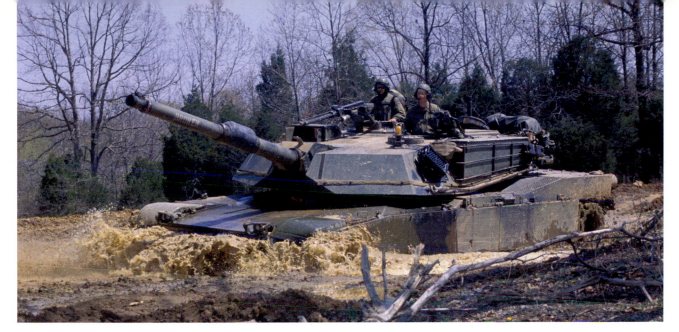

A U.S. Army M1A1 tank takes a mud bath during a training exercise at Fort Knox, Kentucky. Tank crews generally try to avoid operating in heavily wooded areas, because they become restricted to certain trails, roads, and cleared areas. Opponents can easily set up ambushes or set antitank mines in these areas. *Michael Green*

A CONTRACTOR IS CHOSEN

Both General Motors and Chrysler used the period between July 26, 1976, and mid-November 1976 to refine their prototype vehicles. The Chrysler team redesigned their vehicle's turret to both reduce production costs and to incorporate either a 105mm or a 120mm main gun, as demanded by the U.S. Army. Their efforts paid off. On November 12, 1976 the army announced at a press conference that Chrysler had come in with the winning bid and would supply the army with 11 pilot versions of the

XM1 that incorporated all the changes resulting from the original testing process. Evaluation of the pilots would help in determining the final design for a batch of low-rate initial production (LRIP) vehicles.

Chrysler delivered the first of the pilot versions of the XM1 to the army in February 1978 and the last in July 1978. Testing of these vehicles began as soon as the first example arrived. Of the many tests that the pilot models of the XM1 had to undergo to prove their capabilities—the ones that most impressed the U.S. Army—had to

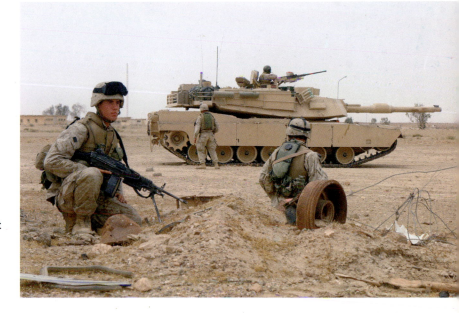

Marine infantry take part in a practice patrol with a Marine Corps M1A1 tank outside of Fallujah, Iraq, in May 2004. The tank commander pictured is in his full-open-hatch mode of surveillance, which provides him with the best viewing and greatest flexibility for seeing in all directions. The open hatch at his back provides small-arms protection to shoulder height. *Lance Corporal Kevin Quishuis Jr.*

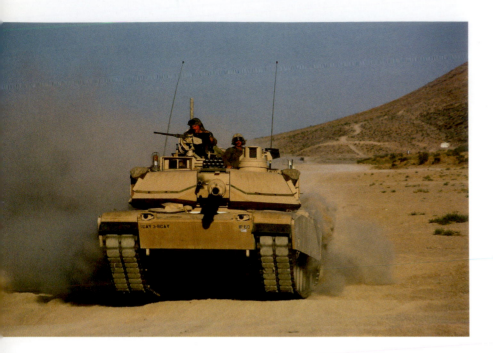

Racing across the U.S. Army's National Training Center is an M1A2 tank. Abrams tank drivers learn quickly that when they are moving forward, they must keep the front of the vehicle toward the main body of the enemy, since the thickest armor is on the front of the tank. *Greg Stewart*

do with their survivability. One of the pilot vehicles successfully withstood attack by 15 large-caliber rounds and one antitank mine, remaining operational after each attack.

On May 7, 1979, Secretary of Defense Harold Brown approved the building of 110 LRIP examples of the XM1 for additional testing. The decision by the army to go into low-rate initial production was not without dissent. The U.S. General Accounting Office (GAO) stated in an April 1979 document sent to Brown: "Recent operational and developmental testing disclosed that the XM1 tank at this point falls short of meeting some of its critical design requirements. The principal problems are in the tank's reliability and durability."

The GAO wanted the army to defer production of the XM1 until additional testing proved that the design changes and modifications proposed by the army to correct the problems identified by the initial testing phase worked. The GAO's reasoning appears in this statement: "Our view has been, and continues to be, that total costs are minimized and system performance maximized by a step-by-step approach that recognizes and attempts to resolve high risk technical problems before going into production."

The army decided that the need for the XM1 was so great that it would accept its current capability while embarking on an improvement program. The army was also en-

couraged in this decision by a blue-ribbon panel, drawn from industry and government, that looked over the XM1's powertrain problems and concluded that the powertrain would eventually not only meet, but even exceed by a considerable margin, the army's durability requirement for the vehicle.

The blue-ribbon panel's conclusions seem to have been borne out by the performance of the Abrams tank series during the first Gulf War in 1991, better known as Operation Desert Storm. A GAO report dated January 1992 and titled "Early Performance Assessment of Bradley and Abrams" read:

> *According to those we interviewed, the Abrams' reliability throughout the ground campaign was very good, provided the necessary spare and repair parts were available. Some crews reported that the Abrams tanks were the "best combat vehicles on the battlefield." Others stated that they traveled unprecedented distances with few reliability problems.*

INTO SERVICE

The official rollout ceremony for the first LRIP version of XM1 took place on February 28, 1980. Attending the ceremony were the wife and three sons of the late Gen-

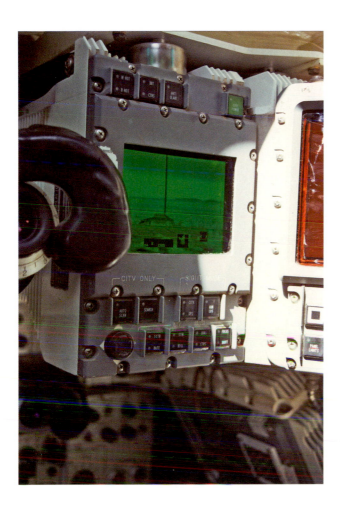

Pictured inside the turret of an M1A2 tank is a portion of the tank commander's integrated display (CID), known as the display and control panel, which consists of all the equipment required for operation and control of the vehicle commander's independent thermal viewer (CITV). Visible on the display monitor is an exterior thermal image of a car in the distance. *Greg Stewart*

eral Creighton W. Abrams. Unknown to them, the army had named the tank in honor of General Abrams. The army also had Chrysler paint the name *Thunderbolt* on the turret of the first production XM1 tank, the same name that Abrams had painted on the various M4 Sherman medium tanks he rode in while commanding the 37th Tank Battalion of the 4th Armored Division in World War II.

The LRIP tanks went straight from the Chrysler production line into testing at a number of military bases around the country between September 1980 and May 1981. With developmental testing still going on, the army ordered series production of the vehicle to begin in February 1981, at an initial rate of 30 vehicles per month. That same month, the army classified the vehicle as standard and dropped the letter *X*, for experimental, from its designation. Hence, the vehicle became simply the M1 Abrams tank. A full production rate of 60 tanks per month was authorized in November 1981.

Due to financial problems, Chrysler had to sell its military product division, Chrysler Defense Corporation, in 1982. The government quickly approved the sale to General Dynamics Corporation, which named its newest acquisition General Dynamics Land System (GDLS). At this time, General Dynamics was already building F-16 fighter planes for the U.S. Air Force and nuclear-powered submarines for the U.S. Navy

THE M1 ABRAMS

The production models of the basic M1 Abrams weighed in at about 61 tons (55.3 metric tons) combat loaded and began appearing in regular army service in 1981. The turret-mounted, stabilized 105mm main gun can easily engage and destroy enemy tanks at a range of more than a mile, day or night, while stationary or on the move. There is storage room in the M1 Abrams tanks for 55 main gun rounds, divided between the vehicle's turret and hull.

The electro-hydraulic-operated turret of the M1 Abrams tank can be rotated 360 degrees in just nine seconds. The Avco-Lycoming AGT-1500 gas turbine engine provides the vehicle a top speed on a level road of 45 miles per hour (72.4 kilometers per hour). The M1 Abrams tank can also climb a maximum grade of 60 percent, cross a 9-foot (2.75-meter) trench with ease, and climb a vertical wall 49 inches (1.25 meters) tall. Cruising range of the M1 Abrams tank on level paved roads at a steady speed tops out at roughly 275 miles (442.5 kilometers).

Chrysler and then GDLS built 2,374 examples of the basic M1 Abrams for the army between 1980 and January 1985. GDLS went on to build 894 upgraded M1 Abrams tanks, called the Improved Product M1 (IPM1),

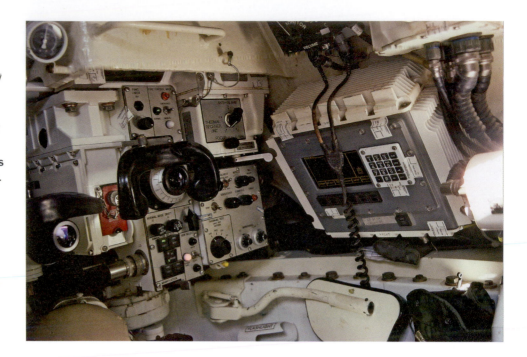

Located to the right of the gunner's position in this M1A2 Abrams tank is the gunner's control and display panel (GCDP). This is the primary soldier-machine interface between the gunner and the tank's fire-control electronic unit (FCEU). It has a flat monochromatic monitor and a keypad, which allows the gunner to enter data into the tank's digital fire control computer. *Greg Stewart*

between 1984 and 1986. Production of the IPM1 ran concurrently with the phase-out of M1 production and phase-in of the next version of the Abrams tank.

The IPM1 came with various improvements planned for incorporation into the next model of the Abrams series, including more armor at the front and a new stowage rack, referred to as a bustle rack, on the rear of the tank's turret. The bustle rack is where the tank's crew keeps most of their belongings, such as sleeping bags and extra uniforms.

The last basic M1 Abrams tank was retired from army service in September 1996. A few M1s and IPM1s remain in Army National Guard service. Those will all be retired by 2007, according to the latest army statements. The majority of basic M1s and IPM1s were placed into storage for possible rebuilding into newer versions of the Abrams series. Others were intended for conversion into bridge launchers, minefield-clearing vehicles, armored recovery vehicles, or armored engineer vehicles.

For a variety of reasons, mostly due to funding shortfalls, only 44 examples of the bridge-launcher version of the Abrams series, called the M104 Wolverine, have gone into service. The army had originally hoped to convert almost 800 early-model M1 tanks into Wolverines in order to replace its existing inventory of M60 series–based bridge launchers.

The only other Abrams-based variant currently in service with the army consists of six examples of the Panther II. It is a specially modified M1 tank stripped of its turret and installed with an Omnitech standardized tele-operation system and mine rollers, which allows it to clear minefields with either a human crew or by remote control. The Panther II is also equipped with a magnetic dog bone at the front of the tank, in between the mine rollers, which sets off both magnetic mines and tilt-rod mines before the vehicle can pass over them.

M1A1 ABRAMS

The M1A1 tank evolved from two separate efforts. The first was the integration of the German-designed 120mm main gun from the Leopard II tank into the Abrams tank. The second was a product improvement program (PIP) that included the following: improved armor; a hybrid nuclear, biological, chemical (NBC) protection system; an improved suspension system; and an upgraded transmission and final drives.

In September 1981, the vice chief of staff of the army approved both efforts and ordered that they be brought together in the next version of the Abrams tank, designated the M1E1. Due to the larger and heavier main gun and the extra armor, the newest model of the Abrams weighed

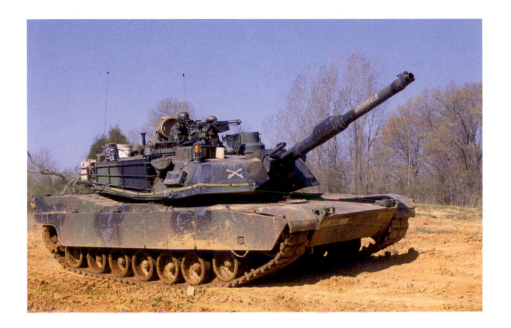

The crew of a U.S. Army M1A2 tank waits for a training exercise to begin. To ease the workload of the crew, the tank comes with a built-in test and diagnostics capability, which gives the crew not only the ability to determine and isolate faults with its software, but also to automatically reconfigure the hardware for the highest level of functionality possible in light of the fault condition. *Michael Green*

about 63 tons (57.1 metric tons) combat loaded. GDLS delivered the first prototypes to the U.S. Army in March 1981. The American version of the German weapon installed in the Abrams tank is designated the M256.

After extensive testing of the M1E1 prototypes at various military bases, the army standardized the vehicle as the M1A1 Abrams tank on August 24, 1984. The army also refers to the M1A1 as the third version of the Abrams, or an M1 with Block I product improvements. The first production example of the M1A1 Abrams tank rolled off the GDLS assembly lines in August 1985, with an additional 4,550 units completed by the time production in the United States ceased in April 1993.

Because of the much larger rounds fired from the 120mm main gun on the M1A1, the tank has room to store only 40 main gun rounds onboard. Thirty-four of these are stored in the rear of the tank's turret (the bustle) and six in the vehicle's hull.

The Egyptian government received permission from the U.S. government to manufacture a license-built copy of the GDLS M1A1 tank. They had over 700 units in service by 2005. More recently, the Australian government has contracted with GDLS, with permission from the U.S. government, to buy 59 M1A1 tanks for its army, with the first deliveries to begin in 2007.

In a 1989 interview conducted by the U.S. Army Center for Military History, Major General Robert J. Sunell (retired), onetime assistant program manager for the XM1, discussed the controversy around the selection of the German 120mm main gun for the Abrams:

We knew that to go to a 120mm would cost the program a billion dollars. It had cost us that. We didn't believe that we needed the 120mm as much then as we do now. There are still those that think that we could have put the same amount of money into improving the 105mm round. . . . Be that as it may, the 120mm was a gun that we needed [in order] to take on the Soviets, and we have that in production. It was the right decision at the time although it cost us quite a bit of money.

Beginning in May 1988, all M1A1 tanks coming off the factory floor had a layer of depleted uranium (DU) armor inserted into the two large compartments on the front of the vehicle's turret. The layer of DU armor did not replace the various types of ceramic armor already installed in the frontal armor array of the tank's turret. It merely supplemented them. Since DU armor is more than twice as dense as homogeneous steel armor, it provided the M1A1 tanks so equipped with an unparalleled degree of protection from armor-piercing (AP) kinetic-energy (KE) projectiles and not just shaped-charge warheads, called high-explosive antitank (HEAT).

The addition of the DU armor on the M1A1 Abrams raised the vehicle's weight by a ton. M1A1 tanks equipped

GENERAL CREIGHTON W. ABRAMS— THE SOLDIER'S SOLDIER

by Brian M. Sobel

The speed, power, mobility, and fire capability of the M1 Abrams tank is the very personification of the general whose name is indelibly associated with one of the world's most feared battlefield weapons. Named for Creighton W. Abrams, who rode the lead tank in numerous engagements during World War II, the M1 gives a commander a variety of options, something Abrams knew was vitally important in battle.

The story of Creighton Abrams and his advancement through the ranks of the United States Army, up to and including army chief of staff, is the material of legend, as were his exploits during three wars. In World War II, he achieved victory after victory against the Germans, including a heroic breakthrough to relieve Bastogne during the famed Battle of the Bulge. The general they called Abe was tough, demanding, gruff, and loved his soldiers. In turn, his soldiers loved him.

The fighting general was born in Springfield, Massachusetts, in 1914 to Creighton and Nellie Abrams. The oldest of three children, Abrams was a success early in life. As a senior in high school he was the captain of the 1931 Agawam High football team that went undefeated and unscored-upon. As important in his overall development, Abrams was also the class president, class orator, and editor of the school paper, and in a singular honor voted by his classmates as the boy most likely to succeed.

From the time he was a young man Abrams thought about an army career; his high school speeches often had a military theme. It was therefore fortune, or perhaps destiny, that found Abrams taking an exam to attend West Point.

In July 1932, Abrams entered the ranks of West Point as a plebe and in 1936 graduated and started his career as a second lieutenant in the 1st Cavalry Division. In August of 1936, Abrams married Julie Harvey. A 1936 graduate of Vassar College, she had met Abrams two years before at a West Point dance. From the first, Julie and Abe were a formidable and loving team. Creighton Abrams would go on to have a storied military career, and Julie, for her part, would contribute to the effort in many ways, including founding the Arlington Ladies, a group whose members attend each graveside service at the famed Arlington National Cemetery.

Abrams was promoted to first lieutenant in 1939, then to temporary captain in September 1940. In April 1941, he was part of the newly-activated 4th Armored Division, then at Pine Camp, New York, where he was made a regimental adjutant of what would quickly become the 37th Armored Regiment. Training was underway in earnest in preparation for battles to come. In July 1942, Abrams, still a captain, took command of the 3rd Battalion, 37th Armored Regiment. Within months, he would become a lieutenant colonel.

Training troops for the war then raging across the globe proceeded at breakneck speed. September 1942 found Abrams in Tennessee for armored maneuvers, followed by training at the California Desert Training Center. Soon thereafter, the division underwent an overhaul that resulted in the creation of the 37th Tank Battalion, with Abrams at the helm. It is

with this courageous group of fighters that he would draw the attention of friend and foe alike.

The 37th was a force to be reckoned with, listing some 70 tanks in its ranks, including 17 light and 53 medium tanks. Abrams took nothing for chance. He was a stickler for training and doing things right; he reasoned correctly that solid training would save lives later when the bullets started flying. After deploying to England for additional training, Abrams led his troops and equipment ashore at Utah Beach in France on July 11, 1944, 35 days after the D-day invasion.

In France, the 4th Armored Division was assigned to the First Army, however, when the Third Army under Lieutenant General George S. Patton Jr. became operational on August 1, 1944, the 4th was shifted to the Third Army. Soon Abrams and the whole of Patton's army began racing across France. Abrams was relentless and seemed to be everywhere at once. Commanding from a tank that the crew and Abrams nicknamed *Thunderbolt*, he went on a tear, with the main concerns of defeating the enemy and looking after the welfare of his men. Abrams was so intense as a commander that by the war's end he had chewed up and spit out seven command tanks, ending with *Thunderbolt VII*. Moreover, his reputation was growing by the day.

As Abrams and the 37th Tank Battalion continued to find success on the battlefield, he was watched with great admiration by commanders throughout Europe. After numerous successful encounters with the enemy, Patton, in a briefing to reporters, reportedly said of Abrams, "If you are going to write about him, you better do it right away. He's so good, he isn't going to live long."

Abrams and his battalion were the lead group in one battle after another. The famed tank battle of Arracourt in September 1944 is only one example of armored fighting in which Abrams excelled. Those who witnessed Abrams during this period well remember the fighting commander with a cigar punched in the side of his mouth, yelling encouragement to his men and leading by example.

Abrams was called upon time and again during the climactic days of World War II. The famous Battle of the Bulge was perhaps the pinnacle of his World War II battlefield experience. Abrams, then fighting in the Saar, led a relief force to the besieged village of Bastogne, arriving one day after Christmas 1944 to rescue the 101st Airborne Division and other members of American units. His star was rising, and the media of the time was informing the world, especially Americans back home, that Abrams was a name worth remembering. Patton would say of Abrams near the end of the war, "I'm supposed to be the best tank commander in the army but I have one peer, Abe Abrams. He's the world champion."

After World War II, Abrams served in numerous leadership positions and during the Korean War served as chief of staff of three successive corps, including the I, IX, and X Corps. After Korea, Abrams served as chief of staff of the Armor Center among other assignments, until he headed back to Europe in 1959 as a brigadier general and assistant division commander of the 3rd Armored Division, in Germany. Abrams was principally involved in the training at Grafenwohr, where tank maneuvers and gunnery activities were the order of the day. Soon, Abrams was named deputy chief of staff for military operations, United States Army, Europe. In 1960, he was promoted to major general and returned to the 3rd Armored Division as commanding general. In this assignment, Abrams again excelled, and officers

who served under him in that command were struck by his depth of knowledge and command presence in nearly every situation. The author's father, a battalion commander under Abrams in the 3rd Armored Division, found him to be demanding yet inspirational and, monst importantly, interested in both the small and large details. Abrams was also a larger-than-life figure when telling stories to or chatting with the sons and daughters of his subordinate commanders.

Abrams continued to receive a great deal of media attention, and it was while at the helm of the 3rd Armored Division that he appeared on the cover of *Time* magazine, highlighting an article about the army in Germany and around the world. The cover photo was vintage Abrams; he was pictured with a helmet on, standing in front of a battle tank, the main barrel looming menacingly near the hardened veteran of war. Intentionally or not, it was a clear message of strength to any potential adversary.

After commanding the 3rd Armored, Abrams returned for a tour of duty in Washington before heading back to Europe in 1963 as the commander of V Corps, with the rank of lieutenant general. Abrams took a special interest in the armored capabilities of his command; his passion for the tanker and tank warfare was felt throughout the command. He believed the mobility and firepower of the tank, especially the M60, was the greatest deterrent to Soviet aggression and therefore vital in the success of the United States during the Cold War.

In 1964, Abrams became the army's vice chief of staff. He was at the center of the storm in Washington, D.C. with even greater responsibilities, including assisting in the early ramp-up of forces for the Vietnam War.

Newly minted as a four star general in September 1964, Abrams set about the task of developing the forces needed to fight in Vietnam. In April 1967, Abrams learned he would soon head to Vietnam to become the deputy commander of the United States Military Assistance Command. As a soldier who had seen plenty of war, 53-year-old Abrams was experienced and left Washington knowing he could make a difference in Vietnam. Others in both military and political circles knew it was only a matter of time before he would take the top job in Vietnam, replacing General William C. Westmoreland.

When Westmoreland returned to the United States in the summer of 1968 to become chief of staff of the U.S. Army, Abrams took over as the commander in Vietnam. He per-

with the DU armor have the designation M1A1 heavy armor (HA) tank. There are no outwardly visible differences between a non-DU-equipped M1A1 tank and the version equipped with the DU armor.

The last model of the M1A1 tank produced by GDLS featured an even higher level of armor protection than the M1A1 HA. Hence, the vehicle received the designation M1A1 heavy armor plus (HA+). The first of the M1A1 HA+ tanks were fielded with the U.S. Army in July 1991 and the last in May 1994.

Of the 4,550 M1A1 tanks built by GDLS for the army between 1985 and 1993, 2,388 of them were the initial model without DU armor fitted in the front of the tank's turret. There were 1,328 examples of the M1A1 HA model built, featuring the original configuration of DU armor in the vehicle's front turret armor, and 834 examples of the M1A1 HA+ tank built with additional armor protection surpassing that found on the M1A1 HA.

Because of hard use in combat and training, the army's fleet of M1A1 tanks continues to wear out like any other military equipment. Instead of building new tanks, the army decided in 1994 to rebuild a portion of its M1A1 tank fleet from the ground up. This rebuild project received the name Abrams Integrated Management for the

formed superbly even though the limitations of the conflict were a heavy cross to bear. In one of the most telling comments of the war, a Sunday *New York Times* magazine article quoted a high-ranking public official as saying, "Abrams is one of the most impressive men I've ever met. You know, it's too bad. Abrams is very good. He deserves a better war."

Nonetheless, Abrams soldiered on, along with the nation and the rest of her soldiers. By June 1972, Abrams was set to return to the United States after more than five years of service in Vietnam; he had served his nation well. While South Vietnam eventually fell to the North Vietnamese, the army and the world remembered Abrams and his tenure in Vietnam in very good light. He had performed brilliantly under the most trying of circumstances.

In June 1972, it was announced that Abrams would be named chief of staff of the United States Army. In that capacity, Abrams oversaw the army in the final stages of the war, including the phased withdrawal of American troops from Vietnam, the transition of the army to a volunteer force, and a host of changes in the army organizational structure.

By 1974, Abrams had made his mark as chief of staff, but fell ill to cancer and died in September of that year. The army had lost its brightest star, and accolades and tributes flowed in from every direction. A combat veteran of three wars and an unparalleled leader of men in battle, Abrams left a large hole in the fabric of the United States Army. He was buried at Arlington National Cemetery, next to the army's first chief of staff, Major General Leonard Wood.

Perhaps one of the highest compliments accorded Abrams after he passed away came from a general who served under him on numerous occasions. The late Major General George S. Patton, whose father commanded Abrams during World War II, said of him, "If Abrams gave me a mission with the chance of staying alive at 1 in 10, I'd ask, when are we moving out? I never felt that way about an officer before or since, and I worked for some good ones. No officer I ever met, either above me or below me in rank, could touch General Creighton W. Abrams. He was the best soldier I have ever known, including all the members of my family."

Abrams served in uniform, including his years at West Point, for 42 of his 59 years. The Abrams tank is a fitting tribute to the army's man of tempered steel.

21st Century (AIM XXI). Its goal was to combine the best of both public and private capabilities and harness them to significantly improve the longevity and capability of the tank. The first 17 rebuilt examples from this new program were sent to the army's National Training Center (NTC) in 1997 for testing. Positive results from this test phase led to the army approving the program in June 1998. If current plans continue, the army hopes to run a portion of its M1A1 tank fleet through the program by 2008. By 2007, the only M1A1s remaining in the army's inventory will be those that went through the AIM XXI program.

The army's current intent is to allocate within its upcoming budget plans enough funding to continue the AIM program throughout the remaining service life of the tank. As they wear out from hard use they can then be recycled through the AIM program again.

MARINE CORPS M1A1 ABRAMS TANKS

In November 1990, 80 engineering changes were introduced into the M1A1 production line. Three of the major items in this upgrade were Marine Corps

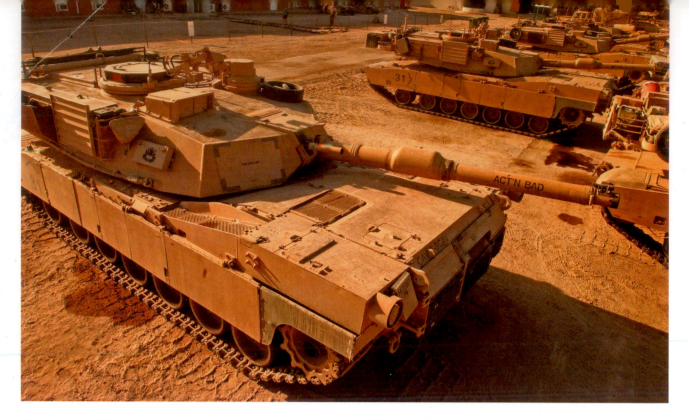

Pictured on a U.S. Army base in Iraq is a group of parked M1A2 SEP tanks. The acronym SEP stands for system enhancement package. The SEP improvements to the M1A2 included modifications to the vehicle's computer. This new system is able to accept the latest U.S. Army command and control. *Department of Defense*

requirements. These included more tie-down points, provisions for a deep-water fording kit (DWFK), and mounting provisions for a position locating reference system. Because these Marine Corps requirements were applied to all tanks, this change is often referred to as the Common tank change. The Marine Corps acquired 269 examples of the new M1A1 Common tanks from 1990 to 1991.

Congress provided funding in 1994 and 1995 to transfer 134 M1A1 tanks from the army's inventory to the Marine Corps. Since 84 of the 134 M1A1 Abrams tanks going to the marines were built prior to 1991, they did not have the extra features that marked them as M1A1 Common tanks. The remaining 48 M1A1 Abrams tanks provided to the Corps were built after 1991 and therefore had all the features that met the Corps' criteria for the Common tank variant. In early 2003, the army transferred an additional 12 post-built 1991 M1A1 Abrams tanks to the Marine Corps.

An important improvement to the Marine Corps' inventory of M1A1 tanks, not yet seen on the army's M1A1 fleet, is the replacement of the driver's existing AN/VVS-2 passive night sight with a new thermal-imaging sight called the driver's vision enhancement (DVE). This thermal sighting system provides the drivers on Marine Corps M1A1 tanks with the same observation range as the vehicle's gunner. The DVE is currently in service on Humvees, some larger trucks, and the wheeled Stryker family of armored vehicles.

To keep pace with the increasing number of precision-guided antitank weapons, the Marine Corps has embarked on a program to enhance the battlefield survivability of its inventory of M1A1 tanks. The program will run through 2012 and aims at keeping the vehicle a viable battlefield asset through 2020. Besides upgrading the armor on all its M1A1 Common tanks, other survivability improvements will include detection avoidance devices aimed at making the tank harder to see on the battlefield by enemy radar or thermal imaging devices.

Another key improvement to the Marine Corps' M1A1 tank fleet is the firepower enhancement program. It includes a second-generation thermal imaging sight and north-finding/far-target-location capability. An eye-safe laser rangefinder is also part of the improvement package. Work on the program started in 1999 and will see completion by 2008, if funding continues.

DIGITAL IMPROVEMENTS TO THE M1A1 ABRAMS

Despite the end of M1A1 tank production in 1993, the army continued to improve the vehicle's combat effectiveness. A major upgrade was the incorporation of information-age technology into the vehicle's design. The result was the deployment in 2000 of the first two battalions (95 tanks each) of an improved type of M1A1 tank, unofficially designated the M1A1 Digitized (D). Due to funding constraints, the army was only able to afford a few hundred examples of the M1A1 (D) before the upgrade program ended in 2003. In 2004, the army pulled all its M1A1 (D) tanks from service and replaced them with an improved version of the vehicle.

The M1A1 (D) was equipped with an add-on computer with a keyboard and monitor installed at the tank commander's position. The computer's software consists of a digitized command-and-control system, which sends and receives automatic position location reports from its interface with the global positioning system (GPS). It also sends and receives text messages and map overlays by way of a wireless tactical internet routed through digital radio transmissions. There were no major external differences between the M1A1 (D) and other versions of the M1A1 tank.

M1A2 ABRAMS

The fourth version of the Abrams is the M1A2, or M1 with Block II product improvements. (The army did not recognize the M1A1 (D) as a separate version of the Abrams series.) Survivability is one of the key goals of the M1A2, mandating a level of armor protection superior to that found on the M1A1 HA and M1A1 HA+. Unfortunately, this goal came at a cost in weight, which pushed the M1A2 tank to more than 68 tons (61.7 metric tons) combat loaded. Due to the problems with weight, the army could not add all the desired extra armor to the M1A2 tank because it would have pushed the vehicle's weight to more than 72 tons (65.3 metric tons).

The M1A2 tank features the same M256 120mm main gun that was mounted on the various versions of the M1A1 tank. A redesign of the ammunition racks in the M1A2 tank turret bustle allows for the storage of two additional main gun rounds within it. This gives the M1A2 tank a main gun ammunition load of 42 rounds compared to the 40 found on the M1A1 tank.

The one feature that visibly distinguishes an M1A2 tank from an M1A2 SEP tank is the external auxiliary power unit (APU) located in the rear turret bustle of the M1A2. The M1A2 SEP did away with the APU and has an air-conditioning unit located in roughly the same location as the APU of the M1A2. *Michael Green*

A key internal difference between the M1A2 tank and its predecessors is the incorporation of digital electronics and microprocessor controls into the vehicle. A description of what the M1A2 tank brought to the U.S. Army comes from Colonel Chris Cardine (retired), who served as the Abrams program manager for the army from 1994 to 1998:

> The installation of a microprocessor, data bus, monochromatic flat-panel display, and modem in the M1A2 tank opened the floodgates of the information revolution in the army. The tank turned out to be a computer that not only controlled its internal operating functions, but it also networked. The vehicle could talk digitally to other tanks and computers through its digital radio in a local area network. Along with providing protection, mobility, and lethal weapons for the crew, it became in effect their personal digital assistant.

GDLS received the contract for full-scale development of the M1A2 model in December 1988 and delivered the first five prototypes to the army in March 1992. Impressed

INFLUENCES ON AMERICAN TANK MAIN-GUN SELECTION

by James L. Warford

The 1973 Arab-Israeli War (better known as the Yom Kippur War) was a key event in the development of American tanks. Many of the tanks used by the Israeli army during that conflict were American-built, including the M48 Patton medium tank and the M60A1 main battle tank. While the M60A1 already featured a M68A1 105mm main gun, the Israeli army had taken the time to up-arm their M48 Patton medium tanks with the same weapon. The U.S. Army would later do the same to its inventory of Patton medium tanks in the mid-1970s.

Prior to the Yom Kippur War, the American and Israeli armies believed that the M68A1 105mm main gun had the needed punch to defeat the latest Soviet main battle tanks, whether deployed by Soviet and Warsaw Pact forces facing NATO in Western Europe, or Arab forces opposing Israel. However, at the start of the war, the Israelis quickly learned that the ammunition fired from the M68A1 105mm main gun was not always capable of defeating the armor on Egyptian and Syrian T54/55 medium tanks and the T62 main battle tank.

The primary 105mm armor piercing discarding sabot (APDS) round used at the time was the American-designed and -built M392. The problem with this round, learned on the battlefields of the Yom Kippur War, was that the very angled and rounded shape of the turrets of the T54/55 and T62 tanks frequently caused the M392 projectiles to glance off the armor without penetrating. While not a problem in every engagement, this was problem enough for American designers to quickly develop a modified version of the round known as the M392A2. This improved version included the addition of a tilt-cone attached to the tip of the perpetrator that would tilt or pivot when initially striking a target. In effect, the tilting action sent the round down and into the target, penetrating the armor, as opposed

with the vehicle's test results, the army quickly approved low-rate production of 62 brand-new M1A2 Abrams tanks. The first of these vehicles was delivered in November 1992, with the last example arriving in April 1993. By this time, the cost of a single new M1A2 Abrams tank had risen to roughly $3 million.

Instead of buying more brand-new M1A2 tanks, nicknamed the "A Deuce" by tankers, the army decided to have GDLS upgrade early-model M1 tanks to the M1A2 standard. In September 1994, the army signed a contract with GDLS to convert 206 M1 tanks into M1A2 tanks.

These vehicles were delivered between October 1994 and September 1996.

A follow-on contract awarded to GDLS in 1996 called for the conversion of 580 additional M1 tanks to the M1A2 standard. The contract also included an option for another 20 M1s upgraded to the M1A2 standard. The army picked up this option also. In total, GDLS was committed to delivering to the U.S. Army 600 M1 tanks upgraded to the M1A2 standard by July 2001. However, in February 1999, the army revised its contract with GDLS, so the last 240 M1 tanks upgraded to the M1A2

to glancing off the enemy tank's armor. This simple solution proved to be a key development for the Israeli tank crews who were fighting for Israel's survival, as well as for those U.S. Army tank crews deployed along the inter-German border facing the Warsaw Pact's armored forces.

Though the ammunition solution successfully dealt with the armor of the well-known Soviet tanks of the time, less than three years after the start of the war, the Soviets deployed a new tank to its forces in the Group of Soviet Forces–Germany (GSFG), located in East Germany. This sent American and NATO ammunition designers back to their drawing boards. The forward deployment of the revolutionary new T64A main battle tank in September 1976 caused a huge reaction in the West. The Soviets had designed and fielded a very modern tank that combined the powerful new 125mm main gun, the increased mobility to drive any planned armored thrusts deep into the heart of Western Europe, and, perhaps most significantly, a new level of armor protection that was beyond the capabilities of the M68A1 105mm main gun and its then-current ammunition.

While the T64A was certainly not a super tank, it still provided the Soviets with a tank beyond the capabilities of contemporary American tanks that had been so successful just a few years earlier against the Arabs. The truly innovative T64A was fitted with a new type of three-layer composite turret armor called Combination K. It consisted of an inner and outer layer of steel with a center layer of a ceramic material called corundum. The three-layer hull front or glacis armor was also innovative, consisting of an inner and outer layer of steel with a center layer of a glass-fiber material that the Soviets called *steklotekstolit*. The T64A, along with other modern and better-protected Soviet tanks, forced NATO forces into a crash development program to develop new ammunition for the M68A1 105mm main gun, and to make a design change to a new American tank design that was yet to come off the drawing board. The new XM1 main battle tank was intended to replace the aging M60 series tanks.

With the XM1 came the controversial decision in 1976 to change the turret designs of the two competing prototypes to allow for the use of either the 105mm or new German 120mm main guns. The rest is history.

standard would be upgraded to an even more advanced configuration.

Due to the revised contract, only 360 M1 tanks were upgraded to the M1A2 standard by GDLS in its second contract with the army. The total number of M1A2 tanks built by GDLS stands at 628 vehicles, not counting the five prototype tanks. Currently, 247 M1A2s are in storage with no plans to reissue them to any units. Additional M1A2s will go into storage when the army units still equipped with the vehicle receive an updated version of the Abrams. The army plans to pull the last of its M1A2s out of service by 2007.

There are two major external differences between the various versions of the M1A1 and M1A2 tanks. The first is the addition of the large periscope-like head of the commander's independent thermal viewer (CITV). It is located on the top of the vehicle's turret in front of the loader's hatch. The addition of the CITV on the M1A2 Abrams tank provides the vehicle's commander access to a second thermal sight, in contrast to the single gunner's thermal imaging sight (TIS) as found on all the earlier versions of the Abrams series. Army tests showed that the addition of the CITV on the M1A2 allowed for 45 per-

cent faster target acquisition by the crew than was possible on the M1A1 Abrams tank.

The second change, which is more subtle and normally requires a close up inspection of the M1A2 Abrams tank, is the commander's station on the roof of the turret. It differs from the commander's weapon station (CWS) found on the M1, IPM1, and variants of the M1A1 tank, in such details as the mounting of the .50-caliber machine gun and a different type of periscope that features a wider field of view than that found on the CWS. The periscopes on the M1A2 vehicle commander's station are also laser-hardened, meaning that they are designed to stop various types of laser light from blinding the tank commander (TC), a feature not found on the CWS on earlier versions of the Abrams tank. The TC's station seen on the M1A2 also appears on an improved version of the tank, the M1A2 SEP.

Besides the U.S. Army, the only other armies to employ the M1A2 tank are the armies of Saudi Arabia and Kuwait. The Saudis bought 315 brand-new M1A2 tanks from GDLS for its army. They were delivered between 1993 and 1996. The army of Kuwait took 218 brand-new M1A2 tanks into service between 1994 and 1997.

M1A2 SEP

To improve upon the information revolution sparked by the fielding of the M1A2, the army went a step farther with the vehicle's electronic capabilities. This decision resulted in the creation of the M1A2 SEP. The letters SEP stand for system enhancement package. It is also the army tanker's nickname for the vehicle. The first SEP tanks began appearing in army field units in 2001. It is the fifth version of the Abrams.

While still armed with the same 120mm main gun mounted on the M1A2 Abrams tanks, the SEP features improved microprocessors and additional memory, including a mass-memory unit that houses the tank's command-and-control system, the same that was used on the M1A1 (D). Survivability enhancements were also an important part of the SEP from the beginning. Not only did the army increase the frontal armor array on the vehicle, but it also beefed up the side armor of the vehicle's hull and turret.

The SEP features a much more powerful thermal viewer at the TC's position than is fitted to the M1A2 Abrams tank. This allows the SEP vehicle commander to search for targets at extended ranges never before thought

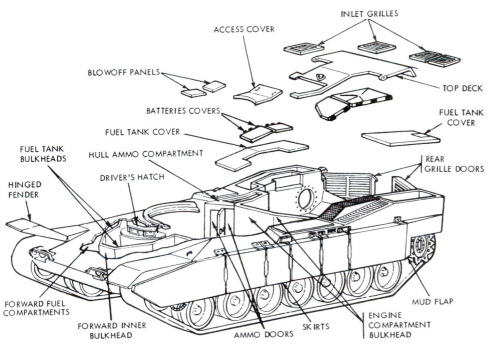

Hull Structural Features

This line drawing from an operator's manual shows the various hull structural components of the M1 through M1A2 Abrams tank series. The only major difference between the hull structural components of the M1A2 SEP and the other tanks in the Abrams series is the fact that it has only three fuel tanks, rather than the four found on earlier versions of the vehicle.

"The First Information Age System"
M1A2

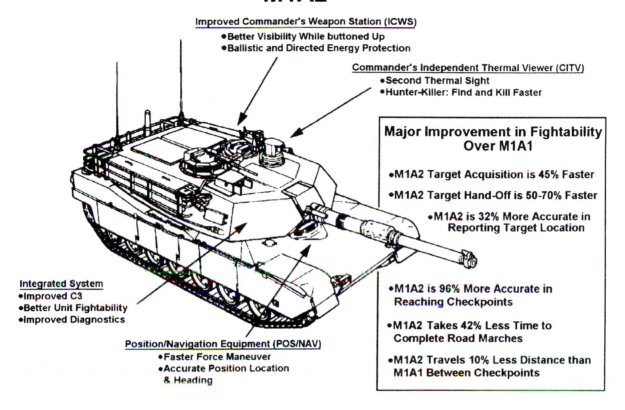

Improved Commander's Weapon Station (ICWS)
- Better Visibility While buttoned Up
- Ballistic and Directed Energy Protection

Commander's Independent Thermal Viewer (CITV)
- Second Thermal Sight
- Hunter-Killer: Find and Kill Faster

Integrated System
- Improved C3
- Better Unit Fightability
- Improved Diagnostics

Position/Navigation Equipment (POS/NAV)
- Faster Force Maneuver
- Accurate Position Location & Heading

Major Improvement in Fightability Over M1A1

- M1A2 Target Acquisition is 45% Faster
- M1A2 Target Hand-Off is 50-70% Faster
- M1A2 is 32% More Accurate in Reporting Target Location
- M1A2 is 96% More Accurate in Reaching Checkpoints
- M1A2 Takes 42% Less Time to Complete Road Marches
- M1A2 Travels 10% Less Distance than M1A1 Between Checkpoints

M1A2 tank improvements are illustrated in this line drawing.

possible. According to GDLS employee Jerry A. Smith, SEP tanks "fire a whole lot faster, easier, and more accurately" than older versions of the Abrams tank. He also stated, "Well-trained crews can hit targets at 4,000 meters [2.49 miles] with the first round."

The developmental history of the SEP dates back to early 1994, when the army identified several important upgrades it wanted to add to the basic M1A2 tank. Rather than wait for GDLS to finish converting 600 M1 tanks to the basic M1A2 configuration, by 2001 the army revised that contract to have the last 240 M1 tanks upgraded to the SEP standard.

A second army contract awarded to GDLS in April 2001 called for upgrading 307 more M1 tanks to the SEP standard. This process began in August 2001 and finished in July 2004. In addition, the army awarded GDLS another smaller contract to upgrade 41 basic M1A2

tanks to the SEP standard by 2004. When all the contracts were completed by GDLS in December of 2004, the army had 588 SEP tanks in service. In 2005, the army received funding and contracted for an additional 129 SEP tanks.

The one major external difference between the M1A2 Abrams tank and the SEP is visible in their respective turret bustles. The M1A2 Abrams has a bulky diesel-powered generator, referred to as the auxiliary power unit (APU), that resides in its turret bustle. On the SEP tank, the APU disappeared. In its place appeared a much smaller air conditioning unit called the thermal management system (TMS).

The SEP does not currently have an APU fitted, although there is room for one within the vehicle's upper rear hull area. The army had experimentally installed a brand-new APU unit in a handful of its SEP tanks, called

the under-armor auxiliary power unit (UAAPU). It consisted of a small 560-pound (254 kilogram) gas turbine engine and generator that provided electrical power to charge the tank's main batteries. Funding shortfalls in the army's budget ended the UAAPU program. The army is now installing advanced batteries in the space within the SEP hull originally intended for the defunct UAAPU. This additional silent watch capacity, provided by the new batteries, could save more than 159 gallons of fuel (602 liters) per day if used properly with the SEP.

Along with the additional batteries for the SEP tank, these tanks will also come with a battery monitoring system, or regulator. The regulator will charge the vehicle's batteries only when needed so they won't be overcharged, which can happen with the current regulator installed on the SEP.

ABRAMS' REPLACEMENT

Based on the army's current budget, the cutting edge of the army's frontline ground power for the near future should consist of about 1,000 SEP tanks and roughly 1,080 M1A1 AIM tanks, with the balance of those being the M1A1 HA+ version. The army currently envisions the Abrams tank remaining in service until at least 2040.

The SEP tanks are currently concentrated in the 4th Infantry Division (formerly the 2nd Armored Division, which was reflagged as the 4th Infantry Division in December 1995) and the First Cavalry Division. Both divisions are based at Fort Hood, Texas, and form part of the army's III Corps. The 3rd Armored Cavalry Regiment, which also forms part of the army's III Corps, has also been issued the SEP.

The eventual replacement for the SEP is something referred to as the future combat systems (FCS), which the army calls the "greatest technology and integration challenge ever undertaken." It will consist of a new generation of 17 manned and unmanned ground vehicles, each of which will tap into a secure wireless network of combat information. These ground vehicles will operate in conjunction with various types of unmanned aerial platforms and fire a new generation of smart ammunition in many cases.

M1A2 SYSTEM ENHANCEMENT PACKAGE

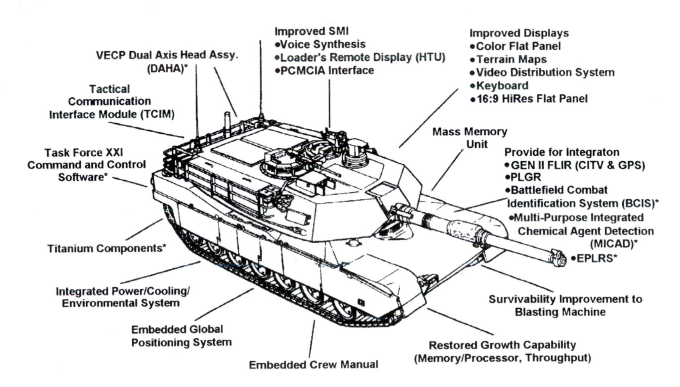

M1A2 SEP tank improvements are illustrated in this line drawing.

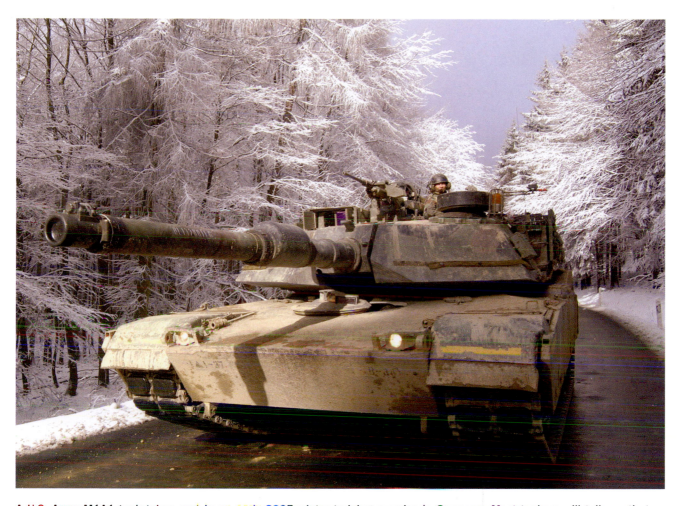

A U.S. Army M1A1 tank takes part in an early 2005 winter training exercise in Germany. Most tankers will tell you that no matter how cold it is outside, it always seems to be colder inside the tanks. *U.S. Army*

Current plans call for the various ground systems that will make up the FCS to be a fraction of the weight of current vehicles, yet remain as lethal and survivable. Rather than rely on heavy armor to withstand an enemy's attack, FCS ground vehicles will depend on superior communications to destroy the enemy before the enemy detects them. The vehicles will also have active armor, which will disable or destroy enemy antitank weapons before they actually strike the vehicle at which they were aimed.

Despite the advanced capabilities that the FCS seems to offer, the army is not taking any chances that this new and evolving technology won't pan out. In late 2004,

Army Chief of Staff General Peter J. Schoomaker released a statement saying that the M1 will stay in the army "until we are convinced that the future combat system is going to give us better lethality."

In late 2004, the army announced that certain technologies from the FCS would be identified as spiral technologies, and these would be integrated first into the current force. This was in recognition that the current force desperately needs some of these technologies today rather than waiting for the fielding of the FCS. These technologies include sensors, unmanned systems, command-and-control technology, and active-protection systems.

In the collection of the Military Vehicle Technology Foundation (MVTF) is this example of an American-built M1917 tank. It was a slightly modified American-built version of the FT17, a light tank originally designed and built by the French during World War I. The long gun tube projecting from the vehicle's turret is nothing more than a piece of steel pipe, with which the foundation staff later replaced the original main armament. *Michael Green*

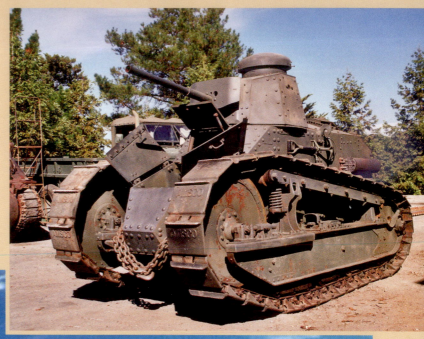

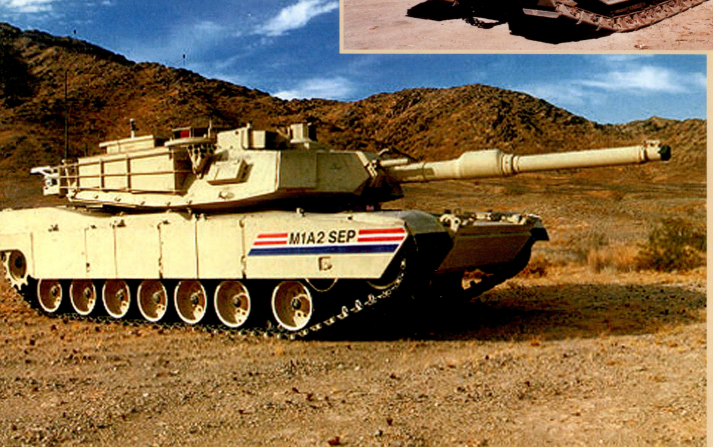

The most important characteristic of the U.S. Army's M1A2 SEP tank that distinguishes it from its predecessor, the M1A2, is an embedded battle command system, allowing its crew to have instant access to the latest information on battlefield conditions from a variety of sources, ranging from ground to aerial platforms. The small piece of metal attached to the front of the tank's turret merely simulates the weight of items not yet fitted to this pre-production version of the M1A2 SEP. *General Dynamics Land Systems*

The M1A2 SEP has a hydraulically-powered gun and turret drive, with the elevation and depression of the main gun depending on a hydraulic cylinder. Turret rotation is actuated by an electronically-controlled hydraulic motor and gearbox combination. A 1-horsepower electric auxiliary pump provides hydraulic power redundancy for the gun/turret drive when the engine is off or in emergency operation mode. *General Dynamics Land Systems*

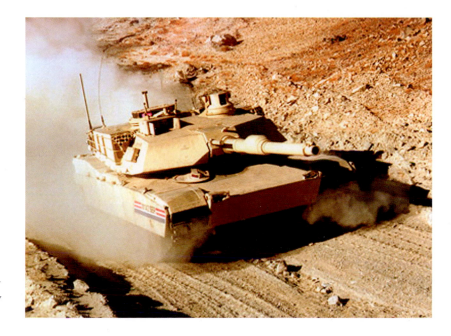

tended only to protect the tank's occupants from small-arms fire and artillery fragments.

FIREPOWER COMPARISONS

The main armament of the M1917 consisted of either a single .30-caliber machine gun or a turret-mounted, low-velocity 37mm gun. Both were antipersonnel weapons. U.S. Army tank doctrine of that era made no design requirements for the vehicle to engage enemy tanks. The 37mm main gun–equipped versions of the M1917 came with a telescopic sight to assist the tank commander in aiming the weapon, while those mounting the machine gun depended on open sights to aim.

The standing tank commander (TC) rotated the turret on the M1917 manually by gripping the inside of the turret and pivoting his body. Since there was no stabilization system fitted to the M1917, it was very difficult to fire the main armament accurately without bringing the vehicle to a halt. When fitted with a .30-caliber machine gun, the M1917 had storage space for 4,200 rounds of ammunition. When mounting the 37mm main gun, the M1917 had storage space for 238 rounds of ammunition. The maximum effective range of the main armament on the M1917 was about the length of two football fields (183 meters).

The main armament of the SEP is an extremely powerful, smooth-bore 120mm gun, designed primarily to destroy enemy tanks. Secondary armament for the Abrams consists

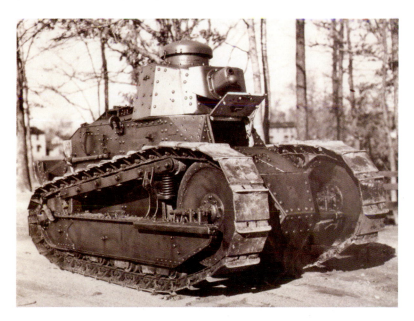

Of the 952 M1917 tanks produced for the U.S. Army during and after World War I, two consisted of soft-steel pilots (pre-series production), 526 came armed with a single turret-mounted machine gun, and 374 appeared with a 37mm turret-mounted main gun, as seen in this picture. The remaining 50 examples of the M1917 were unarmed signal (radio) tanks with a large, fixed armored superstructure rather than a turret. *Patton Museum*

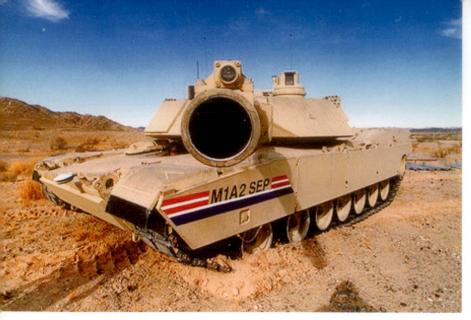

The main armament of the M1A2 SEP is its turret-mounted 120mm main gun. Located on the upper end of the gun tube is the muzzle reference sensor (MRS) that forms part of the tank's muzzle reference system and provides the vehicle's gunner a reference point to determine main gun tube bend caused by uneven heating and cooling of the gun. The gunner manually inputs this information into the tank's fire-control system. *General Dynamics Land Systems*

When an M1A2 SEP gunner takes aim at a moving target, the tank's fire-control system takes into account the lead angle and points the main gun where the target will be when the round arrives. The fire-control system also computes the gun elevation and aims the main gun above the target (called super-elevation) to take into account the effects of gravity on the projectile's flight path. *General Dynamics Land Systems*

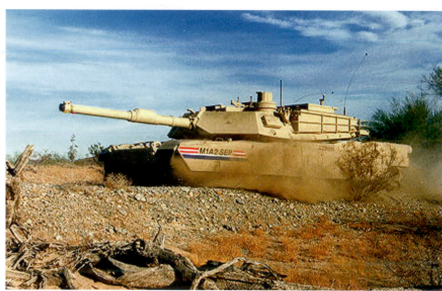

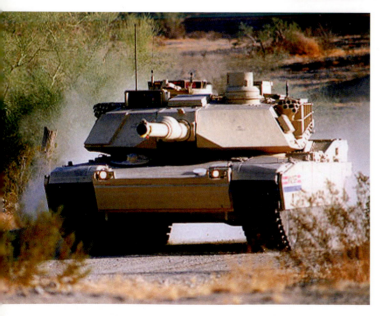

When an M1A2 SEP tank is moving and taking aim at a target, the vehicle's fire-control system holds the gunner's sight display steady by correcting the turret /gun azimuth angle and the gunner's primary sight (GPS) angle. The system also holds the main gun steady in elevation. This allows the gunner to track the target smoothly and keep the main gun on the aim point, even though the tank's hull is moving. The metal plates visible on the roof of the M1A2 SEP pictured, just behind the mantlet (gun shield) housing, are there to simulate the weight of items not yet fitted to this pre-production example of the M1A2 SEP. *General Dynamics Land Systems*

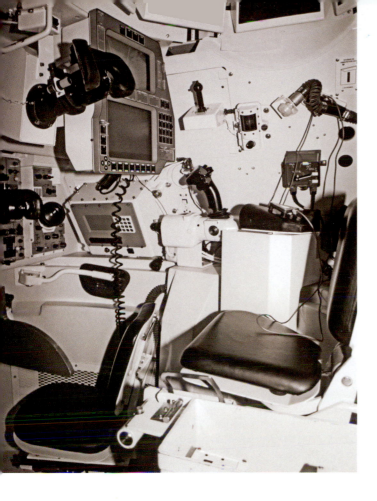

Thermal imaging systems are sophisticated heat-detection devices that provide images of objects, such as infantry or tanks, on a monitor inside the SEP. Since the device sees emitted heat energy and does not use visible light, it provides the Abrams' TC and gunner the ability to identify and engage targets, even on the darkest of nights. It can also see through a variety of natural and artificial visual conditions, such as fog, smoke, natural vegetation, and camouflage nets. The thermal sights are so sensitive that they can even detect the presence of a vehicle that has recently left the area by sensing the difference in temperature of the ground shadow of the departed vehicle.

Like the M1A2, the SEP has storage space for 42 120mm main gun rounds—36 in a rear turret bustle and 6 inside the vehicle's hull. All rounds are stored behind blast-proof doors, within compartments that will vent upward and away from the vehicle's hull and turret any explosion resulting from successful penetration by an enemy antitank weapon. The only time the vehicle's crew

of three turret-mounted machine guns. To assist the SEP gunner and vehicle commander in acquiring and engaging enemy targets, the tank features a state-of-the-art digital fire-control system. Forming part of that system are two daylight optical sighting devices and two thermal imaging systems.

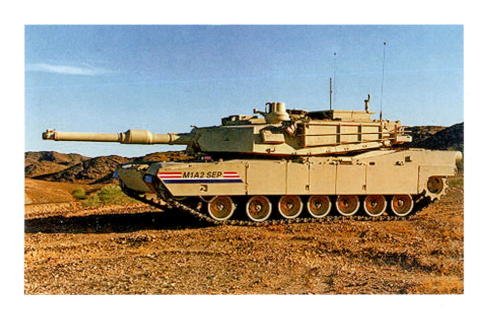

The M1917's driver entered and left his vehicle through the three hatches seen in this picture. When closed, they formed the frontal armor of the vehicle. The vehicle commander entered and left his tank through two small hatches in the rear of the turret, as seen in this picture. When completely buttoned up for combat, the only vision afforded the crew, besides an optical gun sight for those tanks equipped with the 37mm main gun, came from narrow vision slits in the vehicle's hull and turret. *Patton Museum*

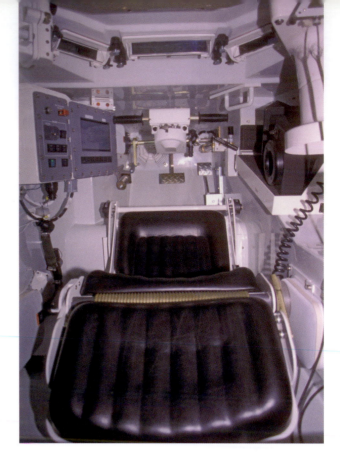

Pictured is the driver's position on an M1A2 SEP tank simulator. To the left of the driver's seat is the driver's integrated display (DID). It shows the driver the status of the tank's hull systems, contains the controls for starting and shutting down the vehicle's engine, and alerts the driver to any unusual or dangerous conditions in the tank's various systems. *Michael Green*

becomes vulnerable to an onboard ammunition explosion is when an antitank weapon achieves penetration during the very brief periods when the SEP loader withdraws a main gun round from behind one of the blast-proof ammunition compartment doors. Aside from the protected storage space for the main gun rounds, the SEP also has room for 12,300 rounds of machine-gun ammunition.

Unlike the TC of the M1917, who had to guess the range to a target, an SEP TC can use an eye-safe laser rangefinder that accurately determines the range to the target and then feeds that information to the vehicle's fire-control computer. Other sensors on the tanks also constantly provide information to the fire-control system on such conditions as the outside wind velocity and direction, propellant temperature, air temperature, gun tube wear and cant, or the lead angle on a moving target. Combined with a hydraulically stabilized turret and main gun, the SEP can successfully engage a variety of targets while either stationary or on the move. The maximum effective range of the 120mm main gun on the SEP tops out at about three miles.

MOBILITY COMPARISONS

A four-cylinder, water-cooled Buda gasoline engine drove the M1917 at a top speed of 5.5 miles per hour (8.85 kilometers per hour) on level, hard-surface roads, through a manually operated selective sliding-gear transmission that gave the driver four speeds forward and one in reverse. The cross-country speed of the M1917 was 2 or 3 miles per hour (4.83 kilometers per hour). Like the famous Model T Ford, the M1917 had no self-starter and had to be hand cranked from either inside or outside the vehicle. With a full load of fuel, the vehicle had a maximum operational range of about 30 miles (48.3 kilometers). The M1917 could cross a 7-foot (2.13 meters) trench and climb over a 36-inch (91.4 centimeters) vertical wall.

The SEP features a 1,500-horsepower multi-fuel gas turbine engine. The U.S. military places a governor on

These side-by-side pictures show the differences between the commander's weapon station (CWS) of the M1 tank (left) and the commander's station of the M1A2 SEP tank (right). From the M1 through the M1A1, the CWS was, in effect, an electrically-powered sub-turret that rotated independently of the tank's main turret and was armed with a .50-caliber machine gun. Beginning with the M1A2 and continuing to the M1A2 SEP, the tank commander's station became a non-rotating fixture with a manually-operated .50-caliber machine gun that rotates on a ring around the outside of the CWS. *Michael Green*

the SEP's engine to restrict the tank to a top speed of about 41.5 miles per hour (67 kilometers per hour) on level ground and on hard surface roads. This reduces the wear on the engine and suspension system. Maximum cross-country speed for the SEP is about 30 miles per hour (48.3 kilometers per hour). The engine connects to a fully automatic transmission that provides the driver with four forward and two reverse speeds. Unlike the M1917, the SEP has a self-starter. On a full load of fuel, the vehicle has a maximum operational range of about 200 miles (322 kilometers). The SEP has the ability to cross a 9-foot trench (2.75 meters) or climb over a 48-inch (1.22 meters) vertical wall.

Located directly behind the tank commander's independent thermal viewer (CITV) on the M1A2 SEP is the vehicle's global positioning system (GPS) antenna. The location information from the tank's GPS system supplements and updates the vehicle's inertial navigation system. This provides the M1A2 SEP with a backup navigational system if the enemy jams the GPS signal or if the GPS satellites come under attack. Just in front of the GPS antenna is a vertical piece of armor that protects the opening in the front of the CITV when it is not in use and reversed. *Michael Green*

Located on the top of the rear turret bustle of an M1A2 SEP tank are two blow-off panels. When an antitank weapon penetrates the turret bustle and detonates the main gun rounds stored within, the lightly affixed blow-off presents the path of least resistance, and the explosive energy vents skyward instead of into the crew compartment. *Michael Green*

Unlike most wheeled vehicles, tanks carry along their own portable roads—tracks. The tank lays these tracks down in front of itself and then picks them up as it moves away. The tracks consist of two conveyer-like belts made up of cast-steel track pads, as found on the M1917, or in the case of the SEP, steel track links with replaceable rudder pads located on either side of the hull. Large steel pins connect the track segments on both vehicles.

Drive sprockets, one on either side of the hull, receive their power from a tank's engine by way of the vehicle's final-drive assemblies. The Abrams is rear drive; that is, its drive sprockets are at the rear of the tank. As the Abrams' drive sprockets turn, they pick up the interconnected track pads, or links, over which the tank has driven and propel the track forward above the top of the road wheels over support rollers to the front compensating idler wheels. The idler wheels maintain track tension through a track-adjusting link and help guide the tracks onto the ground ahead of the vehicle. The tank rolls forward on either large or small metal wheels with rubber rims, over the track pads or links. Along with the tracks, these rubber-rimmed road wheels make up a tank's running gear.

Tank road wheels always connect to the tank's hull by a suspension system that minimizes the amount of shock and vibration transmitted to the tank and its crew as it moves. To help ease the shock of traveling over rough ground, most tanks also incorporate shock absorbers into their suspension systems. When a tank has small road wheels, it normally requires that the upper portion of the track run over smaller rubber-rimmed steel wheels. These track-support rollers control standing waves in the return strand that could otherwise result in the track walking off the idler at high speeds. Higher track tension can also control these standing waves, but that increases sprocket wear.

Like the SEP, the M1917 had its drive sprocket in the rear and adjustable idler wheels in front. The running gear consisted of nine small road wheels on either side of the vehicle's hull, grouped together in two bogie assemblies, or trucks, which were installed inside an inverted U-beam track frame on each side of the vehicle's hull. The front and rear bogies were fitted with five and four road wheels respectively. Due to the small size of the M1917's road wheels, there were six track-support rollers on either side of the vehicle to support the track as it passed over the drive sprockets and adjustable idler wheels. The M1917 suspension system consisted of a combination of coil and leaf springs that gave it about 3 inches of road-wheel travel.

The SEP's running gear consists of seven sets of dual rubber-rimmed road wheels on each side of the hull. Each side of the hull has two track-support rollers to support the upper run of track between the drive sprockets and compensating idler wheels. These are seldom visible on the SEP because the armored skirts on either side of the hull keep them hidden. The vehicle's suspension system consists of high-strength steel torsion bars and rotary shock absorbers (stations 1, 2, and 7 only), which provide 15 inches (38 centimeters) of road-wheel travel. This allows the tank to tackle cross-country dips and bumps at high speed without injury to the crew.

CREW POSITION COMPARISONS

The M1917 had a crew of two men, with the driver sitting in the front hull on a non-adjustable seat positioned about 6 inches above the hull floor. Using technology borrowed from fifteenth-century knights, the designers incorporated a number of very narrow and unprotected vision slots that provided an outside view for the M1917 driver when buttoned up inside his vehicle. Standing almost directly behind the driver's position on the hull floor was the TC,

who also acted as the tank's gunner and loader. There was a provision for a sling within the turret of the M1917 for the vehicle commander to sit on. Like the driver, the vehicle commander had a number of unprotected vision slots through which to view the outside world.

Due to the high noise level inside the M1917 and since the vehicle had no intercom system, the TC transmitted his instructions to the driver by using his feet. To have the driver move the vehicle forward, the TC kicked him in the back. A tap on the right shoulder told the driver to turn right, a tap on the left shoulder meant turn left. To stop the tank, the TC tapped the top of the driver's head. More than one tap to the driver's head indicated that the TC wanted him to place the vehicle in reverse.

The SEP has a crew of four men, with a driver in the front hull and three men in the turret: the TC, gunner, and loader. All four members of the crew wear helmets that contain an intercom system, allowing them to talk to each other and over the vehicle's radios when needed. The driver can also receive instructions from the vehicle commander in the turret via a driver's instrument display (DID) panel located to the left of his seat in the front hull. The DID allows the driver to move the SEP around the battlefield without constant input from the TC, thus allowing the TC to concentrate on other things. In the past, the TC usually had to guide the driver around the battlefield, since his position on top of the vehicle's turret offered a far superior view to that of the driver in the lower front hull.

Unlike the driver of the M1917, who had unprotected vision slots, the driver on the SEP has an overhead armored hatch that incorporates three periscopes, which provide him with an overlapping field of view of 120 degrees of forward vision. When buttoned up, the driver of the SEP sits in a semi-reclining position on an adjustable seat. He controls the speed and direction of the tank with a T-bar steering system that incorporates motorcycle-style hand throttles. This setup eliminates the need for a floor accelerator pedal. As with a car, the brake pedal and parking brake pedal on the SEP operate by applying foot pressure. When not in a combat situation, the driver on the M1917 could open one of his front-hull-mounted armored hatches to look directly out over the front hull of the tank. On the SEP, the driver can open his overhead hatch and then raise his adjustable seat to look out over the front portion of the vehicle's hull.

The SEP gunner seat is on the right side of the turret, with the breech of the main gun to his left. He enters and leaves the vehicle through the TC's overhead armored

Located in the turret bustle of the M1A2 SEP tank is the vapor-compression system unit (VCSU) that forms the exterior portion of the tank's thermal management system (TMS). It replaces the external power unit (EPU) seen in the turret bustles of M1A1 and M1A2 tanks. The upright device to the right of the VCSU is the tank's wind sensor, which folds down when not required. *Michael Green*

hatch. Once seated, the gunner finds himself hemmed in by left and right knee guards that help to protect his limbs from harm when the turret or stabilized gun is moving or when the main gun recoils. The 120mm main gun on the SEP recoils a maximum of 13 inches (33 centimeters). The adjustable chest rest for the gunner, which folds out of the way when not in use, plays an important role in steadying the gunner's upper torso during off-road movement. A wraparound brow piece steadies the gunner's head to prevent him from moving when looking through his main sighting device. The other sighting devices employed by the gunner on the SEP feature cushioned eyepieces.

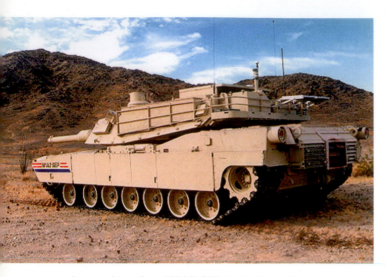

A rear view of an M1A2 SEP tank shows the vapor-compression system unit in the turret bustle that comprises the exterior portion of the thermal management system (TMS). It is a hydraulically driven, vapor-cycle-based cooling system that removes the heat from the inside of the crew compartment and transfers it to the exterior of the vehicle. *General Dynamics Land Systems*

The TC's seat is directly behind the gunner seat. The adjustable seat allows the TC to operate his vehicle while seated or standing. In the seated position, the primary operation position, he can easily view all periscopes and display panels. He can also easily access all dials, switches, and buttons. There is also a convenient flip-out footrest for the tank commander to use when seated.

When the SEP's TC desires to look out over the top of the tank's turret, he has a number of options. If he is worried about threats from above (such as small-arms fire or artillery air bursts), he raises his overhead armored hatch to the horizontal, open protected position just a few inches above the roof-mounted weapon station. He then stands on a platform that is located just slightly above the turret basket floor to look out over the top of the turret.

If the SEP's TC is not worried about overhead threats, he can stand on an intermediate platform and project just his head and upper shoulders out of the top of his roof-mounted weapon station by raising his overhead armored hatch to the vertical name-tag-high position. When maximum visibility is needed while navigating through a very tight spot with his SEP tank, the TC can flip down his seat back and stand on that in the waist-high open-hatch position.

Sitting on the left side of the SEP turret, with the main gun to his right, is the loader. The loader enters and leaves his position through an overhead armored hatch that incorporates a rotating periscope. From his adjustable seat, he has immediate access to 18 of the vehicle's 42 ready rounds—120mm main gun rounds stored on metal ready racks located just behind an inch-thick, hydraulically-operated armored door, directly behind his right shoulder.

To access the 120mm main gun ammunition in the SEP, the loader must normally stand up from his seat and apply pressure with his right knee to a large knee-paddle switch. The knee switch slides open the armored door, behind which the main gun rounds are stored. The loader then releases a spring-loaded tab holding a round of main gun ammunition in place, extracts the round, and turns toward the open breech end of the 120mm main gun. The armored door automatically closes two seconds after the loader removes his knee from the switch. As soon as the loader slams a round into the open breech, it closes automatically and the weapon is ready to fire after the loader activates a firing circuit. The maximum effective rate of fire for the SEP is six rounds per minute.

The army standard for loading the 120mm main gun on the SEP is five seconds. A very quick loader can do it in four seconds. To help the loader operate more efficiently, the main gun decouples from the stabilization system during loading. The gunner's independently stabilized sight allows him to maintain his sight picture while the gun is decoupled. When the loader completes his task, the gun returns to stabilized operation and seeks its proper position relative to the gunner's line of sight. Shoulder, knee, and foot guards protect the loader from the dangers of the recoiling breech and ejected cases. All of these fold out of the way when not in use.

The TC has to access the 18 additional main gun rounds stored in a semi-ready rack within the SEP turret bustle, behind his seat. The TC stands on the turret floor just behind the gunner's position and removes the main gun rounds from the semi-ready rack and hands them off to the loader, who then puts the rounds into his ready rack. The downfall is that you cannot have the ready rack and semi-ready rack doors open at the same time. The other choice is to take out three or four main gun rounds at a time and stand them on the turret floor. This process repeats itself until completed. While it is theoretically possible to load the main gun directly from the semi-ready racks, this is not the preferred method, since it distracts the TC from his main job of managing the operation of the tank.

For the loader to reach the six main gun rounds stored in the hull of the SEP, the vehicle's turret must face a certain direction. When not loading the main gun in combat, the SEP loader is typically up in his hatch assisting the driver in avoiding obstacles and providing external security for the vehicle with his turret-mounted 7.62mm machine gun.

The three crewman seats in the turret of the SEP form part of the turret basket, the tank's internal structure. This circular structure attaches to the bottom of the vehicle's turret and rotates with the turret. In the case of the SEP, the turret basket consists of aluminum armor plate. It hangs from the turret with five posts, two of which mount the seats for the tank commander and the loader. On the floor of the turret basket is a door that allows access to components in the bottom of the tank's hull. For convenience and safety, metal guards protect the limbs of the turret crew when the turret basket rotates with the turret. There are also stops (bumpers) mounted in the SEP hull to prevent excessive stresses from warping the turret basket caused by large dynamic loads, such as those resulting from a high-velocity hit on the turret or a collision with a building, tree, or another tank.

COMMUNICATIONS COMPARISONS

The M1917 had no radios, although a small number of non-armed, radio-equipped versions of the vehicle existed. To communicate with other tanks when under enemy fire, M1917 crews used signal flags or Klaxon horns. Early during World War I, some British tanks depended on homing pigeons to send reports to rear-area command posts. Late in that war, American tank crews first went into combat with the French-designed and -built Renault FT17 light tank (the M1917 was merely a slightly improved copy of the French tank). American unit commanders found it so difficult to control their vehicles in combat that many led them into action on foot. To help identify the American-crewed French tanks and improve command control in battle during World War I, Major George S. Patton ordered that each tank be marked with a playing-card symbol: diamonds, hearts, spades, and clubs.

In the years following World War I, the U.S. Army began working on placing analog voice radios in all its tanks. Analog radios depend on gradual differences in their generated electrical signals to transmit over the air. By the 1930s, most American tanks featured an FM (line-of-sight) analog voice radio receiver. While crews could lis-

ten to their orders, they could not transmit. During World War II, most American tanks, such as the M4 Sherman medium tank series, had FM analog voice radios that could both receive and transmit. While the addition of analog voice radios to all American tanks certainly did much to improve the overall command and control of armored units in battle, terrain features, distances, or simple equipment failures could seriously degrade their performance.

The early radios used the vacuum tube technology of the era. Tube radios took up space in crowded vehicles, gave off waste heat, and drew a lot of power. Additionally, their analog tuning (as opposed to easily selectable discrete channels) made them difficult to use. Unlike large aircraft of the day, tank crews had no dedicated crewman as a radio operator. Thus, a considerable additional workload was placed on the crew members charged with the responsibility of operating the radio.

During the Cold War, American tanks continued to be equipped with incrementally improved FM analog voice radios. While these newer generations of analog voice radios were a big improvement over their World War II counterparts, they remained vulnerable to enemy interception or jamming. To overcome these limitations, the U.S. Army's M1A2 Abrams SEP features a digital radio called the single-channel ground and airborne radio system (SINCGARS), which can accommodate voice, analog, and digital data transmissions. It features

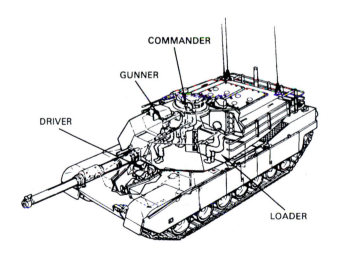

This ghosted line drawing shows the arrangement of the four-man crew within the M1A2 SEP tank. The broken lines within the front hull show the location of the tank's two fuel tanks. *U.S. Army*

EQUIPMENT DESCRIPTION

LOCATION AND DESCRIPTION OF MAJOR COMPONENTS (EXTERNAL)

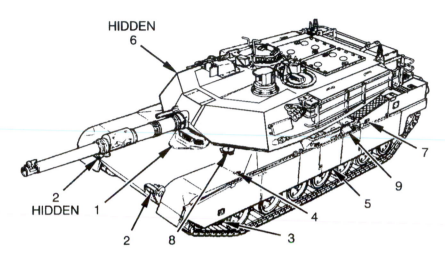

DRIVER'S HATCH (1): Permits driver to operate tank from armor-protected position with driver's hatch (1) closed, or head-up position with driver's hatch (1) open. Closed driver's hatch (1) provides overall view of 170° horizontally and 8° vertically through three periscopes.

HEADLIGHTS (2): Contain service drive lights and blackout (BO) marker lamps.

SKIRT STEPS (3), LEFT AND RIGHT SIDES: Provide foot holds to help crewmembers mount tank.

HAND HOLD (4), LEFT SIDE ONLY: Provides hand grip to help crewmembers mount tank.

SKIRTS (5), SIX ON EACH SIDE: Provide protection to upper portion of tracks and suspension.

SPONSON (6), RIGHT SIDE: Provides stowage for basic issue items. (See Appendix B, Section III for detailed list).

EXTERNAL FIRE EXTINGUISHER T-HANDLE (7): Actuates engine compartment fire extinguisher from outside the tank.

FUEL FILLER CAPS (8): Provide covers for four refueling points at front and rear and left and right side of tank.

NBC MAIN SYSTEM (9): Detects contaminants and provides crew with clean, temperature-adjustable air.

Visible in the line drawings throughout this chapter are the many external features of the M1A2 SEP tank. *U.S. Army*

a 16-element keypad for push-button tuning and can function either in a single-channel mode or in a jam- and interception-resistant frequency-hopping mode.

Digital radios use microprocessors to transmit a stream of zeros and ones that allow for much more information to go out over the air, with much greater accuracy and transmission efficiency than was ever possible with continuously variable analog voice radios. Because the digital signals are in binary code, computers using mathematical algorithms can process them.

ORGANIZATION AND TACTICS

In the summer of 1918, Major George S. Patton, with the help of other U.S. Army officers, first organized the American tank units in France. At the time, the U.S. Army still relied on the French army's FT17 light tank, since the American copy of the French vehicle (the M1917) remained mired in production problems.

After observing both British and French tank units in battle against German defensive positions, Patton organized his light tanks into platoons of five tanks each, as had the French army. Patton also modeled his tank companies on the French table of organization and equipment (TO&E), which consisted of three platoons of five tanks each, under the command of a headquarters detachment consisting of nine tanks and a single unarmed radio-equipped tank, making for 25 tanks per company. Since the tanks of the day were mechanically unreliable, the nine armed tanks in the headquarters detachment were considered spares for the three platoons of the company. This left no tank for the company commander, although in practice, he normally utilized one of the nine spare tanks as his own. Even so, many company commanders walked into battle following their tanks, not a serious problem at the time, since the vehicles' average speed was typically only 2 miles per hour.

By the 1930s, new light-tank designs proved much more reliable than the M1917 light tank, and spare tanks no longer formed part of U.S. Army tank companies. With the creation of the U.S. Army Armored Force in June of 1940, light-tank companies were reduced in numbers to just 13 tanks, one tank for the tank company commander and four three-tank platoons. Medium-tank companies consisted of three five-tank platoons and two tanks in the headquarters detachment of the company. This TO&E became the standard for army and Marine Corps tank companies through World War II and the Cold War.

In the 1980s, the U.S. Army and Marine Corps reduced to four tanks per platoon, with two tanks in the company headquarters section, leaving 14 tanks per company. Concurrently, the tank battalion TO&E was changed to include a fourth tank company, so overall strength of a battalion was only slightly different. The four tanks in the current platoon structure find themselves further subdivided into two sections, with two tanks in each section. In recent years, some in the U.S. Army's armor community have suggested a further reduction of three tanks to each platoon.

The original tactics of American tank platoons in battle, as laid down by Major Patton in 1918, consisted of a couple of simple geometric formations to facilitate command and control, and to avoid confusion. These included the line and wedge formations. In either formation, the infantrymen followed the tanks to mop up enemy combatants and to exploit any breaches in the enemy's lines that were opened by the tanks. Patton believed that whenever possible, the heavy tanks, typically featuring thicker armor and more powerful weapons, were to lead the attack.

With the U.S. Army no longer employing heavy, medium, and light tanks, just main battle tanks, the SEP assumed the traditional heavy-tank and medium-tank roles. (The light-tank mission has been taken over by the M3 Bradley cavalry fighting vehicle.) The combat tactics of contemporary U.S. Army tank platoons are far more complex and elaborate than those practiced by American tank crews during World War I. A description of the role performed by a platoon of SEP tanks comes from a current army manual: "The fundamental mission of the tank platoon is to close with and destroy the enemy. The platoon's ability to move, shoot, and communicate and do so with armored protection is a decisive factor on the modern battlefield."

FINDING YOUR WAY AROUND

One of the most important pieces of information for TCs in combat is knowing exactly where the tank is at all times. This information often helps to determine where the enemy might be located. Knowledge of the enemy's location is usually a prerequisite to battlefield success. From World War I until very recently, American tankers used maps and compasses to find their way around battlefields. A plastic map case and a grease pencil enabled the tank commander to mark operational graphics on his paper map for easy visual reference.

To be successful with a paper map and compass the TC first had to learn how to "terrain associate." By thoroughly studying his map and then identifying major terrain features, contour changes, and manmade objects along the axis of movement, he could pinpoint his position on a map. There are some drawbacks associated with using paper maps and a compass in determining location: it requires a high level of skill and a lot of training, and it can be very time-consuming. Tanks often had to come to a complete stop while the TC oriented himself to the local terrain.

U.S. Army Major Jim Brown (retired), a former tanker, talks about terrain association:

> Terrain association was and still is accomplished on the move. Once you develop the habit of continuous map reading (as opposed to occasional glances at the map), it isn't as hard as it looks, at least in daylight. It was really embarrassing to have to come to a halt and dismount so you could get a compass away from the magnetic mass of the tank. Fortunately, you only had to do that when you were hopelessly lost. Of course, all bets were off at night or in limited visibility. The need for terrain association hasn't gone away with modern navigation tools. The crew still needs to understand how the information on the map correlates to what they are seeing outside in the real world.

To get away from its long-time dependence on maps and the compass, the army introduced a number of electronic devices into the M1A2, predecessor of the SEP. One of these improvements, the inter-vehicular information system (IVIS), is a digital ground-based system with a monochromatic display monitor that allows the TC to view transmitted reports or simple map-like grid coordinates from other M1A2 Abrams tanks by way of the tank's single-channel ground and airborne radio system (SINC-GARS). It also allows the M1A2 Abrams TC to transmit important text messages by way of a fixed keyboard, or send grid coordinates such as the location of an enemy position.

As a first-generation system, IVIS did not prove to be user-friendly. The small fixed keyboard provided with the device turned out to be extremely difficult to manipulate in a field setting, especially when operating under nuclear, biological, and chemical (NBC) conditions. Because inputting text messages into the device takes so

much time and effort, M1A2 TCs seldom use it in the field. Map graphics have to be hand-drawn on the monitor by the M1A2 TC before transmission; this can take hours and is only as accurate as the individual who's drawing them.

A position/navigation (POS/NAV) system is connected to the IVIS. It consists of an inertial navigation system that provides the TC and gunner with the vehicle position—without the use of satellites. It works by manually inputting the tank's initial position as a 10-digit grid location. A computer inside the M1A2 then updates the grid location based on the amount of track rotation. This has led to some problems, since track slippage in muddy or icy conditions causes the grid location to change, even though the tank might still be in the same position. Crew error in inputting starting position data into the POS/NAV system also causes problems. Depending on which of the ten digits were entered erroneously, this can result in a starting position error of a few yards or hundreds of yards. Clearly, this is a serious issue when attempting to call in artillery or air-support on close-in enemy positions.

FBCB2

While the M1A2 tank with the IVIS was cutting-edge technology in 1990, its specially designed military software and hardware was not accepted as an army standard. Therefore, other army combat vehicles, including combat support and combat service support arms, could not electronically integrate with the M1A2 Abrams tank. Instead, the army adopted a new, more advanced digitized military command-and-control software system called the Force XXI battle command brigade and below (FBCB2). It first appeared in army service in the mid-1990s for use at brigade and below echelons. The FBCB2 is part of a much larger post–Desert Storm army initiative to digitize command-and-control functions across the entire service, referred to as the army battle command system (ABCS).

As far back as 1994, General Gordon R. Sullivan, then chief of staff of the army, stressed the importance of information to the army of the twenty-first century:

> The high ground is information. Today we organize the division around the killing system, feeding the guns. Force XXI must be organized around information The creation and sharing

EQUIPMENT DESCRIPTION

LOCATION AND DESCRIPTION OF MAJOR COMPONENTS (EXTERNAL) - Continued

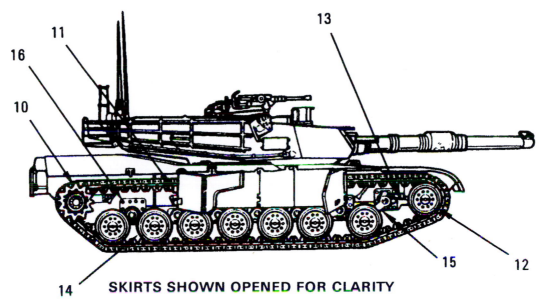

SKIRTS SHOWN OPENED FOR CLARITY

SUSPENSION SYSTEM (10 thru 16): Components of the suspension system are identical for both sides of the tank.

SPROCKETS (10): Transfer power from the transmission and final drive to the tracks (hidden by track retainer plates on tanks with that item installed).

SUPPORT ROLLERS (11): Support the weight of the track between the sprockets and compensating idler wheels.

COMPENSATING IDLER WHEELS (12): Maintain track tension by compensating for changes in the position of the number one roadwheels.

TRACK ADJUSTING LINKS (13): Allow increase or decrease of track tension.

ROADWHEELS (14): Maintain ground pressure and alinement of track. Roadwheels are numbered from front to back as numbers one, two, three, four, five, six, and seven.

ROADARMS (15): Connect roadwheels to hull and torsion bars.

ROTARY SHOCK ABSORBER HOUSINGS (16): Hydraulically dampen torsion bars of number one, two, and seven roadwheels. This helps provide a smoother ride.

EQUIPMENT
DESCRIPTION

LOCATION AND DESCRIPTION OF MAJOR COMPONENTS (EXTERNAL) - Continued

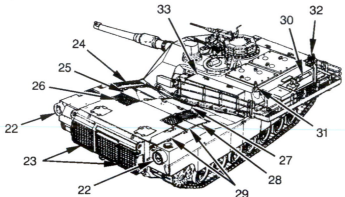

TAILLIGHTS (22): Contain service taillights, service stoplights, blackout markers, and blackout stoplights.

REAR GRILLE DOORS (23): Provide armor-protected exhaust outlet and partial access to powerpack.

AIR INTAKE PORT (24): Provides air intake to engine.

PRECLEANER DOORS (25): Permit access to the precleaner for servicing.

TOP DECK LEFT GRILLE DOORS (26): Permit access to transmission for checking oil level.

ENGINE ACCESS COVER (27): Permits access to turbine engine for checking oil level.

TOP DECK RIGHT GRILLE DOORS (28): Permit access to primary fuel filter bypass handle and fuel lines for doing emergency fuel transfer.

BATTERY COVERS (29): Permit access to batteries for servicing.

CROSSWIND SENSOR (30): Provides measurement of crosswind speed at the tank for input to the fire control electronics unit (FCEU).

RECEIVER/TRANSMIT ANTENNA (31): Provides for transmission and reception of radio signals for the AN/VRC-89D or 92D radio set.

RECEIVER/TRANSMITTER ANTENNA (32): Provides for transmission and reception of radio signals for the AN/VSQ-2 (V) radio set.

TURRET STOWAGE BOXES (33), LEFT AND RIGHT SIDE: Provide stowage for basic issue items and ammunition. (See Appendix B, Section III, and Chapter 5 for detailed list).

of knowledge followed by unified action based on that knowledge which will allow commanders to apply power effectively. The purpose of the Force XXI must be to dominate, to control, to win; information will be the means to a more powerful end. It is information-based battle command that will give us ascendancy and freedom of action— for decisive results—in twenty-first-century war and operations other than war.

In the simplest of explanations, FBCB2 is a wireless tactical internet system that takes real-time information, in the form of data from various sources including ground platforms, and transmits it through SINCGARS. Command and enhanced-position-location radio set (EPLRS) control is accomplished through text messages, and situational awareness information is displayed as tactical symbols on a moving digital color map projected on a touch-screen monitor inside tanks or other army vehicles. This allows everyone, down to the frontline infantryman, to understand what is happening on the battlefield. They can keep up on important events, such as an important bridge going down or an enemy ambush on a nearby road. "It gives us situational awareness," said First Sergeant Antoine Haddar, of the army's 4th Infantry Division.

"Before, you had to listen to the radio carefully, and you couldn't get all the information," Haddar continued. "Now, you can basically see everything, [and] the whole brigade can see the same thing. All that information used to be privileged, and you got surprised. Now, you get surprised less, actually a lot less, and this is an advantage."

Retired Major Jim Brown added:

As cool as the situation-awareness aids are in training, you don't really appreciate their value until you get to the field. The real situation is more complicated than it ever was in training, and seeing things graphically reminds you that a picture really is worth a thousand words. The benefit is further enhanced because you are always tired in the field. I used to test how mentally tired I was by whether I could remember my own telephone number. Having the information flow represented graphically gives your brain a better chance to absorb what's going on in places beyond your visual space.

To accommodate the new FBCB2 software and other future upgrades into the Abrams tank series, the army introduced the SEP into service in 2000. It has better data processors, more memory, and a better soldier-machine interface than its predecessor. The new commander's display unit (CDU) in the SEP includes a portable keyboard that allows TCs to type text messages with ease. There are also pre-programmed text messages for many situations that the TC can send with the push of a button, rather than by typing out a message or making a long-winded radio transmission. This has dramatically decreased the amount of radio traffic among units equipped with the FBCB2.

The SEP TC still needs to draw graphic overlays on his monitor by hand, as the M1A2 vehicle commander did. However, his controls and inputs are slightly more user-friendly, making the process a little easier and quicker.

Prior to a mission, color digital maps representing the area of maneuver are loaded into the FBCB2 systems of the SEP. The POS/NAV then constantly updates the actual location of the tank while on the move. The POS/NAV receives global positioning system (GPS) updates, when available, from the onboard embedded army enhanced GPS receiver (AEGR) system. When GPS signals are not available, the POS/NAV continues to update tank position. These updates are disseminated via the enhanced position location reporting system (EPLRS), a digital data communication system that automatically networks radio sets (RS) together to provide accurate and timely situational awareness, and computer-to-computer communications on the tactical battlefield. This combination of systems enables the TC and higher headquarters to see the location of the vehicle by way of a graphic symbol on their own FBCB2 screen. It is in widespread use in units including the 4th Infantry Division, the 1st Cavalry Division, and the recently fielded Stryker brigade combat teams (SBCTs).

BLUE FORCE TRACKING

Shortly before the American military invasion of Iraq, the army began adding the FBCB2-BFT to some of its inventory of M1A1s and other vehicles. Blue force tracking (BFT) is a satellite communication (SATCOM) version of the ground-based FBCB2-EPLRS. While it uses FBCB2 military software, the information goes out over the same commercial satellite hardware used by the civilian trucking industry.

EQUIPMENT DESCRIPTION

LOCATION AND DESCRIPTION OF MAJOR COMPONENTS (EXTERNAL) - Continued

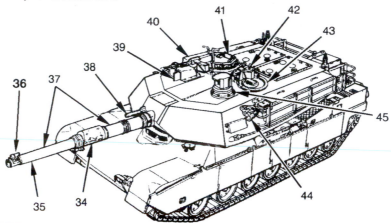

BORE EVACUATOR (34): Prevents main gun gases from entering turret when breech is opened.

MAIN GUN - 120MM (35): Provides main armament for tank.

MUZZLE REFERENCE SENSOR (COLLIMATOR) (MRS) (36): As part of muzzle reference system, provides gunner a reference point to determine gun tube bend caused by uneven heating and cooling of the gun for manual input into fire control system.

THERMAL SHROUD (37): Reduces tube bend caused by heat by using a two-part aluminum cover around main gun.

FLASH SUPPRESSOR (38): Hides flash from coaxial machinegun.

GUNNER'S PRIMARY SIGHT BALLISTIC SHIELD COVER (39): Protects gunner's primary sight head assembly from small caliber fire and shell fragments.

COMMANDER'S WEAPON STATION (CWS) MACHINEGUN (40): Provides small caliber firepower and can be fired only when commander's hatch (35) is in the full open position. Normally a caliber .50 machinegun is mounted, but a 7.62mm (M240) machinegun can be mounted instead.

COMMANDER'S HATCH (41): Provides commander protected viewing from closed, protected open, and full-open positions.

LOADER'S MACHINEGUN - 7.62MM (M240) (42): Provides small caliber firepower.

LOADER'S HATCH (43): Provides crewmembers with normal entrance and exit to and from tank.

SMOKE GRENADE DISCHARGERS (44): Provide smoke to screen tank. There is one discharger on each side. Smoke grenades are fired from commander's station.

COMMANDER'S INDEPENDENT THERMAL VIEWER (CITV) (45): Provides commander with 360° thermal viewing capability. Movement of CITV can be automatic (AUTO SCAN mode) or manually (SEARCH mode) activated by the commander using his control handle.

An article by Captains James Conatser and Thane St. Clair, titled "Blue-Force Tracking—Combat Proven," in the September–October 2003 issue of *Armor* magazine describes the advantages of BFT:

> *In FBCB2-EPLRS equipped units, radio-based communications rely on a denser fielding of systems and good dispersion of platforms throughout the area of operation to maintain network integrity. Wide dispersion and line-of-sight limitations between vehicles affect the terrestrial-based radio network and the effectiveness of SA [situational awareness] and C2 [command and control]. FBCB2-BFT literally breaks the line-of-sight barrier with its satellite link; distance, dispersion, and line-of-sight between vehicles is not a problem.*

The big disadvantage with FBCB2-BFT is the fact that the information goes out over commercial rather than military satellites. This means the army must pay the civilian satellite industry for using its hardware. In addition, BFT can only distribute a subset of the C2 messages available through FBCB2. It can't process secret information nor can it work with the ABCS (army battle command system). In contrast, the FBCB2-EPLRS can process both unclassified as well as secret information and is an important component of ABCS. Also, the BFT bandwidth is much narrower. A reduced message set is employed, with text messages limited to 500 characters. If an incoming message arrives while an outgoing message is being sent, the incoming message will be missed. The Abrams program manager (PM) office is currently addressing the following shortcomings in the system:

> *a. Security: The goal is to make design changes to achieve the same level of security as terrestrial-based FBCB2.*
> *b. Full Duplex: This will allow simultaneous sending and receiving of messages with no loss of communication.*

Currently, FBCB2-BFT is not integrated into SEP. However, integration will be straightforward if the army decides to release BFT across all platforms.

Despite the disadvantages of FBCB2-BFT, those who have used the system in Iraq think its merits make it a worthwhile addition to the U.S. Army inventory. According to Captain James Stewart, commander of A Company, 2d Battalion, 69th Armor, "You are focused [with FBCB2-BFT]. You have just reduced layers of friction, and the fog of war is why units lose. This is simultaneous, real-time synchronization. It reduces the friction of war about a hundredfold."

Based on its successful use of the FBCB2-BFT in Iraq, the army is now expanding its employment to include units never intended for digitization and those that might not have seen it fielded for many years down the line. One of the options now under consideration includes the use of unmanned aerial vehicles (UAVs) as stand-ins for satellites to relay BFT information and greatly increase bandwidth coverage across future battlefields.

The defense department wants to see BFT standardized with the other services. One of the most important short-term goals is BFT's compatibility between the army and Marine Corps. The marines currently use a secure, radio-based military communication system called C2PC, which differs from FBCB2-EPLRS. To prevent any friendly-fire incidents during Operation Iraqi Freedom, the army supplied the marines about 180 examples of the FBCB2-BFT so they could monitor the location of their frontline combat units.

STAYING COOL

To keep all these new electronic systems from overheating, the SEP boasts an air conditioning system that keeps the inside tank temperature between 88 and 95 degrees Farenheit—even when the temperature outside the vehicle soars as high as 125 degrees. The thermal management system (TMS) is a hydraulically driven, vapor-cycle-based cooling system that removes heat from the crew compartment and transports it outside the tank.

The TMS consists of two major components: the vapor compression system unit (VCSU) located in the rear turret bustle rack of the SEP, and the air-handling unit (AHU), located in front of the gunner's primary sight. Small tubes running underneath the bottom of the SEP turret connect the VCSU in the turret bustle rack to the AHU inside the vehicle's turret.

The TMS electronic control unit (ECU) located in the VCSU constantly monitors the status of the TMS and will shut it down during unacceptable operating conditions. The crew of a SEP may also shut off the TMS from either the tank commander's position or the driver's position. Once turned off, there is a one-minute waiting period before the crew can restart the TMS.

The loader of a Marine Corps M1A1 tank is shown with a 120mm main round in the breech. Once the projectile end of the main gun round is inserted into the open breech of the weapon, the loader makes a fist at the rear of the cartridge case and shoves it forcefully into the chamber, just ahead of the breech-block, which quickly closes behind it. At the same time, a safe/arm handle actuated by the loader arms the main gun, and he announces "Up" into the inter-com microphone, informing the gunner and the tank commander that a main gun round is ready for firing. *U.S. Marine Corps*

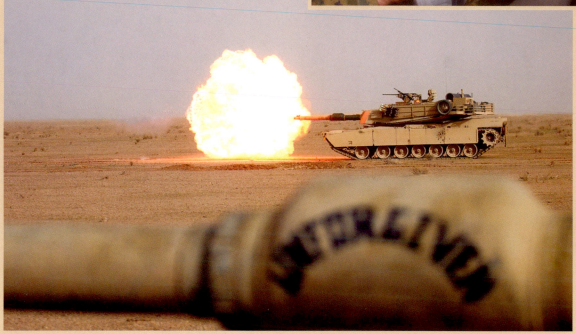

Marines from Tank Platoon, Battalion Landing Team 1st Battalion, 4th Marines, 11th Marine Expeditionary Unit (Special Operations Capable), fire their M1A1 tank main gun in the western desert of An Najaf Province, Iraq, Jan. 24, 2005. The Marine tank crewmen train monthly to remain proficient with the 67-ton M1A1 Abrams tanks they operate. Note the foreground tank's nickname, "Unforgiven," painted on the bore evacuator of its main gun. *Gunnery Sergeant Rob Blakenship*

CHAPTER THREE
FIREPOWER

THE ULTIMATE MEASURE OF TANK performance remains its ability to destroy enemy tanks. To accomplish this goal, modern American and foreign tanks are armed with large turret-mounted, high-velocity main guns. Early versions of the Abrams, including the M1 and IPM1, feature an American-built model of a British-designed 105mm main gun designated the M68A1. Later models of the Abrams, including the M1A1, M1A2, and M1A2 SEP, feature an American version, designated the M256A1, of the 120mm tank gun developed by Rheinmetall of Germany—the same company that designed and built the main gun for the famous German Panther medium tanks and Tiger heavy tanks of World War II.

As expected, the 120mm main gun offers superior range and penetration compared to the smaller 105mm main gun on older M1 and IPM1 vehicles. During Operation Desert Storm, M1A1 Abrams crews used their 120mm main guns to effectively engage and destroy enemy tanks at ranges of more than two miles.

The power of the 120mm main gun mounted on the Abrams tank, compared to the earlier 105mm main gun, hit home clearly to James M. Warford, a retired army officer, in 1988:

I had been a well-seasoned tank commander with a lot of experience on the 105mm armed M60A1 RISE (Passive), M60A3 TTS, and M1 when I was first introduced to the 120mm main gun of the M1A1. While I was walking the firing line behind my battalion's new M1A1 tanks in West Germany, the alert was sounded that indicated a tank was about to fire. Since I was very used to being in close proximity of tanks firing their 105mm main guns and I was wearing the required earplugs, I continued to walk just behind the firing line when suddenly a 120mm gun roared to life and fired a training round. I had never heard anything like it I must have jumped three feet into the air; the concussion was enormous. That one incident quickly confirmed to me the power of the new 120mm tank gun over the older generation 105mm tank gun.

Army National Guard Lieutenant Nicholas Moran, who commanded a platoon of M1A1 tanks armed with the 120mm main gun in Iraq for a year and a half,

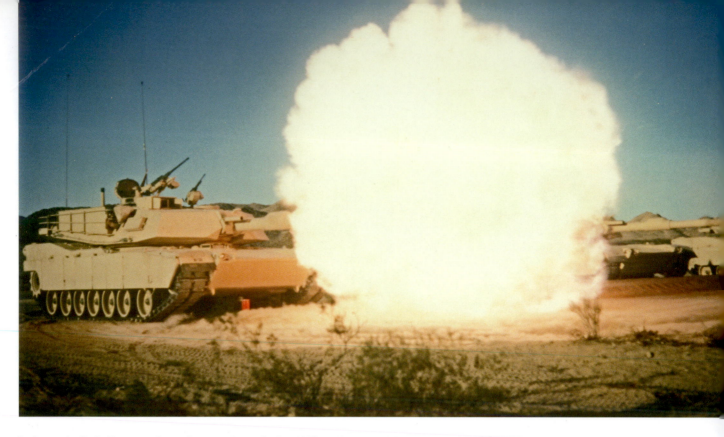

A dramatic fireball erupts from the muzzle end of an M1 tank as a main gun round is fired. The type of ammunition employed by an Abrams tank in battle is normally the tank commander's choice. He must evaluate the vulnerability of a target to determine the type of ammunition to use in its destruction. *Greg Stewart*

describes the powerful impression their main guns made on the local insurgents and fellow soldiers:

> The insurgents learned to respect the main gun very quickly. To the best of my knowledge, no tank ever fired its main gun in Mosul before mine did. For about a week, they had been engaging tanks with RPGs [rocket-propelled grenade launchers] and small arms in small skirmishes. Finally, in one complex ambush, I opened up, and between my wingman and myself fired eight rounds. The reports heard at our base five miles away were so loud that the base firefighter service had a call go out on the radio to make sure that the explosions were not on the base. After that, nobody took a shot at a tank for weeks.

THE MAIN GUN

The gun tube is the most important component of all tank main guns. It contains and guides a projectile during the critical firing phase. The gun tube on the various versions of the Abrams tank is a one-piece steel forging.

On Abrams tanks equipped with a 120mm main gun, the gun tube weighs 2,592 pounds (1,177 kilograms). A device called the breech mechanism, housed within the confines of the Abrams' tank turret at the rear of the gun tube, opens and closes to allow insertion of a round of main gun ammunition into a chamber. The breech mechanism for the 120mm main gun weighs 1,506 pounds (684 kilograms). The breechblock is the part of the breech mechanism that slides downward to open; it weighs more than 100 pounds (45.4 kilograms).

When an Abrams gunner or TC identifies a suitable target and fires the main gun with his firing switch, an electrical current flows through a firing pin, setting off the electrical primer of the cartridge in the firing chamber, just in front of the breechblock; an explosion (really a rapid burning of the propellant within the cartridge case) then takes place. In fewer than 16.4 feet (5 meters) and in less than a hundredth of a second, the projectile reaches an average of over 26,000 Gs as it accelerates to Mach 5 (3,580 miles per hour or 1,600 meters per second). The pressure in the chamber approaches 100,000 pounds per square inch for some types of ammunition.

The sudden expansion of propellant gases and forward movement of the projectile produces an opposite rearward reaction of the gun tube. This force is referred to as recoil and is very powerful in large-caliber guns; it would be impractical to design a rigid mount that could absorb this intense stress. The design solution is a recoil mechanism that allows the gun to move within the gun mount during firing. The recoil mechanism acts as a cushion between the gun and gun mount, allowing the gun to move rearward while the gun mount and vehicle remain stationary. A counter-recoil system returns the gun assembly to its original firing position and holds it there until fired again.

The gun mount on the 120mm main gun–equipped version of the Abrams weighs 7,307 pounds (3,317 kilograms) and is described as a concentric recoil, hydrospring, constant-distance type; it supports the 120mm gun on trunnion bearings installed on pins set in the turret. A hydraulic elevating mechanism allows for the elevation and depression of the gun. The gun mount also provides mounting surfaces for the coaxial (or coax) machine gun, the gunner's auxiliary telescope, and the gun gyroscope for the stabilization system.

MAIN GUN AMMUNITION

The main components of tank main gun cartridges are the primer, the propelling charge, and the projectile. The primer receives the firing impulse and ignites the propellant. Some primers are percussion caps, like those seen on small-arms ammunition, but both the 105mm and 120mm Abrams ammunition use an electric primer. The firing pin in the breechblock is an electrical contact, which is held to the primer until the electrical firing impulse is

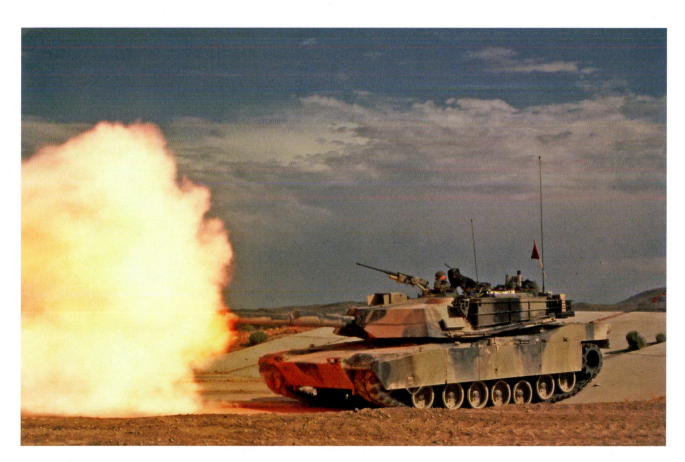

An M1A1 tank fires on a target during a training exercise at the U.S. Army's National Training Center (NTC). Abrams tankers learn in training that when engaging multiple enemy targets on the battlefield, they must take them under fire in the order of the threat they represent. The U.S. Army classifies enemy targets as most dangerous, dangerous, and least dangerous. *Greg Stewart*

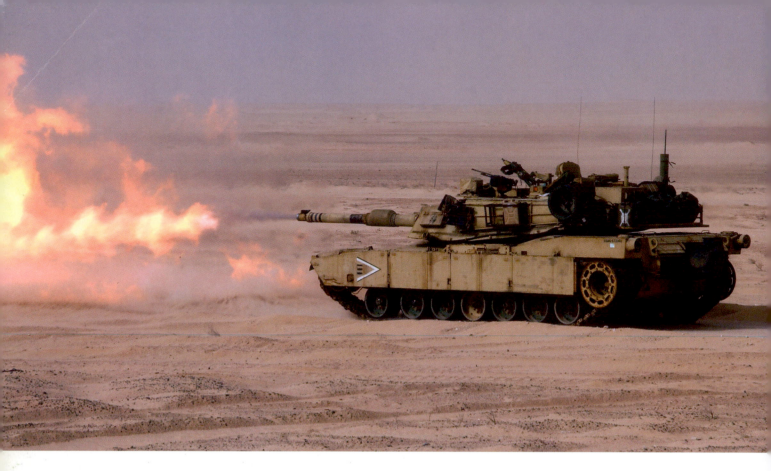

A Marine Corps M1A1 tank is shown firing at a training site in the Middle East. American tankers classify an enemy target that sees you, has the capability of killing you, and appears to be engaging you as the most dangerous. They remain the greatest battlefield threat to the Abrams tank, and crews must quickly dispose of them. If there is more than one, then Abrams tankers learn to engage the closest one first. *U.S. Marine Corps*

sent. Fixed ammunition cartridges contain the three components, with the cartridge case, containing primer and propelling charge, rigidly attached to the projectile.

Because modern tank main gun ammunition is heavy (up to 65 pounds, or 29.5 kilograms, per round) and cumbersome (averaging about 3 feet in length, or 91 centimeters), many foreign tanks use separate-loading ammunition, in which the projectile and cartridge case are loaded into a firing chamber sequentially. The convenience of separate-loading ammunition is offset by the fact that fixed ammunition can be loaded and fired more rapidly because only one item goes into the gun.

A major problem of tank guns is disposition of the empty cases after firing. The cartridge cases are about 2 feet (61 centimeters) long and 5 1/2 inches (14 centimeters) in diameter and are made of steel or brass. On the 105mm main gun–equipped versions of the Abrams tank, these empty cases are ejected onto the floor of the turret basket. The cases are too hot to touch for a time and contain toxic powder residue. The loaders wait for the first

available lull in firing and open their overhead hatches to hurl the empty cartridge cases over the side of the turret, lest they accumulate and interfere with further loading.

With the advent of the 120mm main gun on the M1A1, the cartridge size, weight, and problem of what to do with empty cartridge cases was resolved by employing a combustible cartridge case made from a nitrocellulose—cardboard impregnated with nitroglycerine. The resulting cartridge case can be smaller and lighter because the combustible cartridge case weighs approximately 10 percent of the total propellant. What remains after firing is a smaller, approximately 10-pound (4.5 kilograms), steel-and-rubber stub base—the base or aft cap, which ejects automatically when the breech opens after firing. The ejected stub base bounces off a deflector tray located at the back of the breech ring into a containment cage on the floor of the turret basket.

A disadvantage with older combustible cartridge cases is that the propellant could be accidentally ignited during loading, with fatal results for the entire crew. This could

happen two ways. First, burning or smoldering residue from the propellant or case could remain in the chamber after firing. When the next cartridge case is loaded, the burning residue would ignite the propellant within the new cartridge while the breech is still open and while the loader's hand was still pushing on the cartridge case. The chemistry of the 120mm ammunition used by the Abrams tank is carefully controlled to avoid burning residue.

The other way propellant accidentally ignites is by flarebacks. Propellant inherently does not contain enough oxygen to burn completely. It stops burning when all the oxygen is gone. The remaining high-temperature propellant gas resumes burning when it contacts the air outside the muzzle. If the bore evacuator—used to clear fumes and smoldering residue from a gun barrel—does not function properly, the propellant gas can flare back into the turret when the breech is opened, possibly igniting the next cartridge case. Clogged bore evacuator ports or a headwind combined with forward motion of the tank can exacerbate this condition. Since this flare lasts only a fraction of a second, loaders are cautioned not to remove the next cartridge case or even open the ammunition magazine doors until after the gun has fired, recoiled, and ejected the stub case. Several accidents have occurred when Abrams loaders have not followed this procedure. In most of these cases, everybody in the tanks died.

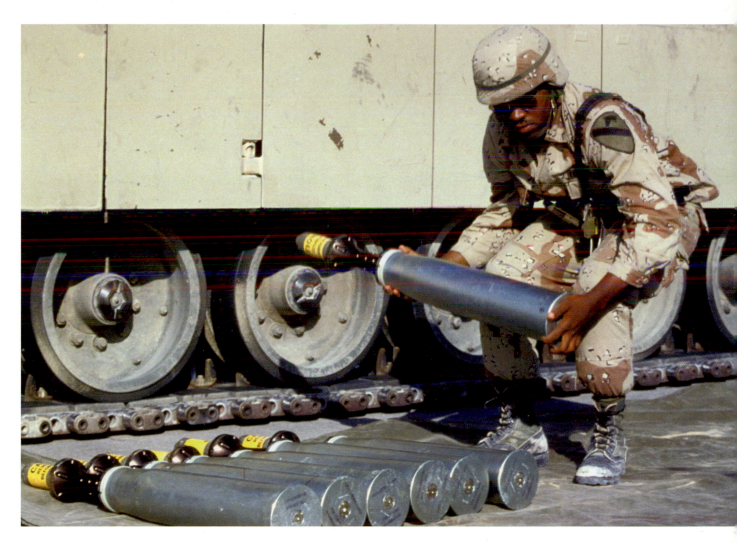

An Abrams tanker carefully picks up a 105mm sabot round. The cartridge case is steel, and the black sabot with the protective cover over the tip of the penetrator identifies it as an armor-defeating round. U.S. Army tankers learn in training that 120mm main gun rounds require great care in handling at all times, since the explosive elements in their primers and fuses are very sensitive to shock and high temperature. *Defense Visual Information Center*

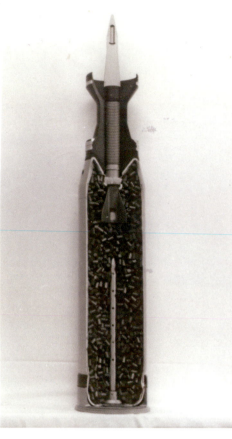

This photograph shows a 120mm main gun sabot round for the Abrams tank on the left and a cutaway example of the same type of ammunition on the right. Visible on the cutaway is the needle-nosed penetrator contained within the sabot that crimps to the top of the cartridge case. Also visible are the aluminum fins on the bottom of the penetrator that stabilize it during flight. At the bottom of the cartridge case, surrounded by propellant, is the igniter tube. *U.S. Army*

Army Major Jim Brown, a retired armor officer, describes the importance of the bore evacuator on main battle tanks such as the Abrams:

A bore evacuator is a chamber set over the tube, which covers several holes through the wall of the tube. The holes are inclined so their inner [bore] ends are closer to the muzzle than are their outer ends. When the projectile passes the holes, some of the propellant gas is vented through the holes and pressurizes the bore evacuator chamber. Once the projectile leaves the tube, the bore returns to near-atmospheric pressure. The gas in the bore evacuator escapes through the holes, whose inclination causes them to have a net velocity toward the muzzle. Their momentum is assisted somewhat by the fact that the propellant gasses already in the bore have an average velocity distribution toward the muzzle. (Gases immediately behind the projectile have the same

velocity as the projectile, while gases near the breech have zero velocity.) The momentum of the gas toward the muzzle leaves a slightly lower pressure between the bore evacuator holes and the chamber. After the breech opens, the momentum entrains airflow from the chamber toward the muzzle. Bore evacuators depend on the breech opening soon after firing, so the momentum can be taken advantage of while the gas column is still moving. The entire action also depends on a relatively high-pressure firing event and a bore with a long length-to-diameter ratio. For these reasons, they are seldom seen on larger caliber tubes with manually operated breeches, such as those on artillery.

Former Abrams TC Don Moriarty describes some of the problems encountered by switching from 105mm gun–armed Abrams tanks to the 120mm gun–equipped Abrams tanks:

Having served on all the Abrams tanks, except for the M1A2 SEP, I consider the differences between the IPM1 and the M1A1 as being the most dramatic. Many of the differences were experienced with the ammunition. In 1988, the 120mm ammo was in its infancy of mass production. To the tank crewman it was not emphasized as being drastically different than the 105mm ammo of the M1. It wasn't emphasized either as being any more dangerous than the 105mm round. Most classes and instructions were in its overall safety, and we were taught not to be afraid of the combustible casing I witnessed an instructor extinguish a burning cigarette on a live 120mm round. His purpose was to reinforce [in our minds] the safety of the new round. This is a perfect example of the misunderstood nature of the new ammunition danger. De-emphasis of safety was commonplace in the early days. After several severe injuries and a few deaths, proper handling and basic respect for the more hazardous 120mm round were instituted.

KE AMMUNITION

The 105mm and 120mm main gun rounds employed on the various versions of the Abrams-series tanks use kinetic-energy (KE) or chemical-energy (CE) armor-piercing (AP) rounds. KE rounds have been the preferred American military choice for killing enemy tanks for the last 30 years because their penetrator is less likely to be deflected and they have greater after-armor effects, that is, lethality.

American World War II KE tank ammunition projectiles generally consisted of a solid hardened-steel shot with a slightly pointed nose that depended on the combination of its weight and striking velocity to penetrate the armor of an enemy armored vehicle. The army classified them as AP shot.

To improve the ability of its AP shot to punch through armor, the army later added a penetrative cap over its nose that helped turn the projectile into the sloping armor of a target, rather than glancing off of it. The cap also spread the load over the point to prevent the projectile from shattering before it could penetrate. This type of round was referred to as an armor-piercing capped (APC).

The follow-up to APC rounds was armor-piercing, capped, ballistic cap (APCBC) rounds. This type of round added a sharply pointed, lightweight nose fairing to reduce air resistance and thereby retain velocity of the pro-

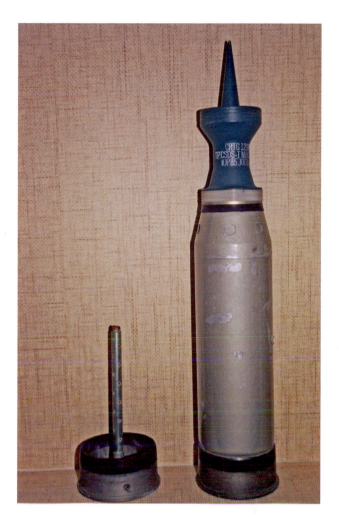

Visible on the right side of this picture is an Abrams tank 120mm main gun sabot training round (inert). To the left is a 120mm main gun round aft cap (also known as the base stub) with its vertical primer element. Part of the cartridge case, the steel and rubber aft cap with the primer, ejects from the breech of the Abrams 120mm main gun after firing, as most of the combustible cartridge case burns up during the process of firing the tank's main gun. *Michael Green*

jectile in flight. Because kinetic energy is proportional to the square of the impact velocity, more speed means improved penetration.

Dissatisfaction with the penetrative abilities of these full-bore steel KE rounds led the army to seek out a harder and denser material to penetrate the thick armor of the German Panther medium tank and the Tiger I and Tiger B heavy tanks produced late in the war.

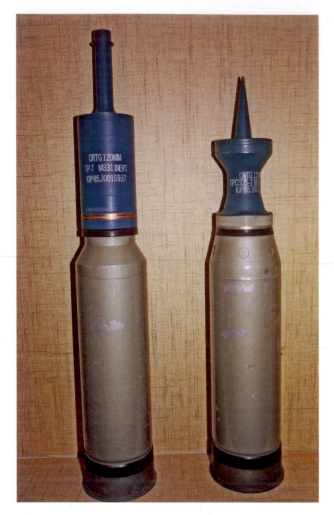

On the right of this picture is an inert example of a 120mm Abrams tank sabot training round designated the M865. To the left of the M865 is an inert high-explosive antitank (HEAT) round designated the M831. Due to their slower muzzle velocity, HEAT rounds are not as accurate as sabot rounds at ranges beyond 2,188 yards (2,000 meters). However, this type of round depends on chemical energy rather than striking velocity, so its ability to penetrate armor is as effective at 4,376 yards (4,000 meters) as it is at 219 yards (200 meters). *Michael Green*

The American military rushed a new KE round into service late in World War II, referred to as hypervelocity armor-piercing (HVAP), or just hyper-shot. In military terminology, it also came to be known as an armor-piercing, composite rigid (APCR) round. It incorporated a sub-caliber core of tungsten carbide—a metal of extremely high density and hardness—centered within a soft, low-density jacket that matched the gun bore. On impact, the soft jacket separated from the sub-caliber core. Because the sub-caliber core was smaller than the full-bore AP, APC, and APCBC rounds, the hyper-shot concentrated its penetrative energy on a smaller area of the target, making it more effective in penetrating armor.

A drawback to hyper-shot was the fact that the sub-caliber core carried its soft jacket all the way to the target. The aerodynamic drag of the jacket and the weight of the projectile caused the projectile to lose velocity during long flights. Despite this shortcoming, hyper-shot remained the American military preference well into the 1950s.

With the introduction of the M68 tank 105mm main gun into American service in the late 1950s, an improved version of hyper-shot called armor-piercing discarding sabot (APDS), or sabot for short, appeared.

The basic principle of the sabot projectile is that it retains a full-bore base area, against which expanding propellant gases push. The pressure (expressed in force per unit area) is multiplied by the base area of the projectile, so we get a force that accelerates the projectile, which consists of a sub-caliber core of tungsten carbide, like that of hyper-shot. However, instead of being centered in a soft jacket that travels to the target, the sub-caliber core is centered in a larger, three-piece, metal-alloy body, called the sabot, that was crimped to the cartridge case. The sabot was made of the lightest possible material (since force divided by mass yields acceleration, the lighter mass projectile gets more acceleration). Immediately after an APDS round left the muzzle of the gun tube, the multi-piece sabot would fall away, and the sub-caliber core would continue downrange to the target.

The sabot round was a win-win situation, because the design retained the largest possible base area for propellant gasses to work against, gave the lightest possible accelerated mass, reduced aerodynamic drag, and concentrated the available kinetic energy into a small area of the target. The sabot design also allows the cannon to retain the ability to fire HEAT and other types of ammunition whose inherent designs favor large bore sizes. Because of its discarding parts, sabot projectiles are unsafe to fire near friendly troops forward of a tank.

The American-designed KE sabot round was improved in the early 1970s by adding six aluminum-alloy fins, located at the rear of the sub-caliber projectile, to stabilize it in flight. The designation therefore became armor-piercing, fin-stabilized discarding sabot (APFSDS).

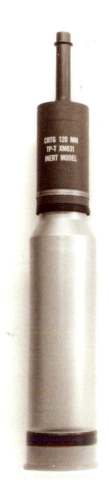

Posed together are a 120mm main gun high-explosive anti-tank (HEAT) round and its cut-away counterpart. At the very tip of the round is the flat, full-frontal impact-switch assembly. Because shaped-charged warheads must detonate away from a target at a certain distance to allow their jet stream to form properly, the impact-switch assembly sits at the end of a standoff spike. *U.S. Army*

APFSDS came into use because longer length-to-diameter (L/D) ratios were found to give even better areal energy density (energy per unit area of the hole they made). However, because of the lower axial mass moment of inertia inherent in the longer L/D projectiles, they could no longer be spin stabilized. The logical improvement was to add stabilizing fins—this led to a breakthrough in tank gun design. Centrifugal force associated with spin stabilization degrades the performance of HEAT projectiles, and the rifling process adds stress concentration points in the bore surface. Since neither fin-stabilized, high-L/D kinetic-energy projectiles nor fin-stabilized HEAT projectiles need rifling, it was possible to employ smooth-bore tank guns.

Rifling was retained in the 105mm M68 because NATO standardization agreements (STANAGS), which were intended to guarantee ammunition and gun-tube interchangeability among all NATO tanks of the era, bound its design. Several NATO countries continued to use high-explosive plastic (HEP) ammunition, which the British army refers to as high-explosive squash head (HESH), white phosphorus (WP), and antipersonnel (APERS), all of which are shorter L/D projectiles that require spin stabilization.

Major Jim Brown (retired) adds an example regarding areal energy density:

I used the following example to teach West Point cadets the underlying principle of areal energy density. Suppose you have two identical slugs of penetrator material. Fashion one into a coin-shaped disk and the other into a nail. Give each an equal amount of energy (one hammer full). Which one penetrates farther into a board? Although both transmit the same amount of kinetic energy into the board, the nail penetrates deeper because its energy is concentrated over a smaller area.

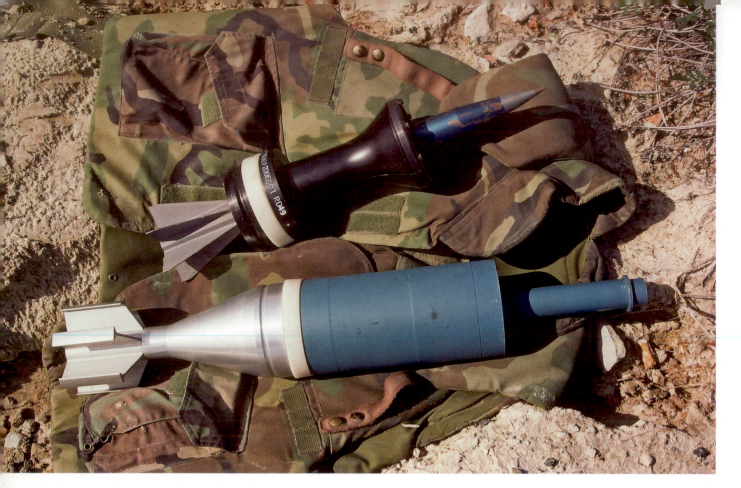

Visible are training examples of the 105mm armor-piercing, fin-stabilized discarding sabot (APFSDS) at the top and a 105mm high-explosive antitank (HEAT) round at the bottom. The fins on the end of the projectiles reflect the switch from spin-stabilized tank ammunition to fin-stabilized tank ammunition. *Greg Stewart*

In the late 1970s, the American military began using depleted uranium (DU) alloy in its sub-caliber KE projectiles in place of the tungsten alloy used until that time. DU is a uranium byproduct that has undergone a process to remove the material useful for nuclear rector fuel and nuclear weapons. Since it is a very dense, hard, and tough material, it makes the perfect KE projectile.

Modern KE rounds composed of DU incorporate velocity (the speed of the projectile in flight), mass, hardness, and length of a depleted uranium penetrator to punch through modern tank armor. The impact heats the uranium to several thousand degrees as it pushes its way through the armor. The longer the penetrator, the more armor it can defeat as it is consumed and shattered during the process of penetrating armor. If the penetrator successfully defeats the tank's armor, fragments of the tank's own armor and burning fragments from the penetrator push into the vehicle's interior at high velocity. This has a disastrous effect on the crew and interior equipment of tanks struck by these rounds.

The first U.S. Army DU-equipped 105mm KE tank-killing round appeared in 1982 and was designated the M774. It had better long-range armor penetration performance than the tungsten-alloy KE projectiles. Because the Soviet military continually improved the armor-protection levels on its tanks, the U.S. Army in turn developed new and deadlier tank-killing KE main gun rounds.

In 1983, the American military fielded a new DU-equipped 105mm KE round designated the M833. Some sources claimed that the M833 could punch a hole through 16.8 inches (420 millimeters) of steel armor. The M833 was eventually replaced by another even more potent DU 105mm KE projectile: M900. When it first appeared in service, the M900 round quickly acquired the nickname as the 105mm Magnum round. Due to its propellant power, only the most recently produced 105mm gun tubes could fire it.

Only one type of DU-equipped KE sabot round, the M829 APFSDS-T, is currently available for 120mm main gun–equipped Abrams tanks. The "T" suffix stands for

tracer, an element inserted in the base of a projectile that burns during flight and allows the gunner and tank commander to observe the projectile's trajectory and impact. Tracer elements have been standard on most tank main gun ammunition since World War II.

During the first Gulf War in 1991, M1A1 tankers began referring to the M829A1 (an improved version of the M829 DU round) as the silver bullet because of its destructive abilities against Iraqi tanks. In one incident, an M829A1 DU projectile punched a hole all the way through one Iraqi T72 main battle tank and went out the other side to destroy another T72 located nearby.

Following the M829A1 APFSDS-T into American military service was the M829A2 APFSDS-T. It first appeared in American military service in 1998. It features a longer and heavier DU penetrator than that found on the M829A1. In addition, the M829A2 employs something the manufacturer, Primex Technologies' Ordnance and Tactical Systems Division, refers to as Super DU, which is manufactured in a process that greatly improves its already highly destructive properties. The M829A2 also comes with an enhanced high-density, conventional propulsion system using JA2 propellant and a new graphite composite sabot.

The most controversial aspect of DU is that uranium metal oxidizes at very high temperatures to form uranium hexaoxide (chemical formula UO_6), a gas. Formation of UO_6 is an extremely exothermic burning process called

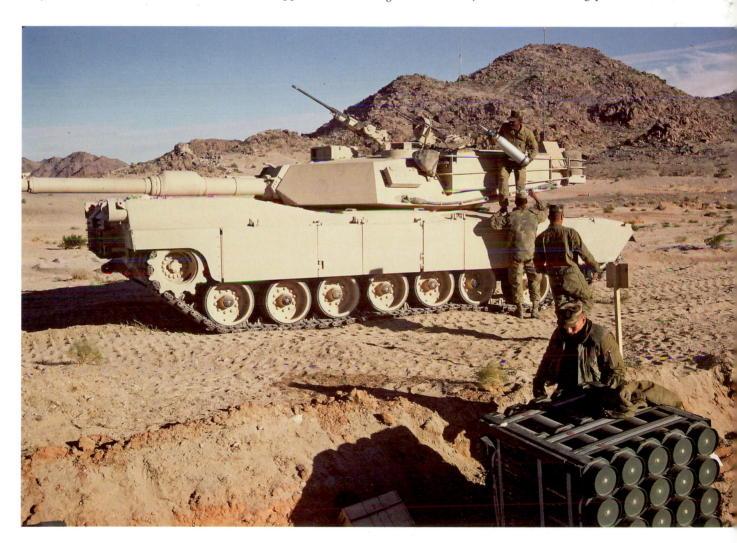

Marine Corps tankers load their M1A1 tank with sabot training rounds from an ammunition storage site. Since the effectiveness of sabot rounds depends on the density of the target surface being engaged, Abrams tankers learn in training to shoot at the flanks or rear of enemy tanks, where the armor is less dense, whenever possible. *Greg Stewart*

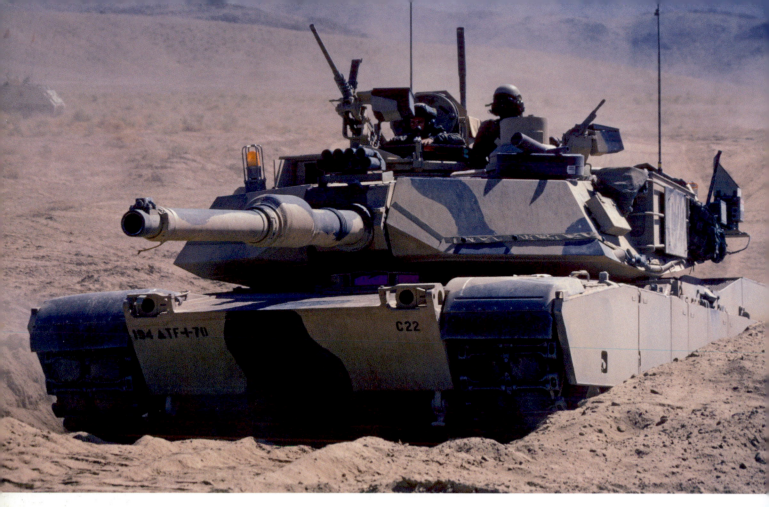

The crew of a U.S. Army M1A2 tank has taken a hull-down position during a training exercise. This is a favorite position of all Abrams tankers during defensive operations, as it helps to conceal and protect the vehicle's hull but still permits main gun direct fire. When not firing, but observing or acquiring possible targets, the Abrams tank takes a turret-down position that conceals most of the vehicle but leaves the tank commander station exposed so he has the ability to see the battlefield. *Greg Stewart*

pyrophoresis, which turns the region behind the penetration site into a fireball. Since uranium hexaoxide is a gas, it has the potential to carry metallic uranium atoms into the lungs. Any macroscopic fragments of uranium also pose a heavy-metal hazard (like lead, mercury, or cadmium).

The M829A3 APFSDS-T round was approved for series production in 2002. Because of its higher energy propellant, it offers Abrams tankers significantly greater lethality at extended ranges beyond that provided by the earlier versions of the M829 APFSDS-T round. According to Lieutenant Colonel Dave Rice, product manager, at Large Caliber Ammunition Systems, "The M829A3 is a new hot-to-go munition that significantly enhances the ability of the Abrams armored force to engage and decisively defeat the most challenging targets that we could face today." According to the army, the A3 version of the M829 round will defeat the latest generation of explosive

reactive armor (ERA) found on some foreign tank designs that are specifically designed to defeat modern KE projectiles.

CE AMMUNITION

The chemical energy (CE) rounds currently in use with the 120mm main gun-equipped versions of the Abrams tank series are referred to as high-explosive antitank, or HEAT. Their intended targets are lightly armored targets, field fortifications, and personnel. The two types of available 105mm HEAT rounds are the M456A1 HEAT-T and the M456A2 HEAT-T.

A typical HEAT round utilizes a shaped explosive contained in a steel case with a copper-lined conical cavity at the front of the detonating charge. This hollow space directs the force of the explosion forward toward the target. Protruding in front of the projectile is a steel spike,

or standoff tube, that allows the explosive to be detonated just before the body of the projectile impacts the target. This feature gives the exploding shaped-charge time to form into a jet of superheated metal and gas capable of burning through the target armor.

The 120mm gun–armed versions of the Abrams use the M830 HEAT-MP-T round and the newer M830A1 HEAT-MP-T round—MP standing for multipurpose. The M830 HEAT-MP-T round goes by the term HEAT in tank fire commands, while tankers refer to the M830A1 round during fire commands as the MPAT—AT standing for antitank. Despite a designation that makes the M830A1 sound like a product improvement version of the M830, they are two completely different types of main gun rounds.

The M830 HEAT-MP-T is the preferred main gun round for use in urban combat settings in Iraq for both the marines and the army. It does very well when engaging enemy combatants located in buildings or hiding behind walls. Supposedly, HEAT rounds need at least 98.4 feet (30 meters) to properly arm after leaving their gun tubes. Abrams tankers fighting in Iraqi urban centers have often found themselves engaging enemy combatants at ranges of less than the required distance with their HEAT rounds and finding that they have still had great killing power due to the combination of their explosive punch and overpressure.

The MPAT round earned its multipurpose designation because its high-explosive warhead comes equipped with a proximity fuse, allowing it to be fired in either air or ground mode. When used against lightly armored ground targets, the fuse is set to ground (contact) mode and announced in fire commands simply as "MPAT." When employed against an aerial target, such as a hovering or slow-moving helicopter, the TC or gunner will announce "MPAT air" to inform the vehicle's loader to set the round's proximity fuse. Once the round is loaded, the loader announces "Air up." The Abrams tank is unable to engage faster-moving aerial targets because of its fire-control system's limited ability to induce the correct lead angle for a moving target and still keep both the target and reticle in the gunner's field of view.

In Iraq, the MPAT rounds see employment in a manner very similar to the HEAT rounds. While the MPAT round is supposed to have an antipersonnel role, some Marine Corps tankers in Iraq found that it was not as effective as was hoped for when engaging enemy combatants. This is due to the physical characteristics of all

Taken inside an early Abrams tank turret simulator, this picture shows the seating arrangement between the tank commander and the gunner. Abrams crews use a standard terminology to speed up target engagement. Unarmored vehicles are called trucks, while armored personnel carriers are PCs. Helicopters are called choppers and enemy personnel are troops. *Michael Green*

shaped charged warheads, which tend to be very concentrated in their destructive effects.

Army National Guard Lieutenant Nicholas Moran talks about another disadvantage with the MPAT round:

While HEAT is a shaped-charged round like MPAT, the fact that MPAT is a saboted round means that you had to be a little bit more careful about people being near the line of fire. HEAT has no sabot, so it's just one projectile. With MPAT, you've got the one big projectile, and three little ones that go anywhere Newton decides.

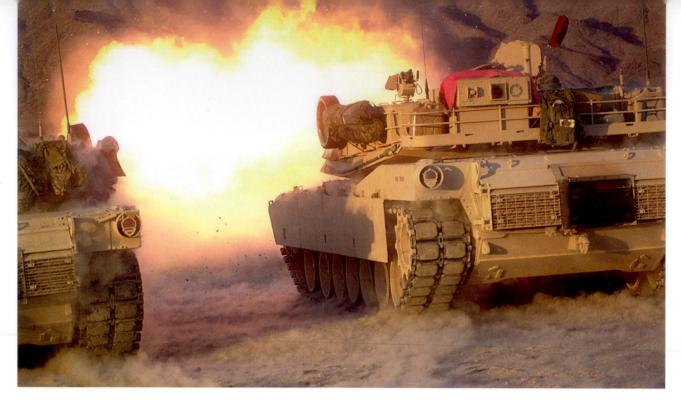

A Marine Corps M1A1 tank fires upon a target at a training range. Abrams tankers often use battle carry in combat situations because it's the most rapid method of engaging an enemy target. Battle carry gunnery consists of a pre-loaded round in the tank's main gun, with the ammunition select switch set for the type of round loaded, and a specific range applied to the vehicle's fire-control computer. The correct sight reticle must also be set prior to going into action with battle carry. *Corporal Allan J. Grdovich*

The 105mm main gun–armed Abrams tanks have a round called the M494 antipersonnel-tracer (APERS-T). It bears the official nickname Beehive and contains 5,000 finned steel sub-projectiles (flechettes) that disperse in a precise pattern, set manually in the fuse by the tank's loader, for any range between 656 and 1,312 feet (200 and 4,000 meters), even immediately outside the muzzle. The fire command for this use is "Beehive," while "Beehive Time" tells the loader to set the fuse, calibrated in meters, to the range announced in the fire command.

Until recently, there has not been a dedicated antipersonnel round for the various 120mm main gun–equipped versions of the Abrams. However, that changed in January 2005, when the army awarded General Dynamics Ordnance and Tactical Systems a $5.8 million contract for low-rate initial production of 3,600 M1028 120mm antipersonnel canister cartridges.

The new blunt-nosed M1028 round contains more than 1,000 tungsten balls, which hurl out from the muzzle of a 120mm main gun in a shotgun-like pattern, similar to that of the old canister ammunition of previous generations. According to a General Dynamics Ordnance and Tactical Systems press release, the new round "can

be used to clear enemy dismounts, break up hasty ambush sites in urban areas, clear defiles, stop infantry attacks and counterattacks, and support friendly infantry assaults by providing cover-by-fire."

ANTI-BUNKER AMMUNITION

The army withdrew the M728 combat engineer vehicle, based on an M60 series chassis, from service in the late 1990s. Its departure left the army's combat engineers without a means to destroy obstacles such as concrete bunkers and walls since the 165mm main gun on the vehicle fired a specially-designed 35-pound (15.9 kilogram), high-explosive demolition round—M123.

To take over the role once performed by the M123 demolition round, the army modified a version of its MPAT round to perform the same function. The high-explosive obstacle-reducing tracer (HE-OR-T) round looks very similar to the existing MPAT round. Many tankers have taken to calling it the MPAT-OR round.

In place of the proximity nose switch on the MPAT, the HE-OR-T round has a hard, steel, nose cone that allows it to penetrate deep within a concrete obstacle be-

fore the warhead detonates, resulting in concrete breaking up from the inside out. This has proved far more successful than large explosive charges placed on the exterior of concrete obstacles.

The disadvantage of the HE-OR-T round, as discovered by some units during the fighting in Iraq, is that it makes a smaller breach (hole) in buildings than the M830 HEAT-MP-T round and often penetrates through several buildings before detonating. This becomes a serious safety issue when American units are engaged in combat operations in an urban area. Within Marine Corps tank units in Iraq, the crews of the Abrams tanks often use their sup-

ply of HE-OR-T rounds early during their offensive operations. They save their M830 HEAT-MP-T rounds for the bulk of actual fighting in an urban area.

This is not to say that there is no need for the HE-OR-T round. Some Marine Corps TCs in Iraq believe there remains a need for the HE-OR-T round to be used against reinforced concrete buildings. Non-reinforced concrete is common in many buildings in Iraq.

According to Army Colonel Pat White of the 1st Armored Division, who wrote an article in the November–December 2004 issue of *Armor* magazine titled "Task Force Iron Duke's Campaign for Najaf:"

A Marine Corps M1A1 tank fires its 120mm main gun into a building that marines received fire from during a firefight in Fallujah, Iraq, in support of Operation al Fajr (New Dawn) on December 10, 2004. The tank pictured belongs to 2nd Tank Battalion. In urban fighting, tank-mounted machine guns can deliver fire around corners by ricocheting it from buildings, walls, or streets. Notice in this picture the improvised armored gun shield fitted to the loader's roof-mounted machine gun. *Lance Corporal James J. Vooris*

Two U.S. Army M1A2 Abrams crewmembers from Alpha Company 1st Battalion, 12th Cavalry Regiment, based in Iraq in 2004, remove a brand new gunner's primary sight (GPS) from the shipping container in which it arrived. The GPS is the primary optical device for all the Abrams-series tanks and includes a day channel and a thermal channel. It allows the gunner to control the ranging and sighting of the tank's main gun and coax.
Sergeant Dan Purcell

The most precise weapons system in the task force was the M1A1 tank Tank commanders learned early on that firing a multipurpose antitank (MPAT) round, a high-explosive antitank (HEAT) round, or an obstacle-reducing (OR) round immediately silenced enemy massed formations due to tremendous psychological effects. A tank can fire a main gun round through a window and destroy the enemy while damaging only one room, minimizing collateral damage. Tanks can also create entry points for scouts or infantry by firing a main gun round into the wall of a school or directly into the side of a building. OR and MPAT rounds are effective in destroying hasty obstacles, and the task force even used the MPAT rounds to suppress enemy dismounts on the street.

RIFLED AND SMOOTHBORE MAIN GUNS

Most modern guns utilize rifling to stabilize a projectile in flight. These spiraling grooves cut into the bore of the gun tube or barrel give the projectile its spin. On large-caliber guns, a rotating soft metal band on the projectile engages the rifling as it moves down the bore. This rotating band also seals expanding propellant gases behind it.

Once a projectile leaves the muzzle of a gun, it is the spin imparted to it by the rifling in the gun tube that keeps it aimed at the target. Without that spin, a projectile would tumble erratically. Quarterbacks improve the accuracy of their footballs, shaped to cut down both wind and air resistance, by making the ball spin; that's what rifling does to a projectile.

Despite having developed experimental smoothbore tank main guns during the 1950s, the first production American tank armed with a smoothbore main gun was the M1A1 Abrams in the late 1980s. Smoothbore tank guns have some advantages over rifled tank guns. They can withstand higher pressure, are cheaper to build, and do not wear out as quickly. Given the same explosive charge, the muzzle velocity of a smoothbore gun is higher because it doesn't waste energy to engrave the rotating bands and to spin the projectile as in a rifled tank gun.

Because modern tank-gun projectiles are fin stabilized, they do not need to spin in flight. In fact, spin would curtail the armor-penetrating capabilities of both KE and CE projectiles. Instead of rotating bands, fin-stabilized projectiles utilize slipping bands that prevent the projectiles from spinning when fired from rifled gun tubes. The 105mm gun tube on the original M1 and the IPM1 were rifled.

A rubber seal, called the obturator seal, prevents the gases generated during firing from leaking in front of fin-stabilized projectiles as they accelerate down a rifled barrel. Obturator seals also appear on all types of fin-stabilized ammunition used by the main gun–equipped versions of the Abrams tank series.

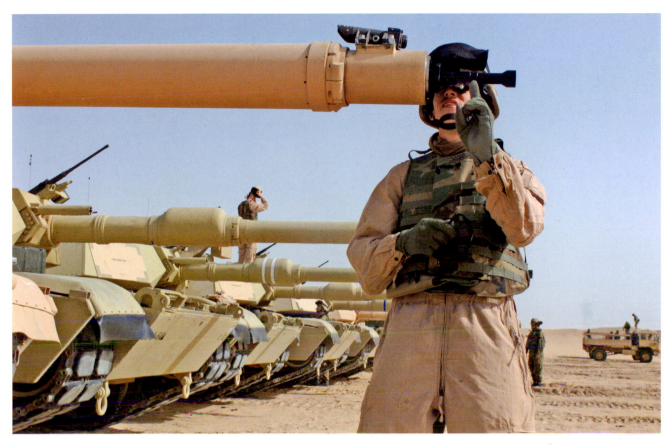

In tank gunnery, firing with any chance of success is impossible without an accurate sight alignment. For this reason, bore sighting is of the utmost importance in tank gunnery. It provides a basis for all tank sight alignment and sets up a definite relationship between the axis of the gun tube bore and the tank's sights at zero super elevation. The U.S. Army tanker in this photograph is using a muzzle bore sight device to line up his gun tube with his optical sighting devices.
U.S. Army

FIRE-CONTROL SYSTEM

Having the most powerful tank main gun and the deadliest ammunition in the world means little without the ability of a tank crew to effectively acquire, track, and engage enemy targets under a variety of conditions. To accomplish these tasks, tanks are fitted with fire-control systems. A key component of every modern tank fire-control system is the sighting systems that allow the gunner and the TC to visually acquire a target.

The main optical sighting instrument on the Abrams series is the gunner's primary sight (GPS), not to be confused with global positioning system (which shares the acronym), which is electromechanically linked to the main gun in both elevation and azimuth. It also has an extension for the TC called the gunner's primary sight extension (GPSE) that physically attaches to the gunner's sight.

The exterior portion of the GPS protrudes through the roof of the Abrams turret in front of the CWS. Protection for the upper portion of the GPS comes from an armored enclosure referred to by Abrams tank crews as the doghouse. The doghouse contains the independently stabilized head mirror that is the breakthrough technology that enables the Abrams to fire so accurately on the move. Two small armored doors at the front of the doghouse protect the sight mirrors from harm. The gunner can open and close the armored doors by using a set of small handles located just above the GPS.

In case of GPS failure, the gunner can use a backup (auxiliary) optical sight on the right side of the main gun mount just below the coax machine gun. The auxiliary sight is an articulated telescope whose objective lens moves with the gun mount, but whose eyepiece remains

nearly fixed with respect to the gunner's eye. This allows even the auxiliary sight to be used on the move. The small exterior opening for the gunner's auxiliary sight is visible just below the coax machine gun flash hider on the front of Abrams tanks.

Aiming points for the gunner appear as an aiming dot within a circle in the optical image of the GPS. The aiming points superimposed within the sighting system are called a reticle. In the past, the reticles were etched onto a glass plate; the auxiliary sight still is. With modern optical sighting devices such as those found on the Abrams

series, they appear in the optical path by way of a small projector.

A number of fire-control issues can throw off the accuracy of a tank main gun during firing. These include design tolerances, metal fatigue, and vehicle vibrations. The fire-control system on the Abrams tank series can compensate for such conditions as thermal bending caused by uneven heat distribution along the gun tube. On the 105mm and 120mm main gun–armed versions of the Abrams tank, a thermal shroud affixes to the outside of the gun tube and reduces the uneven heat distri-

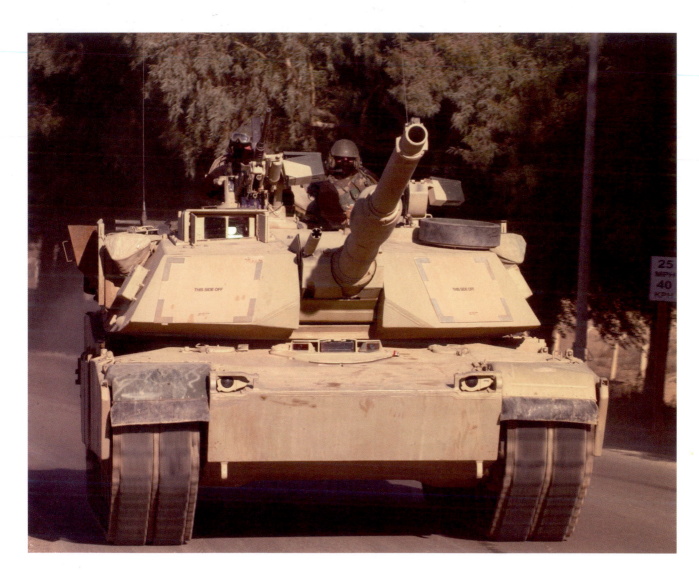

In a head-on view of an M1A1 tank, the small exterior armored doors on the gunner's primary sight (GPS) appear in the open position. The gunner's recticle (aiming point) visible in his sight picture of the GPS remains in the center of his picture without any recticle offset, while the tank's fire-control system inputs ballistic solutions for engaging enemy targets. *Michael Green*

On the M1 tank shown, the small exterior doors on the upper portion of the gunner's primary sight (GPS) are closed. The GPS is nicknamed the doghouse by Abrams tankers. The Abrams' fire-control system has a great deal of redundancy to provide for survivability and fightability through alternate modes of operation if the primary system suffers damage.
Michael Green

bution. Army Major Jim Brown (retired armor officer) describes the importance of the thermal shroud on tank main guns:

> When I was testing optical bore sights for the 105mm gun at the Armor and Engineer Board in the late 1970s I had occasion to observe the practical effect of uneven heat distribution on an unshrouded tube. One day we were doing an extended firing test to determine how well the tanks held bore sight during firing. A Kentucky summer thunderstorm hit while I had a muzzle bore sight in the tube, and I was able to see the bore sight move as the top surface of the tube was cooled by the rain.

The fire-control system on the Abrams tank series also accounts for propellant temperature, tube wear, air tem-

perature, wind speed and direction, cant, and angle of site, in addition to motion imparted by a moving target and/or the moving Abrams. The resulting ballistic solution makes the Abrams tank more accurate than a sniper rifle at ranges greater than about 1,313 yards (1,200 meters).

THERMAL SIGHTS

A key part of the Abrams' GPS is the thermal imaging sight (TIS), which presents on a monitor an image based on small outside temperature differences. In simple terms, it sees the heat produced by objects, rather than the objects themselves. On the battlefield, soldiers and tanks intent on destroying the Abrams tank normally produce more heat than the greenery, rocks, and buildings around them. For this reason, warm-bodied soldiers and their vehicles stand out in the TIS in contrast to their colder surroundings.

This overhead picture of an M1 tank shows the skate rail surrounding the loader's hatch, on which the mount for a 7.92mm M240 machine gun attaches. Visible in the center of the loader's open hatch is the bottom portion of a 10-inch-wide adjustable periscope, which is interchangeable with the driver's center-vision periscope. *Michael Green*

Vehicles have internal temperature variations that form visible patterns. In the TIS, the shapes of the hottest vehicle parts, such as engines and exhausts, appear the brightest. Objects with a moderate temperature, such as warm tank tracks, appear slightly dimmer. Objects with a cooler temperature, such as the hull of a tank, appear black. A well-trained Abrams gunner or TC can use the TIS to determine from engine and exhaust cues whether the vehicle they are observing is a tank or a truck, whether it's a front-engine or rear-engine vehicle, and whether it's making evasive maneuvers.

The earlier versions of the Abrams series were limited to 3-power or 10-power magnification, due to the limited resolution of the thermal detectors in use at the time. Experience gained during the first Gulf War showed that the maximum effective range of the ammunition fired from the 120mm main gun on the M1A1 far exceeded the ability of the crew to positively identify a target with the existing TIS.

To rectify this shortcoming, the TIS on the SEP is capable of 3-power, 6-power, 13-power, 25-power, and 50-power magnification. New thermal detector technology is responsible for both the improved magnification and better image resolution.

Unlike the passive optical sights used by Iraqi tanks in both the first and second Gulf Wars—which can be degraded or blinded by smoke, fog, dust, rain, haze, light vegetation, camouflage netting, and other conditions—the Abrams TIS can clearly identify soldiers and vehicles through a wide variety of visual conditions. The superior effectiveness of the TIS in both daytime and nighttime environments has made it the main sighting instrument for Abrams crews.

Despite the many advantages the TIS provides to Abrams tankers, it is not infallible. The Russian army has developed thermal countermeasures to defeat it, as have other armies around the globe. A thermal-defeating smoke throws up clouds of heated particles that can block the transmission of thermal energy. The setting of fires all over a battlefield is another effective countermeasure to TIS. These fires create hot spots, which obscure targets by raising the background heat level and forcing the TIS to go into saturation.

CITV

Long before the first Abrams tanks entered service, the army had hoped to incorporate a second thermal imag-

The vehicle commander of an M1A1 tank pauses during a training exercise. The .50-caliber machine gun mounted at his position is effective against a wide range of targets, including enemy infantry using small trees, hastily built barricades, and even lightly constructed buildings as cover. *Michael Green*

ing sight into the CWS. In official military jargon, it became the commander's independent thermal viewer (CITV). In an effort to keep vehicle costs down, the army did not incorporate it into the first Abrams design. A CITV did not appear on a version of the Abrams series until the start of M1A2 production; it also appears on the SEP.

The CITV on the M1A2 and SEP is located in front of the loader's hatch and is enclosed under a rotating armored housing. It provides the TC an almost 360-degree view of the battlefield in all weather and lighting conditions.

By definition, the CITV is completely independent of the gunner's TIS. This allows the TC to search for new targets while the gunner engages an active target and prepares to fire. As soon as an M1A2 or SEP gunner fires the

tank's main gun, the TC can provide a new target to the fire-control system with the press of a button. The gunner can immediately acquire this new target and fire while the TC looks for additional targets. This feature allows M1A2 and SEP crews to engage sequential targets about 40 percent faster than M1A1 crews. In case of damage to the GPS, the TC, using the CITV as a backup sight, can also fire the main gun.

RANGE FINDING

Once the crew has acquired a target by using a tank's sighting system, the range to the target must be determined. If the target is very close, a visual estimate is normally

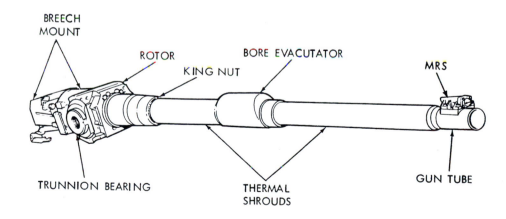

BREECH MOUNT

ROTOR

KING NUT

BORE EVACUATOR

MRS

TRUNNION BEARING

THERMAL SHROUDS

GUN TUBE

120mm, M256 Main Gun and Mount

Key components of the 120mm M256 main gun and mount appear in this line drawing. The smooth-bore gun tube fits into a concentric hydro-spring recoil mechanism and comes with a sliding-wedge breech-block. It's equipped with a bore evacuator and thermal shrouds and is electrically fired. The ejection of the stub case from the breech is automatic and supplied by recoil energy.

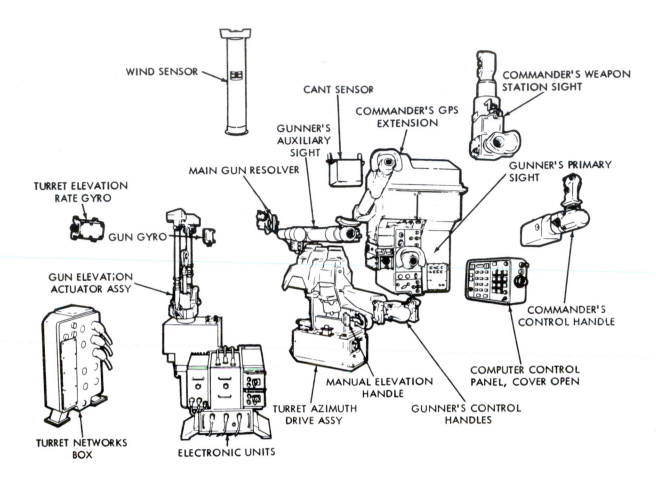

WIND SENSOR

CANT SENSOR

COMMANDER'S WEAPON
STATION SIGHT

COMMANDER'S GPS
EXTENSION

GUNNER'S
AUXILIARY
SIGHT

MAIN GUN RESOLVER

GUNNER'S PRIMARY
SIGHT

TURRET ELEVATION
RATE GYRO

GUN GYRO

GUN ELEVATION
ACTUATOR ASSY

COMMANDER'S
CONTROL HANDLE

COMPUTER CONTROL
PANEL, COVER OPEN

MANUAL ELEVATION
HANDLE

GUNNER'S CONTROL
HANDLES

TURRET AZIMUTH
DRIVE ASSY

TURRET NETWORKS
BOX

ELECTRONIC UNITS

Fire Control System Components

A line drawing illustrates the components that make up the M1A1 tank's fire-control system, which consists of all the equipment provided for target sighting, ranging, aiming, and firing the tank's 120mm main gun and the vehicle's various machine guns.

adequate. For a distant target, an accurate measurement of range is crucial to aiming accuracy. An increase in range increases the time of flight of a projectile, which amplifies the effects of gravity, air resistance, wind, and other factors on the trajectory.

The effects of gravity are well known and predictable. Depending on the range and elevation of a target, a fire-control computer in the Abrams series automatically elevates the main gun barrel of the tank to a firing angle higher than the direct line of sight to the target. The military refers to this as super-elevation. When engaging targets at a greater height than the shooter, the super-elevation angle naturally increases. Super-elevation also

depends on muzzle velocity. HEAT projectiles have a lower muzzle velocity than sabot projectiles, so they require more super-elevation. Sabot projectiles have relatively flat trajectories and do not need as much super-elevation.

During World War II, the gunner and TC of American tanks estimated the range to a target by using the ballistic reticles in their optical sights. The range lines of these reticles added the super-elevation. The gunner's auxiliary sight also had a ballistic reticle that allowed him to add super-elevation in the event the full fire-control solution could not be implemented in the tank's primary sight. This method of acquiring, tracking, and firing at

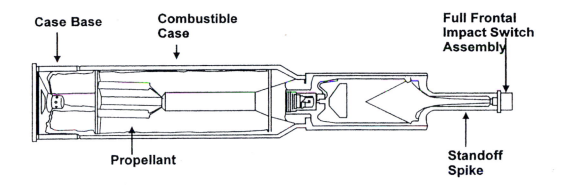

Case Base Combustible Case Full Frontal Impact Switch Assembly Propellant Standoff Spike

Muzzle Velocity:	1,140 m/s.
Announced in fire command as:	"HEAT."
Fuze:	Point-initiating, base-detonating and full frontal area impact switch.
Employment:	Light-armored targets and field fortifications. Secondary round for tanks or tank-like targets.
Color Code:	Black with yellow letters.
Weight:	53.4 lbs.
Length:	38.6 in.

A line drawing depicts an M830 HEAT-MP-T 120mm main gun round for use on the M1A1, M1A2, and M1A2 SEP. The primary damage mechanism of a HEAT projectile striking a tank is heat transfer and dynamic erosion of the target material by the molten jet. After perforation is achieved, melted armor material may be entrained and carried through the hole to produce further damage.

targets resulted in a lot of main gun ammunition going downrange before a successful hit. It took the typical tank gunner at least three rounds before he could successfully engage targets at ranges of more than a few hundred yards. More experienced gunners could sometimes hit targets with only two rounds. Some gunners could hit nearby targets with one round.

From the early 1950s through the 1970s, tanks relied on turret-mounted optical rangefinders. These instruments yielded measurements that were better than estimates,

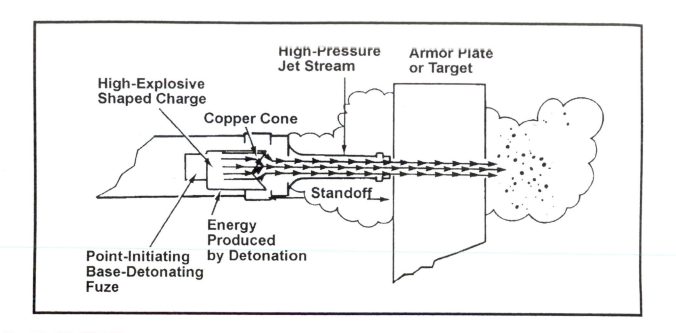

A line drawing illustrates what happens when a HEAT main gun tank round strikes a target. As the fuse becomes activated by inertia (setback forces), it detonates the high-explosive shaped charge. Because the body of the projectile, except towards the front, restricts the energy produced by detonation of the shaped charge, it will seek the path of least resistance (the front). This energy (pressure) is refracted by the copper cone and at the point of intersection is focused, forming the reinforced high-pressure jet stream necessary to produce the desired effect on the chosen target.

but they were still inaccurate at long ranges and were almost useless in dark conditions, bad weather, and dusty or smoky environments.

Even worse, the nature of a coincidence rangefinder, which relies on measuring the parallax of a target scene as viewed from two ends of a baseline, means that the resulting range estimate is quite accurate at close range (where precise range estimation is not critical) and is progressively poorer at long ranges, where range information is critical to a first-round hit.

When affordable commercial lasers became available, the army mounted laser rangefinders on its tanks, beginning with the M60A2 main battle tank. Laser rangefinders work by emitting a narrow beam of coherent laser light at a target, which emerges in precise phase synchronization. This synchronization allows the beam to propagate without internal interference, which would result in wave cancellation and loss of beam intensity. This simple property is what allows a low-power device, such as a laser-pointer, to project a spot for many hundreds of

yards/meters and still retain enough beam intensity to be visible to the unaided eye.

When the laser light strikes a target, some of the light reflects back to the source. The laser rangefinder bases a range distance calculation on the time it takes the laser beam to travel to the target and return to a sensor on the rangefinder.

The laser rangefinder (LRF) on the Abrams series integrates into the GPS for relative target ranging. Range calculations are displayed superimposed on the TC's and gunner's optical sight pictures. While the LRF on the Abrams can accurately range objects to almost 8,752 yards (8,000 meters), the tank's digital fire-control computer, however, can only compensate for firing data out to 4,376 yards (4,000 meters). Abrams tankers can still successfully engage targets beyond 4,000 meters; it just takes longer to aim and fire the main gun.

Should the LRF fail, the TC can enter battle range (a predetermined sight setting) and make any changes to the battle range by means of a toggle switch and the GPS eyepiece range readout. The default battle range, which can

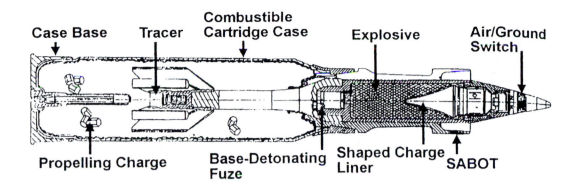

Case Base Tracer Combustible Cartridge Case Explosive Air/Ground Switch

Propelling Charge Base-Detonating Fuze Shaped Charge Liner SABOT

Muzzle Velocity:	1,410 m/s.
Announced in fire command as:	"MPAT" (ground mode). "MPAT AIR" (air mode).
Fuze:	Point-initiating, base-detonating (ground mode). Proximity or point-initiating, base-detonating (air mode).
Employment:	**MPAT GROUND:** Light-armored vehicles, buildings, bunkers, ATGM platforms, and personnel. Secondary round for tank or tank-like targets. **MPAT AIR:** Helicopters.
Color Code:	Black with yellow letters.
Weight:	50.1 lbs.
Length:	38.74 in.

The various parts of an M830A1 HEAT-MP-T 120mm main gun round are shown in this line drawing. The fuse in the head of this round can be set for ground and aerial targets. This provides Abrams tanks, which are equipped with a 120mm main gun, the ability to engage and destroy enemy helicopters (especially gunships) at ranges far beyond that of their on-board machine guns.

be changed by the crew to adapt to current conditions, is intended to provide a trajectory whose highest point never rises above the height of the intended target. When firing a purely battle-range engagement, the gunner aims at the middle of the target. The gunner can also manually enter the estimated range to a target on the digital fire-control-computer control panel. When a partial or complete fire-control solution is available, the point of

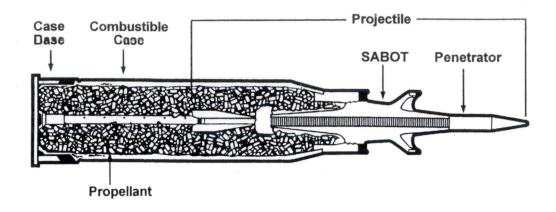

Case Base — Combustible Case — Projectile — SABOT — Penetrator — Propellant

Muzzle Velocity:	1,670 m/s.
Penetrator Composition:	Depleted uraniumn.
Announced in fire command as:	"SABOT" (pronounced SAY-BO).
Fuze:	None.
Employment:	Tank or tank-like targets.
Color Code:	Black with white letters.
Weight:	43.0 lbs.
Length:	36.8 in.

A line drawing displays the various component parts that make up the M829 APFSDS-T 120mm main gun round. This was the original main gun round developed for the M1A1 tank. American tank main gun ammunition can be identified by its shape, color code with markings, and location prescribed by the tank's stowage plan. *U.S. Army*

aim for the gunner and tank commander will always be the center of the target's visible mass.

SECONDARY WEAPONS

All Abrams tanks feature three machine guns in addition to the main gun. These weapons are primarily for use against targets that do not warrant the use of a main gun round. The targets can range from personnel to light armored vehicles and aircraft.

Abrams tanks normally mount two 7.62mm M240 machine guns (American-built versions of a Belgian-designed weapon). One, the coax or coaxial machine gun, is located above and to the right of the main gun. It follows the main gun in both azimuth and elevation and was the most frequently used weapon on Abrams tanks in Iraq. This gun is carried on the stabilized main gun mount and can be furnished with a ballistic solution. It is the preferred secondary weapon when firing on the move.

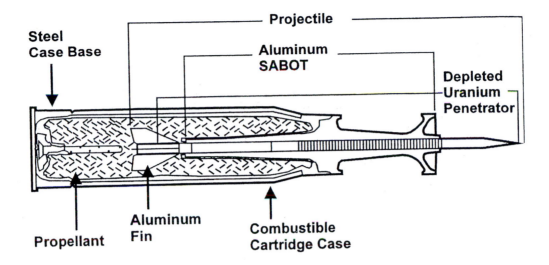

Steel Case Base

Projectile

Aluminum SABOT

Depleted Uranium Penetrator

Propellant

Aluminum Fin

Combustible Cartridge Case

Muzzle Velocity:	1,575.28 m/s.
Penetrator Composition:	Depleted uraniumn.
Announced in fire command as:	"SABOT" (pronounced SAY-BO).
Fuze:	None.
Employment:	Tank or tank-like targets.
Color Code:	Black with white letters.
Weight:	46.22 lbs.
Length:	38.75 in.

The M829A1 APFSD-T 120mm main gun round shown in this line drawing was an improved version of the M829 APFSD-T 120mm main round and saw productive use in the first Gulf War in 1991. Air resistance acting upon the three metal petals comprising the sabot will cause them to break away from the penetrator once it exits the muzzle of a gun tube. The three-piece sabot is a lightweight carrier in which the sub-caliber penetrator is centered to permit firing the projectile in the larger caliber weapon. *U.S. Army*

The second 7.62mm M240 machine gun is located on the top of every Abrams turret, at the loader's position. It is pedestal-mounted on a skate rail that allows the loader to provide fire coverage to the left side of the turret. The gun is not stabilized, but offers a wide field of fire and is often used for suppression missions, even on the move. Its main disadvantages are that it requires the loader to expose himself to enemy fire and it reduces his responsiveness in loading the primary armament.

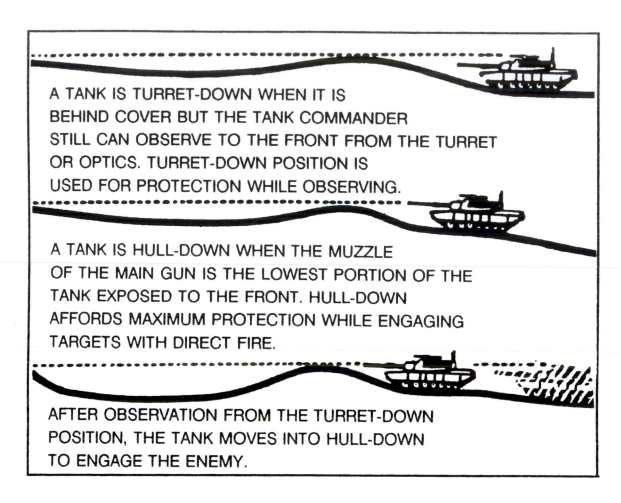

A TANK IS TURRET-DOWN WHEN IT IS
BEHIND COVER BUT THE TANK COMMANDER
STILL CAN OBSERVE TO THE FRONT FROM THE TURRET
OR OPTICS. TURRET-DOWN POSITION IS
USED FOR PROTECTION WHILE OBSERVING.

A TANK IS HULL-DOWN WHEN THE MUZZLE
OF THE MAIN GUN IS THE LOWEST PORTION OF THE
TANK EXPOSED TO THE FRONT. HULL-DOWN
AFFORDS MAXIMUM PROTECTION WHILE ENGAGING
TARGETS WITH DIRECT FIRE.

AFTER OBSERVATION FROM THE TURRET-DOWN
POSITION, THE TANK MOVES INTO HULL-DOWN
TO ENGAGE THE ENEMY.

A line drawing illustrates the various defense firing positions practiced by Abrams tankers. Cover is defined by the American military as protection from direct fire. Defilade positions that provide cover, depending on the part of the tank protected, are known as hide, turret-down, and hull-down. Tank commanders are taught in training that they must make sure the slope is not so steep that their tank's main gun cannot be depressed enough to engage targets. *U.S. Army*

The M240 machine gun has an official maximum effective range of 985 yards (900 meters). Beyond this range, the tracer component in the bullets burns out. In reality, the firer can often observe the impact of the bullets at more distant ranges and direct the firing onto intended targets.

A third machine gun, the .50-caliber M48, or Chrysler Mount, appears on the top of the M1, IPM1, and the various versions of the M1A1 Abrams turret. It differs from the standard M2 HB (heavy barrel) .50-caliber machine gun mounted at the TC's position on the M1A2 and SEP by having an M10 charger mounted on the left instead of the charging handle on the right, and having a safe/fire selector on the rear. Its official maximum effective range is 1,800 yards (1,645 meters). The weapon can engage tar-

gets at longer ranges on occasion, with the firer using bullet impact to determine accuracy.

On the M1, IMP1, and the M1A1 Abrams tanks, the .50-caliber M48 machine gun is attached in a fixed mount to a low-profile, steel-armored sub-turret, or cupola, located at the TC's position and referred to as the commander's weapon station (CWS). In theory, the CWS can be rotated 360 degrees independently of the main turret. The TC can point the .50-caliber M48 machine gun with power or manual controls. In practice, the CWS is limited to a field of fire that extends from the left front fender to the right rear fender of the vehicle. Rotating the CWS any farther over the top of the turret results in interference from the loader's hatch (in its raised position)

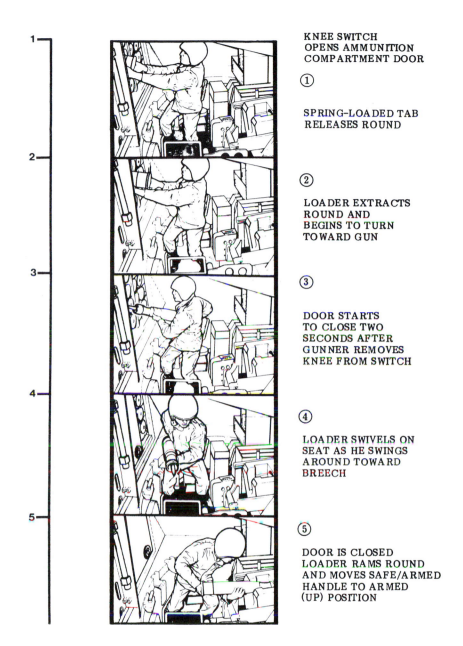

1

KNEE SWITCH
OPENS AMMUNITION
COMPARTMENT DOOR

①

2

SPRING-LOADED TAB
RELEASES ROUND

②

LOADER EXTRACTS
ROUND AND
BEGINS TO TURN
TOWARD GUN

3

③

DOOR STARTS
TO CLOSE TWO
SECONDS AFTER
GUNNER REMOVES
KNEE FROM SWITCH

4

④

LOADER SWIVELS ON
SEAT AS HE SWINGS
AROUND TOWARD
BREECH

5

⑤

DOOR IS CLOSED
LOADER RAMS ROUND
AND MOVES SAFE/ARMED
HANDLE TO ARMED
(UP) POSITION

A line drawing shows the various events that transpire as a loader on the Abrams tank series goes through the process of loading the tank's main gun. The primary reason that the main gun ammunition on the Abrams series is stored behind moveable armored doors is to improve the chances of crew survival. *U.S. Army*

and the loader's pintle-mounted 7.62mm M240 machine gun. The vehicle's rear-mounted turret antennas also get in the way when rotating the CWS 360 degrees.

Some Marine Corps tank units in Iraq's urban areas have removed the loader's pedestal-mounted M240 7.62mm machine gun to improve the TC's all-round visibility when buttoned up. In such cases, the loader's ma-

chine gun becomes a spare for the coax. Flank security for the Abrams tanks operating in such an environment must come from supporting infantry.

On the M1, IPM1, and M1A1, the TC can aim and fire the .50-caliber M48 machine gun from inside the vehicle with the overhead hatch closed. Visibility in this mode of operation comes from six vision periscopes located

around the overhead hatch. A 3-power telescope, forming part of the CWS, allows the TC to aim the M48. Since tank commanders often find it advantageous to trade the superior visibility of an open hatch for the safety of a closed hatch, provisions for the TC to fire the M48 machine gun from this position were designed in.

Because the .50-caliber M48 machine gun on the M1 through M1A1 tanks reloads from outside the vehicle, the process can sometimes become a very dicey affair for the TC, especially when under heavy enemy fire. What some Marine Corps Abrams TCs now do is traverse their CWS toward the loader's hatch. The loader then opens his hatch just far enough to reach out and attach a fresh can of ammunition to the CWS. The TC then needs only to open his hatch far enough to reach out and charge his weapon before returning to the interior safety of his tank.

With the introduction of the M1A2 into service, the complex rotating CWS disappeared from the Abrams series. In its place is a non-rotating commander's station that features the standard M2 HB flex .50-caliber machine gun fitted on a pintle mount. Rather than have the entire TC's CWS turn to allow for the aiming and firing of the M2 HB, the weapon manually rotates around the outside of the commander's station with the TC's assistance. This rotation requires the TC to elevate his entire upper torso over the top of his station, leaving him vul-

nerable to small-arms fire and all types of lethal battlefield fragments. This change reflected the army's belief during the Cold War that the Abrams TC should be concentrating on overseeing the aiming and firing of the main gun rather than spending his time as a machine gunner.

The machine guns on the Abrams turret often end up being the weapons of choice in many engagements in Iraq. The Iraqi insurgents tend to remain in their hidden fighting positions until Abrams tanks are very close. These attacks often negate the tank's main gun. In many situations, Iraqi combatants get so close to Abrams tanks that their crews must employ a variety of small arms, including pistols, to defend their vehicles. In one case in Iraq, an Iraqi insurgent actually managed to get on top of an Abrams tank and cause injuries to the crew.

Based on combat experience gained in Iraq, the army has come up with a series of proposed short-term fixes to allow its Abrams tanks and crews to better survive the rigors of urban combat. Under a program collectively referred to as the tank urban survivability kit (TUSK), the army and Marine Corps began adding armored gun shields to the loader's pintle-mounted 7.62mm M240 machine guns on their Abrams tank fleets in Iraq sometime in 2004. Also incorporated into the loader's firing position on the Abrams tank is a small thermal sight, pro-

viding him the ability to aim and engage targets in the dark. In the future, the army hopes to incorporate provisions into the Abrams tank to allow the loader to aim and fire his machine gun from within the safety of the turret.

Plans are also in the works to install a remote weapon station, equipped with a thermal weapon sight, at the TC's station on M1A2 and SEP tanks. This would allow the TCs of those tanks to fire their .50-caliber machine guns from within the confines of their turrets. According to Lieutenant Colonel Michael Flanagan, product manager for TUSK, "We're developing a remote weapons station (RWS) that will probably be similar to the one used on the Stryker [a wheeled U.S. Army armored fighting vehicle] to allow that weapon to be fired from inside the turret." Flanagan also mentioned that a brand-new RWS mounted on army Humvees in Iraq beginning in 2004 might fit their needs.

SOME LESSONS LEARNED

The fighting in Iraq has demonstrated to the army some shortfalls in gunnery training for its Abrams tankers. Some of these appear in the following extract from an article in the January–February 2004 issue of *Armor* magazine titled "1-64 Armors Rogue Gunnery Training Program," by Lieutenant Colonel Eric Schwartz, Major Daniel Cormier, and Staff Sergeant Bobby Burnell:

Operation Iraqi Freedom revealed a need to train armored crewmen to fight under close combat conditions and in urban terrain. The difficulties of an urban environment are numerous. The crew must acquire targets three dimensionally The nature of close urban terrain will at times prevent the main gun from engaging targets, except those to its direct front. The enemy's ability to attack from perpendicular alleyways or doorways, and then quickly hide, prevents the tank's main gun from reacting decisively. Therefore, [when] crews button-up and rely on their armor protection and gunner's weapons, they limit their ability to engage enemy targets and must rely on movement or supporting fires to survive attacks Any analysis of potential future combat scenarios leads to the conclusion that enemy forces will seek to fight in close terrain The armor community can no longer afford to focus primarily on the conventional fight. We must adapt our training to likely future scenarios and . . . tank gunnery must adapt to the changing threat environment.

U.S. Army Sergeant Scott Junkin (right) mounts an M240 7.92mm machine gun on the skate rail surrounding the loader's overhead hatch on an M1A1 tank in Iraq. He and the tank belong to Bravo Company, 1st Battalion, 198th Armor, 155th Brigade Combat Team. *Chief Petty Officer Edwards Martens*

Two gasoline-powered U.S. Army M2A2 light tanks take part in a training exercise in the late 1930s. The turret on the right side of the 12.8-ton (11.6 metric ton) vehicle featured a .50-caliber machine gun, and the turret on the left a .30-caliber machine gun. Both the turret and hull of the M2A2 tank consisted of face-hardened steel armor plates, either welded or riveted together. Disadvantages of face-hardened armor are that it's difficult and expensive to make and it tends to be very brittle. *National Archives*

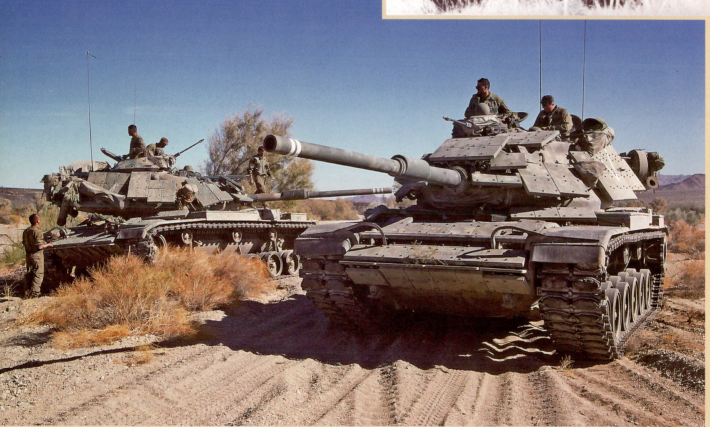

Pictured are Marine Corps M60A1 main battle tanks during a desert training exercise. The explosive reactive armor (ERA) tiles visible are non-functioning versions that simulate the weight and bulk of the real thing so the tank crews can become familiar with the system. The complete ERA system fitted to the M60A1 consisted of 91 tiles attached to mounting hardware using retaining clips and machine bolts. Some of the exterior tow cables and brackets were modified or relocated due to the fitting of the ERA tiles on the tanks. *Greg Stewart*

CHAPTER FOUR

PROTECTION

FROM THE INTRODUCTION OF the M1917 light tank into U.S. Army service in 1918 through the fielding of the M60 series of main battle tanks in the 1960s, American tank crews found themselves protected by hard steel armor. Three different forms of armored steel have seen use: rolled homogeneous armor (RHA) plates, cast homogeneous armor (CHA), and face-hardened armored plates for lighter vehicles. Of the three, only RHA appears on the Abrams tanks. Homogeneous means that the material has the same characteristics throughout its thickness. This contrasts with the hard surface layer of face-hardened steel plate.

CHA provides the ability to change its thickness over a large area. For this reason, it has historically been used on tank turrets and mantlets (gun shields), whose complex shapes require different thicknesses in the front than on the sides and rear. The rounded steel armored turrets of NATO and Soviet tanks offer examples of the use of CHA. The big advantage of using CHA comes from avoiding the fabrication problems of welding thick sections of armored steel plate with ballistic-quality welds. A disadvantage of CHA is that it lacks the toughness added by the work-hardening process of RHA manufac-

turing. However, even the latest Russian tanks use smoothly contoured cast armor as part of the containment shell for their composite-armor turrets.

RHA armor offers some advantages over face-hardened steel armor because it's easier to produce in large quantities and welds easily to a vehicle structure. It also offers superior protection when struck by antitank projectiles due to its ductility (the property of a material that allows it to withstand large amounts of deformation before fracturing). RHA also does well in protecting against the shock waves generated by large-caliber projectiles striking the exterior of a tank's armor and the blast from high-explosive rounds. The big disadvantage of RHA is its inability to form easily. Because of this, flat plates tend to be standard.

THREAT SOLUTIONS

The RHA plates and CHA that protected the U.S. Army's M4 Sherman medium tank fleet during World War II provided little protection against German handheld antitank launchers, which fired shaped-charge warheads at close range. The most dangerous of these was the *Panz-*

This World War II picture shows the rear of a homogeneous cast-steel armor hull version of a U.S. Army M4A1 Sherman tank. Homogeneous cast-steel armor molds into almost any shape and desired thickness, giving it a big advantage over rolled homogeneous armor (RHA) plates. The big disadvantage with homogeneous cast-steel armor is that, when compared to RHA plates, it has poorer resistance to penetration. *National Archives*

erfaust (armored or tank fist), which first entered German military service in 1943.

Unlike the reusable American bazooka and its German counterpart, the *Panzershreck* (armored or tank terror), which were both rocket launchers, the one-shot, disposable *Panzerfaust* was a simplified recoilless gun that fired

a large shaped-charge warhead that could penetrate up to 7.9 inches (20 centimeters) of steel armor. The typical M4 Sherman tank had armor no thicker than 3 inches (7.6 centimeters).

When a shaped-charge warhead strikes the exterior armor of a tank protected by conventional steel armor, a high-energy molten jet blasts a hole through it. The shrapnel generated by this event is lethal, and the heat can set off fuel and ammunition inside the tank. Tanks cannot carry RHA plates or cast armor thick enough to protect against this threat.

In an attempt to protect themselves from shaped-charge warheads, U.S. Army tankers covered their M4 Sherman tanks with a wide assortment of materials, including wooden planks, sandbags, and extra armor plate. All these materials acted as simple forms of standoff armor that helped in dissipating a shaped-charge jet so that it could not penetrate the vehicle's hull or turret. Crews found that spaced armor also helped to disrupt conventional rounds by absorbing energy and changing the path of a round before it struck a vehicle.

In response to this new German threat, the U.S. Army designed a number of official forms of standoff armor. The war ended before most of these new armor protection systems were fielded. However, standoff armor work continued in the postwar period, as the U.S. Army realized that even more potent shaped-charge warheads would appear in the future.

In order to improve the armor protection levels of its inventory of M4 Sherman medium tanks during World War II, the U.S. Army had the factories building some of the tanks weld extra armor plates onto the hulls and turrets of the vehicles at critical areas, as seen in this wartime picture of a U.S. Army storage yard in England in early 1944. *Patton Museum*

A U.S. Army officer examines a captured German *Panzerfaust*. This one-shot disposable antitank weapon posed a serious threat to all U.S. Army armored vehicles until the end of the war in Europe in May 1945. The maximum effective range of the Panzerfaust 60 was about 66 yards (60 meters). *National Archives*

An additional threat came from a new generation of HEAT rounds fired by large-bore tank guns. These rounds could be fired at long range by crews under armor protection and were even more lethal than handheld weapons with their smaller shaped-charge warheads.

One interesting type of standoff armor consisted of 12-inch-thick (30.5 centimeters) blocks containing quartz gravel, asphalt, and wood flour fitted to the sides of a M4 Sherman hull and turret. While tests showed it to be very effective against World War II–era German shaped-charge warheads, it offered minimal weight savings compared to adding thicker RHA plate or cast-steel armor. A further disadvantage was that the first round destroyed the quartz armor, and a second round in the same general area could easily penetrate the vehicle.

Other concepts soon evolved, including the fitting of gapped, or perforated, standoff armor. One concept consisted of various sized steel spikes welded to the exterior of a tank. While this armor solution was light enough to be practical and was effective against shaped-charge warheads, it was difficult to manufacture, and the spikes were often stripped off the vehicle's hull and turret by trees and other obstacles encountered during normal tank operation.

A form of standoff armor currently in use is slat armor. It employs a screen of equally spaced steel bars attached to a steel framework that extends a certain predetermined distance away from a tank's hull and turret in order to disrupt the forming of a shaped charge's high-speed molten jet. Slat armor currently appears on the U.S. Army's fleet of Stryker wheeled armored fighting vehicles in Iraq.

During the opening stages of the operation, a small number of slat armor kits designed to protect the rear-hull engine area of Abrams tanks were flown to Iraq. Their usefulness in combat has convinced the army that it would like to order more of the slat armor kits for its Abrams tank inventory, if funding becomes available. The proposed addition of slat armor kits to the rear of Abrams tanks falls under an army program currently referred to as the tank urban survivability kit (TUSK).

NEW TYPES OF ARMOR

Tests conducted by the army in the late 1950s showed that ceramic armor deserved further study as an alternative to RHA and CHA. Ceramics are about four times harder than the hardest steel and can effectively defeat shaped-charge warheads. They can also provide a respectable degree of protection against KE projectiles. Ceramics are too brittle as a stand alone structure and therefore must serve a secondary role when mounted on tanks. Another disadvantage is that an entire ceramic panel will be destroyed on the first hit, leaving that area of the tank vulnerable to a second hit.

Despite the promising early showing of ceramic armor materials for tanks, the army did not continue its work on the project because the armor was more expensive and more delicate than RHA and CHA. However, the U.S. Army did conduct further research on ceramic armor in the 1960s, not for its tank fleet, but for its helicopters. Just before the first Gulf War with Iraq in 1991, the Marine Corps added thin ceramic armor tiles to the exterior of their wheeled light armored vehicles (LAVs). In 2002, the army began acquiring ceramic armor tiles for fitting to the exterior of its brand-new fleet of eight-wheeled armored fighting vehicles, called the Stryker.

The Soviet army was also exploring ceramic armor in the late 1950s. Their first tank to incorporate ceramic armor was the T64A main battle tank, armed with a 125mm main gun. When it appeared in service in 1967, it rendered American tank main guns and their ammunition obsolete for decades, until the M833 sabot round appeared on American tanks in 1983.

Unhappiness with the thin armor-protection levels of its M4 Sherman series medium tanks led many U.S. Army tankers to add a variety of material on their tanks for additional protection. The crew of this M4A3 Sherman tank has added spare road wheels and sandbags to the vehicle's upper front hull. Along the side of the tank's hull, the crew has attached wooden logs. *National Archives*

NEW TYPES OF ARMOR PROTECTION

It fell to the British military to spark the U.S. Army's interest in ceramic armor once again. In the early 1960s, a British scientist discovered that a multi-layer "recipe" of different materials was far more effective than any single material for stopping shaped-charge warheads. It was also easier to fine-tune the recipe for different threats. As a long-time military ally of the United States, the British shared this discovery with the American military. The merits of this new type of armor, code named Burlington (but more commonly referred to as Chobham armor for the English village near which it was developed), came

During the Vietnam War, U.S. Army tankers were often confronted by enemy handheld rocket-propelled grenade launchers (RPGs) firing shaped-charge warheads. In order to protect themselves from these weapons, they often added sandbags to their vehicles, just as their World War II counterparts had done. The U.S. Army M48A3 Patton medium tank pictured features sandbags on both its turret and hull. *Jim Loop via Dick Hunnicutt*

The U.S. Army continued using homogeneous cast steel armor turrets and hulls for most of its tanks long after World War II, all the way through to the M60 series of main battle tanks. These tanks remained in use among some Army National Guard and Reserve armor units into the 1990s. The tank pictured is a United States Marine Corps M60A1 main battle tank armed with a 105mm main gun. *Defense Visual Information Center*

to the attention of those involved in the design of the XM1 tank.

To the dismay of the British military, the army's Ballistic Research Laboratories (BRL) at Aberdeen Proving Ground, Maryland, quickly developed an improved American version of Chobham armor for the XM1. An unofficial designation for the first American version of Chobham armor was BRL 1. As a rule, the Chobham-type armor on the entire Abrams tank series is called "special armor" in the American military. While the exact nature

To strengthen the protection levels of its new Stryker family of eight-wheel armored fighting vehicles, the U.S. Army had contractors add slat-armor to the exterior of the Strykers deployed to Iraq in 2003. It has proven a success in combat and has saved a number of vehicles from destruction by enemy handheld antitank rocket launchers firing shaped-charge warheads, such as the RPG-7. *U.S. Army*

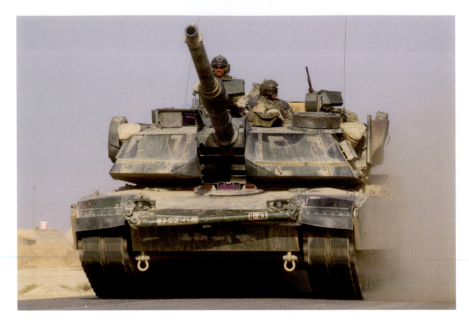

The addition of Chobham-type armor to the design of the XM1 led to a drastic change in appearance for American tanks. The traditional rounded curves of the cast steel armor seen on earlier generations of American tanks, such as the M48 or M60 series, disappeared. In its place came the box-like shape of the Abrams turret, with its large slab-like frontal plates, as seen on this U.S. Army M1A1 in Iraq. This development occurred because Chobham-type special armor works best when arranged in such a fashion. *Staff Sergeant Shane A. Cuomo*

of the American version of special armor mounted on the M1, IPM1, and early models of the M1A1 tank officially remains a military secret, a U.S. Army Center for Military History publication dealing with the first Gulf War with Iraq in 1991 titled "The Whirlwind War; The U.S. Army in Operations Desert Shield and Desert Storm" describes it as "ceramic blocks set in resin between layers of conventional armor."

According to some websites specializing in defense-related issues, when a shaped-charge warhead strikes the Abrams tank's special armor, the ceramic blocks at the point of impact shatter and form a dense cloud of small ceramic particles. When the high-speed molten jet reaches the ceramic cloud a fraction of a second after impact, the jet energy is effectively defeated. The shattered ceramic material can also strip away mass from a KE pen-

Since the majority of hits on tanks occur on their turrets, the U.S. Army began exploring the possibility of moving the crew (minus the loader) into the front hull of a much-modified Abrams tank and leaving only a small unmanned turret on the roof of the vehicle, mounting the main gun. Ammunition for the main gun would come from a 44-round magazine in the hull by way of an automatic loader. Nothing ever came of this tank test bed (TTB) program. The only example of that program now resides in the storage yard of the Patton Museum of Cavalry and Armor, located at Fort Knox, Kentucky. *Michael Green*

Antitank mines have always posed a serious threat to tanks, since the armor on the bottom of tanks' hulls tends to be very thin. Normally with larger and heavier tanks, older-generation antitank mines destroyed tracks and road wheels and damaged suspension components, as seen on a Marine Corps M26 Pershing tank that set off a North Korean antitank mine in September 1950. *National Archives*

etrator as it moves through special armor, a process known as erosion.

Of the two plates of conventional steel armor that form the box that contains the ceramic inserts on the early models of the Abrams tank, a number of defense-related magazine articles have indicated that it is the rear plate, often called the backing plate, that's most important. This is because the backing plate determines the strength and resistance of the ceramic inserts, while the front plate merely contains the ceramic insert and acts to confine the shattered ceramic material when struck.

Damaged Abrams tank ceramic blocks can be replaced by removing the tops of the armor's steel containers. This

feature also allows the U.S. Army to change the armor recipe with better-performance ceramic inserts against different or new antitank weapons.

While the various recipes of special armor used on the M1, IPM1, and the M1A1 Abrams tank gave the vehicles an extremely high degree of protection from a wide variety of shaped-charge warheads, they did not provide enough improvement over conventional steel armor plates when hit by sabot projectiles. Beginning in 1988, the army announced that it was adding plates of depleted uranium (DU) armor to the array on the front of M1A1 turrets. The M1A1 tanks featuring the new DU armor had the designation M1A1 Heavy Armor (M1A1 HA). An additional

The biggest threat to American tanks during the Vietnam War turned out not to be enemy tanks, but antitank mines and various types of improvised explosive devices (IEDs). This picture shows an American soldier using a magnetic minesweeper to perform the unpopular job of minesweeping. The crew of an M48A3 Patton medium tank waits for the all-clear signal. *National Archives*

A Marine Corps M1A1 tank, fitted with a dismountable mine plow, is pictured driving down Route 27 toward An Nu'maniyah, Iraq, during the opening stages of Operation Iraqi Freedom, in April 2003. The mine plow is not a popular addition to Abrams tanks, due to its weight of almost five tons and the fact that when the mine plow is lowered into the ground, the vehicle can only drive forward at low speed. Turning the vehicle with the mine plow lowered is impossible, since the blades will break. *Corporal Ryan Walker*

improvement to the armor array on the front of the M1A1 HA tanks resulted in the vehicle designation M1A1 Heavy Armor Plus (M1A1 HA+).

The special armor of the M1A1 HA–model turret and the subsequent M1A1 HA+, M1A2, and M1A2 SEP turrets consists of an array of spaced ceramic armor plates, with DU backing plates. When a sabot projectile or a shaped-charge jet penetrates into the special armor array, each of the plates absorbs and dissipates a portion of its incoming energy.

Since DU armor is one and a half times the density of lead, its sheer mass prevents non-DU sabot projectiles from penetrating the special armor array on the front of the M1A1 Abrams tank turret. To protect against improved sabot projectiles, the DU armor plates within the front of the turret on later versions of the Abrams series, such as the M1A2 and the M1A2 SEP, have probably been thickened.

ARMOR PLACEMENT AND DESIGN FEATURES

The heaviest component of all tanks is their armor protection. Its placement is almost as important as its thickness. Due to weight considerations, designers cannot provide a tank with the same degree of armor protection all the way around the vehicle's hull and turret. If they did, they would have a vehicle too heavy for any road or bridge to support. For this reason, designers place armor on a tank based on each area's probability of being hit. Since the 60-degree frontal arc of a tank's hull and turret has traditionally been the place where most strikes have occurred, this is where designers have long placed the thickest armor on tanks. This is where the special armor on the Abrams tank series is concentrated. The remainder of the vehicle depends on varying thicknesses of RHA plate for protection.

Since the sides, rear, and tops of tanks normally do not suffer as many attacks as do their frontal arcs, those areas have always tended toward light armor. On the Abrams tank, only the forward portions of the vehicle's side skirts are equipped with special armor. The rest are non-ballistic steel. The M1A2 SEP tank features an improved level of side armor protection than its predecessors. How much of an improvement this armor is and how much it will stop remains classified. Because of the urban combat environment experienced in Iraq, the army is also working on technical solutions to increase the armor protection levels along the sides of its M1A1 tanks.

In the 1980s, the U.S. Army tested the concept of eliminating the large manned turret on the Abrams tank. Traditionally, 90 percent of hits on tanks have been on the front of their turrets. In its place would be only a smaller-frontal-profile unmanned turret containing the main gun and various sighting and observation devices. The crew, consisting of only two men—driver and tank commander—would sit side-by-side in the front hull of the vehicle. An automatic loader would have taken the place of the human loader. For a number of reasons, the army did not pursue that idea. The biggest disadvantage was the fact that the tank commander would no longer have the 360-degree view from the top of the tank's turret. While there now exists a variety of very capable optical sighting devices, none yet compare to the resolution and field of view of human eyes.

THE THREAT

During the opening stages of Operation Iraqi Freedom in 2003 and the ongoing occupation phase, Abrams tanks have had their non-ballistic side skirts repeatedly penetrated by Iraqi insurgents firing Russian-designed, hand-held, rocket-propelled grenade launchers fitted with

Abrams tanks disabled during the opening stages of Operation Iraqi Freedom in 2003 were often stripped for parts by their own units to keep other tanks running. This was due to a constant shortage of spare parts. This same problem had bedeviled the U.S. Army and Marine Corps during Operation Desert Storm in 1991. *Russ Bryant*

shaped-charge warheads. By lucky coincidence, the rocket-propelled grenade (RPG) has the same acronym in both English and Russian; in Russian it's *raketniy protivotankoviy granatomet,* or rocket antitank grenade launcher. The RPG-7 first appeared in Soviet army service in the early 1960s. Its development came from work originally done by the German military in World War II on a reusable version of the *Panzerfaust,* designated the 250 model, which never reached production before Germany surrendered. The most common RPG currently in worldwide use is designated the RPG-7 and has been built in dozens of countries, including Iraq.

In the February 18, 2005, issue of *Army Times,* U.S. Army Major General Terry Tucker stated that over 1,100 Abrams tanks have seen action in Iraq, and of that number, 70 percent have been struck and damaged in some manner. "In fact," he added, "it's hard to find an Abrams tank out there that has fought in Iraq that has not been damaged." Tucker also stated that 80 Abrams tanks suffered enough damage in Iraq to warrant the process of shipping them back to the United States. Of that number, 63 of them will go back into service, while 17 of the damaged Abrams tanks are no longer worth fixing.

Major General Tucker explained that "the technique that they're [Iraqi insurgents] using is massed fire against one tank: 14, 18, 20 RPGs—I've heard reports of 50 RPG hits. It's a new technique that they're using, and in fact we're having some significant damage on tanks that had to be repaired before we put them back in the fight."

An account of the use of RPG-7s by Iraqi insurgents appears in an article by Army Captain John C. Moore titled "Sadr City: The Armor Pure Assault in Urban Terrain" in the November–December 2004 issue of *Armor* magazine. Moore recounted: "I saw three RPGs launched at my tank that initially looked to be coming right at the tank from the front, but they all dropped short, with one skipping under the tank, one exploding short and one failing to explode as it skipped into our right track and deflected right across the line of march of my right file of tanks."

Armor-piercing rounds from an enemy 30mm gun (possibly from an Iraqi army BMP-2) disabled one Abrams tank after hitting it in the rear of the hull, near the engine exhaust grilles—a mobility kill. Two Abrams tanks were lost in friendly-fire incidents during the opening stages of Operation Iraqi Freedom. In one incident, an army Bradley infantry fighting vehicle (IFV) fired a

This picture shows two U.S. Army M2A3 Bradley Fighting Vehicles (IFVs) in Iraq. The vehicles are armed with a turret-mounted 25mm automatic cannon and a coaxial 7.92mm machine gun. The hull and turret of the vehicles both feature explosive reactive armor (ERA) tiles in a variety of sizes and shapes to fit every corner of the vehicle. *U.S. Army*

number of 25mm armor-piercing DU projectiles at the rear engine grilles of an Abrams tank and destroyed its gas turbine engine.

No Abrams tanks were lost to Iraqi antitank mines early in Operation Iraqi Freedom. This was not due to a lack of effort by the Iraqi military, which did build some very extensive and well-laid-out defensive positions that included minefields. During the later occupation of Iraq, insurgents improvised an antitank mine consisting of a 55-gallon (208 liters) oil drum packed with C-4 plastic explosives. An M1A2 Abrams tank triggered the mine—three of the four-man crew were killed and the tank lost its turret. No other reports of Abrams tanks destroyed or disabled by antitank mines had surfaced out of Iraq as of the time of this writing.

To assist Abrams tank units in dealing with minefields, a full-width mine plow can attach to the front of Abrams tanks. Once mounted in place, the mine plow raises and lowers electrically or, if required, manually.

Abrams tanks fitted with the mine plow are nicknamed plow tanks.

Due to a lack of mine plows, many Abrams tank crews have come up with their own method of clearing mines and IEDs in Iraq. According to Army National Guard Lieutenant Nicholas Moran:

> The heavy armor of the tank led it to some uses that we hadn't really considered before arriving in Iraq, such as minesweeping. If we had a tip that there was a roadside bomb (IED) somewhere, we'd go in the tanks and drive up and down a few times to see if anything blew up before letting people get close on foot. The 10-power optic was great for safely investigating suspicious items. Except for the biggest of bombs, the worst that would happen is it would blow off a track. Better a track than to have the bomb go off next to a supply truck or a Humvee.

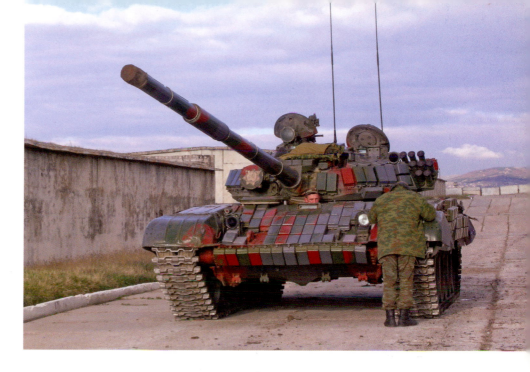

The T72 main battle tank pictured sports a multicolored covering of early model explosive reactive armor (ERA) tiles on the exterior of its turret and hull. Armed with a powerful 125mm main gun, the T72 is currently the most widely deployed main battle tank in service around the world, with more than 20,000 built by at least five countries. It first entered Soviet army service in 1978. *U.S. Army*

SLOPING ARMOR

Armor designers try to keep armor surfaces sloping so an incoming projectile will ricochet upward. Another benefit of sloped armor is the increase in areal density. A vertical armor surface hit by a round with a horizontal line of fire defeats a threat based on its thickness alone. A sloped plate presents a thicker profile to an incoming round and possesses a higher areal density. If the angle of the slope is steep enough, rounds will deflect from the surface rather than penetrate the armor.

Sloped armor does not save weight. Imagine a tall stack of playing cards sitting on a table. Now tilt the stack back, keeping the individual cards level with the table top. The stack has not changed thickness or weight. It has the same areal density as it did before you tipped it back. Its thickness as measured perpendicularly to its surface is reduced, but its increased length has precisely compensated, with the result that the stack of cards still weighs the same.

The increase in protection offered by sloping tank armor is usually gradual below 30 degrees and increases as

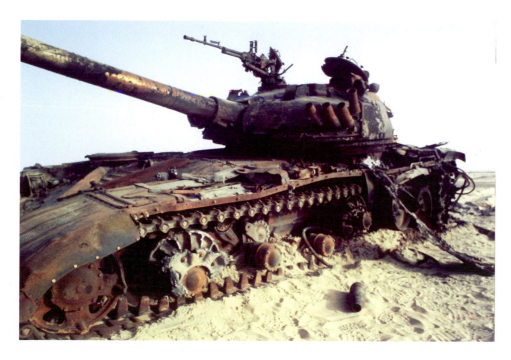

The threat that comes from storing main gun ammunition within the fighting compartment of a tank is evident in this picture of a destroyed Iraqi T72 main battle tank. When an anti-tank weapon penetrates the turret interior and strikes the propellant stored within any of the main gun cartridge cases, the resulting explosions will kill the entire crew and destroy the tank. *Department of Defense*

the angle goes up. The roughly 2-inch (5 centimeters) upper-front-hull armor plate, or glacis, on the Abrams tank has an 82-degree slope. The lower front hull plate is sloped at only 20-degrees and may be about the same thickness. By comparison, the 45-ton (41 metric ton) German Panther medium tank of World War II had a glacis that was 3.2-inches (80 millimeters) thick, sloped at 55 degrees, while its lower hull plate was 2.4-inches (60 millimeters) thick at a slope of 40 degrees.

EQUIVALENT THICKNESS

Armor performance is is stated in terms of the equivalent thickness of RHA plates needed to defeat a particular threat. For example, the 2-foot-thick composite armor slab on the front of the M1 Abrams tank is the equivalent of a 3-foot-thick steel RHA plate in its ability to stop a shaped-charge warhead. Its RHA equivalent against sabot rounds is only about 12 inches (30.5 centimeters). Because of its steep slope and high areal density, the approximately 2-inch-thick armor-plate glacis of the M1 Abrams has about the same RHA equivalent against shaped-charge warheads and sabot projectiles as the much thicker composite armor on the front of the turret.

According to a declassified CIA report from 1984, the U.S. Army concluded that the composite armor array on the front turret of the Soviet army's T64A main battle tank had an RHA equivalent of 20 to 23 inches (500 to 575 millimeters) when defeating shaped-charge warheads. For sabot projectile threats, the T64A armor package had an RHA equivalent of 14.8 to 17.6 inches (370 millimeters to 440 millimeters).

With the addition of DU to the M1A1 HA armor recipe in 1988, the front of the turret is claimed to perform as well as 52 inches (1,300 millimeters) of RHA steel armor when confronted by a shaped-charge warhead. Against sabot rounds, the front protection of the M1A1 HA turret increased to about 24 inches (600 millimeters) of RHA. Armor protection on the glacis of the M1A1 HA is about 42 inches (1,050 millimeters) RHA equivalent against shaped-charge warheads and 23.6 inches (590 millimeters) RHA against sabot projectiles.

The SEP turret armor upgrade is, according to some educated guesses, able to provide shaped-charge protection of almost 65 inches (1,620 millimeters) of steel armor on the front of its turret. Protection against sabot rounds is estimated to be about 37.6 inches (940 millimeters) of steel armor. In contrast, the Russian army's T90 main battle tank turret composite armor array is about 40 inches (1,000 millimeters) RHA equivalent.

COMBAT LESSONS LEARNED

For the last two decades, the U.S. Army has believed that tanks were not suitable for combat in heavily urbanized areas. When tanks were required to enter an urban area,

These side-by-side images show the main gun ammunition storage arrangement in the turret bustle of an M60A1 tank on the right and the M1 tank on the left. While the main gun rounds of the M60A1 remain unprotected in this picture, the main gun rounds in the M1 are protected by one-inch-thick blast doors, which are closed in this image. *Michael Green*

Visible in this picture, taken inside an M1A tank, is the open main gun ammunition compartment located directly behind the loader's seat. Also visible is the loader's knee switch, which opens the hydraulically operated blast door. In case of a vehicle power failure, the blast doors disconnect from the hydraulic control and operate manually. *Greg Stewart*

infantry troops were sent ahead to protect the tanks from ambushes by enemy antitank teams.

Combat experience in Iraq showed that it makes more sense to send in the Abrams tanks first. Not only do they intimidate the enemy, their main guns allow a degree of precision fire that is not possible with an artillery piece or aerial weapon. This tactic minimizes civilian casualties in crowded urban battles. The director of the RAND Cor-

poration's Center for Middle East Policy said, "It turns out that the tank we thought we were going to fight the Russians with is the best thing we've got to fight in an urban environment."

According to Marine Corps First Lieutenant Matthew A. Stinger, part of the success of using tanks in Iraq comes from the lasting effects of Saddam Hussein's regime: "The regime used their tanks as symbols of power. They would

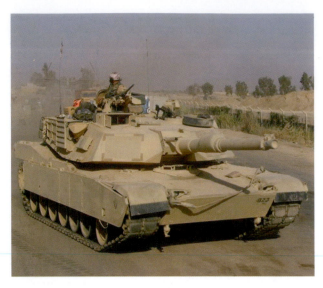

A California Army National Guard M1A1 tank from 2nd Platoon, B company, 1st Battalion, 185th Armor Regiment, 81st Enhanced Separate Brigade, exits the main gate of Logistical Supply Area Anaconda, near Balad, Iraq, in 2004. The tank was drawn from pre-positioned stores in Kuwait, so the only marking is the bumper number on the lower front hull plate. *Nicholas Moran*

its rapid success in route to Baghdad. During MOUT [military operations on urbanized terrain], no other ground combat system currently in our arsenal could have delivered similar mission success without accepting enormous casualties.

During the initial offensive of Operation Iraqi Freedom in 2003, Abrams tanks were attacked by RPGs on thousands of occasions, yet only three Abrams tanks were immobilized because they were hit in the rear or other places where the armor was minimal. Several more Abrams tanks were destroyed due to secondary effects rather than by direct hits.

Secondary-effects weapon strikes are blows that do not penetrate or damage the vehicle directly but may still result in a loss. For example, an Abrams tank was immobilized by an engine fire when an incoming round ignited flammable materials stored on the outside of the turret. The burning materials dropped onto the air-intake grilles of the vehicle and were ingested by the gas turbine engine, resulting in a mobility kill.

Three other Abrams tanks were lost during the early stages of Operation Iraqi Freedom when they became stuck in soft terrain and were abandoned by their crews. Iraqi insurgents later destroyed these tanks by setting them on fire. Other Abrams tank losses were attributed to driver error. In one incident, a Marine Corps M1A1 Abrams was driven into a river, resulting in the death of its four-man crew.

The majority of Abrams tanks withdrawn from combat during Operation Iraqi Freedom were pulled out because of mechanical breakdowns. As it had in Operation Desert Storm in 1991, the army supply system had problems keeping up with its fast-moving armored units; often, spare parts were unavailable for the repair of Abrams tanks.

The high level of protection offered by Abrams tanks was convincingly demonstrated during Operation Iraqi Freedom in 2003 when a number of damaged Abrams tanks were unrecoverable from the battlefield. Rather than have them fall into enemy hands, their own units attempted to destroy them before leaving the enemy-held areas. However, in almost all cases, main gun fire from operational Abrams tanks using sabot-DU rounds at almost point-blank range failed to completely destroy the damaged Abrams tanks. One abandoned Abrams tank took a thermite grenade, a sabot round in the ammunition compartment, and two aircraft-launched air-to-

often park a tank in the middle of a town as a symbol of Saddam's power. Tanks have a similar effect on Iraqi insurgents today."

From an army report summarizing impressions during the initial offensive phase of Operation Iraqi Freedom appears this description of the value of heavy armor in urban combat:

This war was won in large measure because the enemy could not achieve effects against our armored fighting vehicles. While many contributing factors, such as air interdiction (AI), close air support (CAS), army aviation, and artillery, helped shape the division battle space, ultimately any war demands closure with an enemy force within the minimum safe distance of supporting CAS and artillery. U.S.-armored combat systems enabled the division to close with and destroy heavily armed and fanatically determined enemy forces with impunity, often within urban terrain. Further, the bold use of armor and mechanized forces striking the heart of the regime's defenses enabled the division to maintain the initiative and capitalize on

surface Maverick antitank missiles, and was still not totally destroyed.

ADDITIONAL PROTECTION FEATURES

The Abrams is equipped with several diff...

Abrams turret. The grenades discharge electrically and contain the propellant as well as smoke-producing (red phosphorus) pellets. The TC activates the system from inside the turret. When all 12 smoke grenades fire, the smokescreen arc is 120 degrees at up to 30 meters (32.8 yards) in front of the tank. Normally, only six smoke grenades are required for hiding the vehicle. However, during heavy rain, high wind, or very low humidity, the tank commander may fire all 12 smoke grenades for the desired effect.

The M250 smoke-grenade system can fire three smoke grenades simultaneously to either the right or left of the vehicle. Since enemy forces can easily see the ignition flash of the M250 grenades, vehicle commanders are encouraged to immediately move to a new location after firing the smoke grenade launchers.

A recent replacement for the M250 smoke-grenade system on some Abrams tanks is the state-of-the-art M6 countermeasure dispenser. Besides firing smoke, the M6 can also fire flares that can decoy heat-seeking missiles. The M6 is the first step in adding an integrated defense system to the Abrams tank.

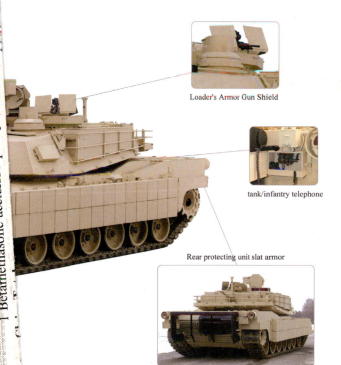

Loader's Armor Gun Shield

tank/infantry telephone

Rear protecting unit slat armor

f Abrams tanks under a program collectively referred to as

BE INFORMED: Treat your Medicare Card as you would a credit card.

Appeals Address... Appeals Information -Part B Section.

This is a summary of claims processed from 11/25/2008 through 01/27/2009.

PART B MEDICAL INSURANCE - ASSIGNED CLAIMS

Claim number 11-09026-111-530
Central Indiana Orthopedics, PO Box 1643,
Muncie, IN 47308-1643
Dr. Haller, Kenneth H. M.D.

Dates of Service	Services Provided	Amount Charged	Medicare Approved	Medicare Paid Provider	You May Be Billed	See Notes Section
						b
01/23/09	1 Office/outpatient visit, est (99213-25)	$118.00	$58.66	$0.00	$58.66	a
01/23/09	1 Drain/inject, joint/bursa (20600-LT)	140.00	47.38	0.00	47.38	a
01/23/09	1 Betamethasone acet&sod phosp (J0702)	16.00	6.08	0.00	6.08	a

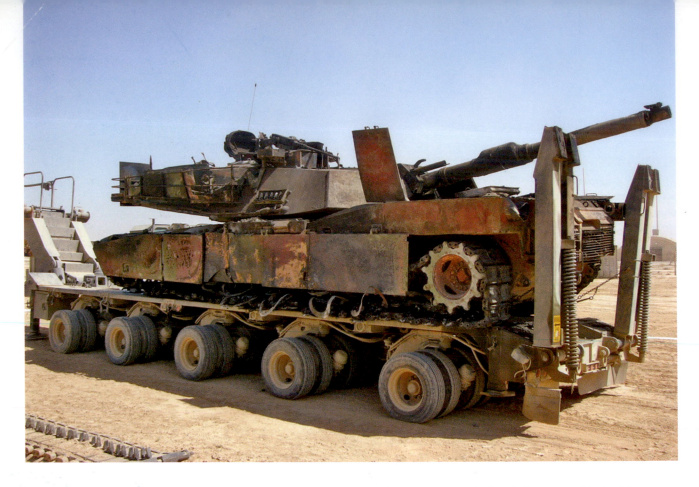

Sitting on a heavy-equipment transporter (HET) is a U.S. Army M1A1 tank that caught fire during an accident while under tow in Iraq in 2004. The aluminum road wheels have completely melted from the intense heat of the fire.
Nicholas Moran

NEW FORMS OF PROTECTION

The armor on the Abrams tank is classified as passive. Even though advanced combinations of materials are more weight-efficient than RHA, increasing the passive protection almost always comes with the penalty of increased weight. With the latest version of the Abrams tank reaching a weight of almost 70 tons (63.5 metric tons), the army is seriously considering non-traditional ways to protect the Abrams tank.

In Iraq, one form of non-traditional protection—explosive reactive armor (ERA)—appears on the army's inventory of Bradley infantry fighting vehicles (IFVs) and the Bradley cavalry fighting vehicle (CFV). The Bradley's ERA consists of angled metal boxes of various sizes and shapes, affixed to the hull and turret. The boxes contain a small plastic explosive charge sandwiched between two thin steel plates. When struck by a shaped-charge warhead, the plastic explosive element propels the front steel plate into the path of the round and disrupts the formation of the molten jet. An instant later, the back plate of

the sandwich reacts by following the front plate into the path of round. The result is that the lethality is lowered to that of a conventional round impacting at a relatively low velocity.

Before the army began fitting ERA to the exterior of its Bradley fighting vehicles in the early 1990s, the Marine Corps had, in the early 1980s, added an early form of ERA to the exterior of some of its M60A1 tanks. This new type of armor had started as an army project for use on its own fleet of M60 series tanks. However, the army decided not to field the new armor.

Officials in the Soviet army had long been strong believers in the value of ERA and had begun work on its development in the late 1960s. However, an accident during early testing held back their fielding of ERA until they saw the Israeli army making successful use of their own version of ERA in 1982. By the following year, ERA began appearing on a growing number of Soviet army main battle tanks. The addition of ERA to these already well-protected tanks se-

riously degraded the performance of much of the U.S. Army's inventory of antitank missiles, which were armed with shaped-charge warheads, during the remaining years of the Cold War. In response, American industry soon produced antitank missiles with tandem warheads, with the first setting off the ERA boxes and the second then penetrating the target's unprotected armor.

The Soviet army added to the U.S. Army's problems in case of World War III by fielding a new generation of ERA on its tanks in 1985. This new armor, heavy ERA, was equally effective against shaped-charge warheads and KE projectiles. Heavy ERA works on the same principle as the original versions of ERA (now light ERA). The big difference is the increased thickness of the plates used in the heavy ERA to deflect or break up incoming KE projectiles.

The Cold War ended in 1991 with the internal collapse of the Soviet Union and its breakup into a loose federation of semi-independent republics. Because of this, the massive tank battles on the plains of Western Europe that many had dreaded for decades became unlikely. How well the Soviet tank's ERA would have withstood the test of combat has therefore remained unproven in combat.

The U.S. Army has never shown as much interest in heavy ERA as the Soviet army and it successor, the Russian army, until its involvement in the military occupation of Iraq. Due to the ever-growing strength of the Iraqi insurgent movement and their heavy reliance on RPGs, the army has now expressed an interest in protecting the hull sides of their Abrams tanks with ERA similar to that found on the army's M2/3 Bradley fighting vehicles, already in Iraq. This proposed addition to the Abrams protection falls under an army program referred to as tank urban survivability kit (TUSK).

Army Colonel Michael Flanagan, product manager for TUSK, describes the reason for its creation:

> You have to remember, the tank [Abrams] was a Cold War design, aimed at a threat that was always to its front. It's still the most survivable weapon in the arsenal from the front. Today it's a 360-degree fight, and these systems are designed to improve survivability in the urban environment.

Looking beyond the use of ERA on its Abrams tanks, the army is also awaiting further development on a new form of protection from United Defense, designer and builder of the Bradley IFV and CFV series, which is cur-

rently developing a new active protection system (APS) for the Abrams and the U.S. Army's new future combat system (FCS) vehicles. The new active armor system will protect against CE and KE rounds. It will employ both soft-kill electronic countermeasures and hard-kill, active-protection counter-munitions to achieve these goals. In both cases, sensors will detect incoming enemy antitank weapons, and a computer will determine which countermeasures to deploy. If the hard-kill system is determined to be the most effective in stopping an incoming projectile, it will destroy the projectile in flight by a close-range weapon fired from the targeted Abrams tank.

Soft-kill systems work by confusing or diverting an inbound enemy antitank missile with the use of obscurants, jamming devices, decoys, and signature-reduction methods. Examples of the latter are the lowering of the noise and masking the hot surfaces of an armored fighting vehicle.

The first soft-kill system fitted to the Abrams tank was implemented by the Marine Corps just prior to Operation Iraqi Freedom. They placed a small box-like antitank

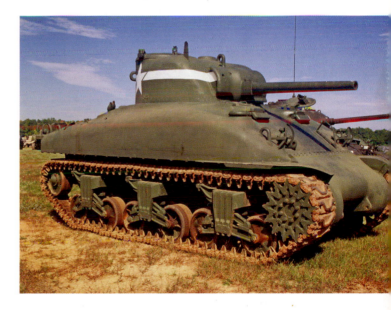

The gasoline-powered M4 Sherman medium tank series of World War II fame came in a variety of versions. While engine types differed among the versions (including some diesel-powered versions) they all shared a homogeneous cast-steel armor turret. Some models featured a homogeneous cast steel armor hull as seen in this picture of a 33-ton (29.9 metric ton) M4A1 Sherman belonging to the Virginia Museum of Military Vehicles. *Michael Green*

This photo shows a burned-out Marine Corps M1A1 tank attacked by Iraqi insurgents using RPG-7s (rocket-propelled grenades). Normally employed in massed volley-fire against American tanks, shoulder-fire RPG-7s are an unsophisticated and easy-to-use antitank weapon. Since the RPG-7 cannot penetrate the M1A1's and M1A2's special armor, its only real capability against American tanks is to start fires. There have been several cases where American tanks in Iraq have been severely burned by RPG-7s initially igniting externally stored equipment and personal gear, where these small fires have gotten out control and eventually consumed the tank. *Defense Visual Information Center*

missile countermeasures device (MCD), designated the AN/VLQ-8A, on the top of their Abrams tank turrets, just in front of the loader's hatch. The AN/VLQ-8A is an electro-optical jammer that disrupts the semi-automatic command to line-of-sight (SACLOS) antitank guided missiles, laser rangefinders, and target designators.

LAST-RESORT PROTECTION

No matter how well designed a tank's armor is, there are situations where rounds find a way through the hull or turret. The two most serious dangers from a round entering the hull is fire and the detonation of stowed main gun ammunition. A U.S. Army report from World War II indicated that somewhere between 90 and 95 percent of all non-repairable American tanks from that time period had burned. Practically all of these were due to ammunition fires rather than fuel fires.

During World War II, the army installed water-filled compartments around the ammunition racks in some of its M4 series Sherman tanks to slow ammunition fires. The modification made little difference.

While the idea of water-protected, main gun ammunition racks proved to be a dead end for the army, it did lead to a more productive line of development for storing main gun ammunition rounds within armored steel boxes. To access the ammunition stored within, a tanker would manually open a small armored hatch, remove a main gun round, and then manually close the hatch. If the steel box was penetrated by an antitank weapon and the ammunition contained within detonated when the reloading hatch was closed, a steel armor chimney that led to the exterior of the tank would vent the resulting hot gases.

In an army report from September 1950, a brief passage describes the initial impression of installing armored ammunition containers within tanks:

This type of ammunition container offers the possibility of allowing the crew of an armored vehicle to evacuate without being burned and it may also prevent the complete destruction of vehicles by fire. The great number of vehicles which were burned out in World War II attests to the importance of this design and the need for application of this principle of ammunition storage to armored vehicles as soon as possible.

The army did not heed this report's conclusion until the development of the Abrams tank in the 1970s. It was the heavy emphasis on crew survivability during the early development of the Abrams tank that made it the first American tank fitted with armor-protected ammunition stowage compartments.

In the Abrams tank, the main gun ammunition is stowed in isolated compartments with venting arrangements that direct any explosions to the exterior of the vehicle, away from the crew areas. The Abrams turret bustle provided the most logical location for storing most of the vehicle's main gun ammunition. The stowed rounds are contained behind 1-inch-thick blast-proof sliding doors easily accessed by the loader. On top of the turret bustle of 120mm main gun–equipped versions of the Abrams are two lightly attached, blow-off panels that help to channel the gaseous energy of an ammunition explosion upward and outward. The M1 and IPM1 tanks feature three blow-off panels over their turret bustles.

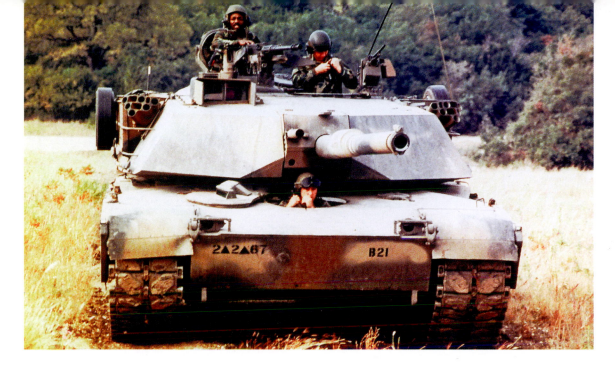

Seen on either side of the turret of the M1A1 tank pictured are the two six-cell launchers that make up the M250 smoke-grenade launcher system. The effective use of the smoke from this system depends on the tank crew's awareness of the wind speed and direction. If the wind is too strong, or blowing in the wrong direction, it may prove difficult to establish an effective smoke screen. *Defense Visual Information System*

When an Abrams tank turret bustle is penetrated and the main gun rounds stored within detonate, the propellant and primers normally take a minute or two to go off. However, Abrams tank crews learn in training that some HEAT and MPAT rounds take as much as an hour to cook-off (explode). After an hour's time, the turret bustle will have cooled sufficiently to preclude further cook-offs of intact rounds.

The effectiveness of this main gun ammunition-storage arrangement on the Abrams tank was demonstrated during the fighting in Iraq. An extract from an army publication titled "On Point; The U.S. Army in Operation Iraqi Freedom" describes some of the fighting around the Iraqi city of An Najaf between March 25 and 28, 2003, conducted by the 3rd Squadron, 7th U.S. Cavalry:

As B Troop moved north it was ambushed. Two 2nd Platoon tanks took hits to the turrets that started fires involving ammunition. In both cases, the blow-off panels worked as designed, venting the flames from the ammunition propellant upward and out of the crew compartment. Stunned tankers abandoned their tanks. The 3rd Platoon stopped to recover the crews and secure the site.

Additional main gun rounds for the Abrams tank are stowed in isolated compartments within the hull. Blowout panels at the top and bottom of the containers allow explosive energy to escape in directions away from occupied spaces. Plastic liners on the wall of the hull stowage compartments absorb energy and protect the surrounding structure when ammunition detonates.

An automatic fire-suppression system increases the Abrams' survivability even more. Seven dual-spectrum infrared detectors activate the suppression system when they sense the radiation characteristics of a hydrocarbon fire. The system is designed to ignore flashlight beams, lighters, matches, sunlight, metallic insignia, and red clothing. The sensors can detect an 18-inch-diameter (46 centimeters) fire at a distance of 1.6 yards (1.5 meters) within 6 milliseconds. It reacts quickly enough to prevent buildup to a full explosion. Abrams crews still need to extinguish smaller interior fires with handheld extinguishers.

During training at Fort Knox, Kentucky, a U.S. Army M1A1 tank rears up as it moves over rough ground. All new Abrams tank drivers spent time practicing driving over rolling terrain to get a feel for the size and capabilities of the vehicle. *Michael Green*

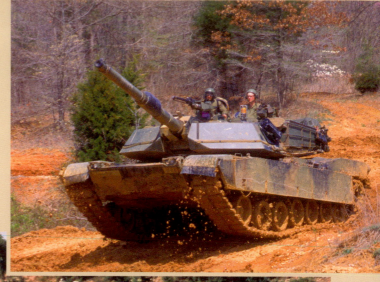

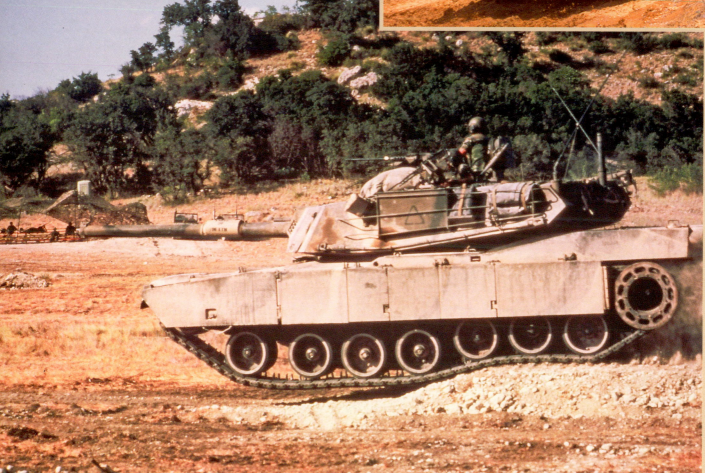

In an era of one shot, one kill, high-speed maneuverability can be key to survival on the modern battlefield. To remain proficient, drivers must regularly train at high-speed operations on off-road terrain as shown by the M1 Abrams tank participating in field training at Fort Hood, Texas, in the 1980s. *Michael Green*

CHAPTER FIVE
MOBILITY

MAXIMUM CROSS-COUNTRY SPEED for the Abrams series is about 30 miles per hour (48 kilometers per hour). Its predecessor (the M60A3) could barely muster 15 miles per hour (24 kilometers per hour) on uneven ground. From a standing stop, the 120mm main gun–equipped version of the Abrams can go from zero to 20 miles per hour (32 kilometers per hour) in about 7 seconds on a dry, level-surface road. Top speed on a level road averages about 40 miles per hour (64 kilometers per hour) for the 120mm main gun–armed version of the Abrams series. The tanks could go a little faster if not for the governor control system that limits the gas turbine engine's maximum output speed to approximately 3,150 rpm. The engine governor also protects the turbine against over-speed transients if the load is lost at high power (for example, if the tank becomes airborne from hitting a bump). Dan Shepetis, a retired Marine Corps master sergeant, remembers the time he got a chance to drive an XM1:

> I gave the throttle a twist and off we went. "Damn," I said to myself, "this thing is a hot rod." I mean, it has power up the ass, no lugging at the start, just smooth power! As we moved down a road, I backed off the power and discovered there was no engine braking. That was something new for me. I was soon moving a little too fast and I let the instructor know there were some bumps coming. The instructor was waiting for that and told me to pour on the speed. "She'll take it," he shouted into the intercom. As we hit the first series of bumps, the damn tank floated over them. If it had been an M48 or M60, we would have gone airborne as we hurled off the first bump and crashed into the ground with enough force to snap everyone's neck back and forth and maybe knock a few teeth loose. The crew would have been bloodied and mad as hell. It was then I thought to myself that this was the tank tankers have been dreaming about for the last 20 years.

THE ABRAMS DRIVER

All of the jobs on the Abrams tank are important to the success of the tank and its crew in battle. While the job of driving a tank sounds like the ultimate off-road adventure,

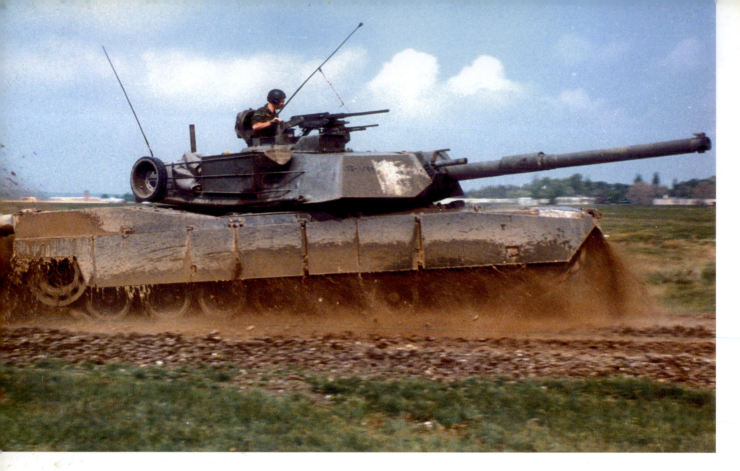

The powerful gas turbine engine on the M1 tank pictured in West Germany in 1984, coupled with an advanced suspension system, allows the vehicle to practically fly across terrain that would bog down any other tank. Unlike a diesel, the gas turbine engine will start at minus 25 degrees Fahrenheit, is very quiet (track noises are louder than the engine), and has practically no smoke signature. *Michael Green*

there is more to it than meets the eye. The driving skills required by a tank driver in combat far surpass anything in the civilian world, or for that matter, any other driving job in the military, since few other driving situations put you in the direct line of sight of an enemy's weapons.

The skill set required by a tank driver and advice on what to do in combat appears in an army training manual:

> *Motorists on American highways are constantly cautioned to drive defensively. Track combat vehicle drivers must drive aggressively as well as defensively. Learn how to exploit battlefield situations and turn them to your advantage. Seek out hull-down positions that protect your vehicle from enemy fire but allow your gunner to put maximum fire on the target. Learn to anticipate the actions your vehicle commander will want you to take in given situations so that he seldom has to issue detailed driving instructions during combat.*

The driver of an Abrams tank sits at the front of the vehicle's hull, with the turret located just behind him. He enters and leaves his position through a large lift-and-swing hatch, which contains three periscopes. In other American tanks, the driver sat upright on a conventional seat with a removable vertical backrest. In the Abrams, the driver eases himself into a comfortable semi-reclining seat, much like that found in a dentist's office. He drives from a supine position. This driver station concept first appeared on the British army Chieftain tank in the early 1960s.

There are a number of advantages to having a tank driver sit in a semi-reclining position. Most important is the ability to reduce the overall height of the vehicle. A shorter tank normally lasts longer on a battlefield than a taller tank. According to Dr. Phillip W. Lett, Chrysler team leader for the Abrams tank, "The reclining seat was

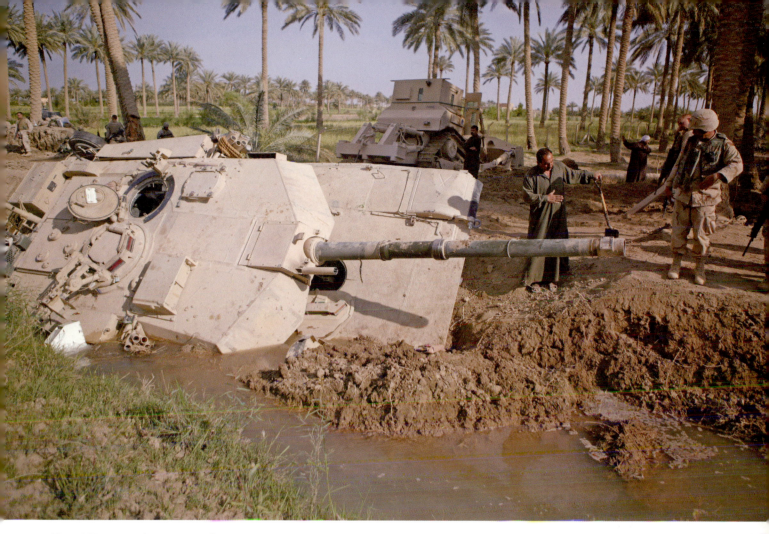

The ability to evaluate terrain is an important skill that comes with experience for both the Abrams tank driver and vehicle commander. Knowing what types of terrains will, or will not, support the size and weight of a tank weighing almost 70 tons is crucial in combat. This photograph shows what happened when, in the heat of combat, a Marine Corps M1A1 went down a narrow Iraqi dirt road to chase enemy combatants. The shoulder of the road collapsed, sending the vehicle sliding into an adjoining canal. *Staff Sergeant Bill Lisbon*

chosen because it allowed us to lower the [turret] race ring and the height of the tank some four inches [102 millimeters]."

The Abrams driver's seat accommodates almost any size soldier (the 95th percentile American male) from the smallest to the largest, even if the driver is wearing bulky, arctic cold-weather gear. The seat has four different positions, adjusted by a tab control located at the lower right. An upper backrest on the seat and a hull-mounted headrest allow for visual alignment with the driver's periscopes and general upper-body comfort.

Two levers to the right of the driver's seat open and close his overhead hatch. The first one raises the hatch from the flush position up a few inches to allow it to swing open. The second is a hand crank that actually swings the hatch over to its open position.

The Abrams driver's seat moves to the open-hatch position without disturbing the closed-hatch headrest setting. An adjustable lower-lumbar support, controlled by a large knob on the lower left side of the seat, permits the driver to dial in the precise amount of lower-back support that he desires. In the closed-hatch position, with the seat properly positioned, the driver can quickly adjust each of his three hatch-mounted periscopes for the best forward visibility. The seat back can be lowered to a horizontal position so an injured driver can be pulled into the turret if he can't be evacuated through the driver's hatch.

For closed-hatch day vision, the 10-inch-wide (25.4 centimeters) center periscope and the two 7-inch side scopes with individually adjustable mirrors are located in the driver's hatch. The field of view for the center periscope is approximately 9 degrees vertical and 45

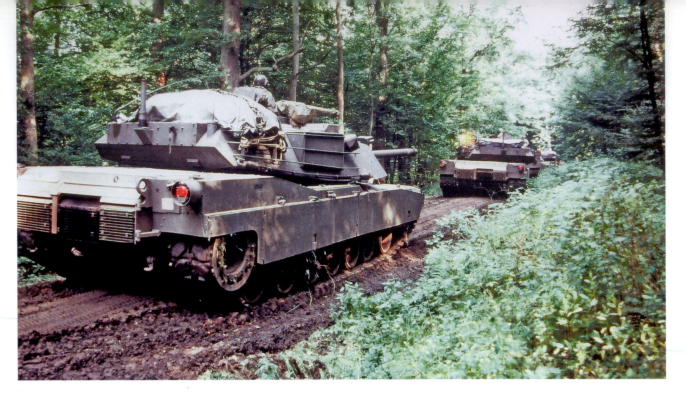

Traveling down a muddy West German trail in a 1985 training exercise are two U.S. Army M1 tanks. Clearly visible on the tank in the foreground are the rear-hull grille doors that vent to the exterior of the vehicle the hot exhaust gases generated by the vehicle's gas turbine engine. The M1 lacked the rear bustle rack fitted to the IPM1 tank. *Defense Visual Information Center*

degrees horizontal. The field of view for the side periscopes is 9 degrees vertical and 33 degrees horizontal. The periscopes provide overlapping fields of view with minimal driver head motion.

All three of the Abrams driver's periscopes incorporate optical coatings to protect the driver's eyes from laser beam damage. The driver can clean the center periscope by using a foot-operated washer and hand-operated double wiper device.

If the driver's center periscope needs replacement due to battle damage, an adapter allows the fitting of one of the other two driver's side periscopes in its place, or the periscope from the loader hatch. The Abrams driver also has access to a passive night-vision periscope for closed-hatch night driving. The night-vision device and adapter are stored in a box under the loader's seat. The driver installs it by removing the center optical periscope and clamping the night-vision periscope in its place.

DRIVER'S CONTROLS

The Abrams throttle and steering controls are a motorcycle-style T-bar. This setup eliminates the need for a separate accelerator pedal, thus providing extra foot space for the driver. The hand throttles, utilizing motorcycle-style grips, allow for operation with either or both hands. The Abrams tank driver controls the speed of his vehicle by twisting either or both handgrips on either side of the steer-throttle T-bar. The grips rotate over a 60-degree range between zero and full speed. Push-to-talk buttons are conveniently located on the T-bar so the driver can key his intercom without removing his hands from the controls.

The steer-throttle position is adjustable for seat-up and seat-down positions by providing it with three locations and a stowed position, selected by the driver. Under normal operating conditions, return springs provide a steering feel and return the steer-throttle T-bar to the neutral centered position.

Steering is infinitely variable over the 25-degree range of the T-bar. Like an automobile steering wheel, the vehicle moves straight, whether forward or backward, at the center T-bar position. Both tracks move at the same speed.

The electrical shift selector on the T-bar allows the driver to control all transmission modes in forward or reverse. These modes include a normal forward drive range (D) and a low-speed high-tractive-effort range (L), reverse (R), and neutral (N). Early tank drivers steered by applying the brakes to the inner track. In modern tanks

such as the Abrams, power is mechanically transferred within the transmission to provide the differential track speeds required for turning.

Like other tracked vehicles, the Abrams has an additional transmission mode: pivot (P). This mode allows the Abrams driver to spin the vehicle on its own axis by locking one track in place, with the tank then pivoting around that track. If the selector remains in neutral (N) mode, and the T-bar is turned, then you have a neutral steer, where the tracks counter-rotate. The transmission drives one track backward and the other forward, allowing the vehicle to make turns within its own length by rotating on its own vertical axis.

The Abrams' service-brake pedal, located centrally on the floor of the driver's compartment, controls the tank's deceleration during normal operation. The multiple-disc-brake mechanisms are located inside the transmission housing.

An independent parking and emergency brake lever is located on the floor of the driver's compartment, to the right of the service brake. It can hold the Abrams tank on slopes up to 60 degrees. The parking brake system is hydraulic. It amplifies the brake lever force to apply the large force necessary to engage the brake in this heavy vehicle.

ACCIDENTS DO HAPPEN

The importance of having an experienced driver at the controls of an Abrams tank is apparent in this brief story from Army Captain Jerry Hill, in which he describes an incident at the army's National Training Center (NTC), located in the high desert of Southern California:

While at my first NTC rotation, one of my buddies, a platoon leader in the company I was attached to as an FSO [fire-support officer], fell off his tank, breaking his leg. Since my own FISTV [M981 fire support team vehicle] never made it out of the assembly area, I inherited his tank. I really didn't know much about tanks as a Redleg [artilleryman], but I took station in the loader's hatch and we rolled out with his platoon sergeant in the lead. We moved to the "sound of the guns" (as they say) at about 45 miles per hour cross-country. At the NTC there's an area known as the Washboard, because it's broken by numerous wadis, some of them very deep. It's really rough terrain for a tank to work through. Unbeknownst to me, my driver was brand new and hadn't been driving tanks for more than a week. Since I wasn't

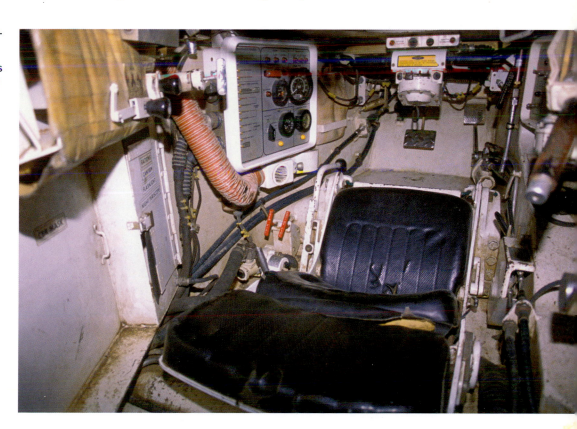

This picture shows the driver's station of an M1 tank. Visible is the driver's steer-throttle T-bar control assembly, which also includes the electrical shift selector. Directly below it on the floor is the service brake. To the left of the driver's seat is the vehicle's control panel. The two red handles located underneath the driver's control panel are manually-operated fire extinguisher handles. *Michael Green*

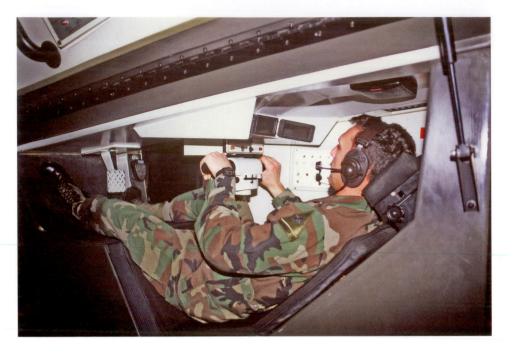

This picture shows the driver's compartment of an Abrams tank simulator. Simulators help save wear and tear on the real vehicles and cost far less to operate. They also allow new drivers to make mistakes that would be deadly in the field. Evident in this picture is the semi-reclining seating position assumed by drivers of Abrams tanks when their overhead hatches are closed. *Michael Green*

familiar with tanks either, I was just enjoying the ride. In retrospect, we were moving far too fast through broken country. That was made evident to me when I heard the tank commander yell "Stop, Stop, Stop!" as we vaulted off the side of the wadi. The nose of the tank dropped as the ground fell away beneath us. Luckily, the wadi wasn't as wide as it was deep, and the gun tube and front hull of the tank slammed into the opposite side of the wadi, stopping our descent. During that instant, my ribs met the ring of the loader's hatch and I felt my breath leave my body. After a momentary pause, I asked for a crew check; one by one, the driver, the gunner, and the TC [tank commander] answered up. Then the expletives started to flow. If you've never tried digging a tank out after getting it stuck, I will tell you from experience it isn't fun, but we managed it.

SUSPENSION

A tank's ability to maintain high speeds on rough terrain is dependent not only on engine power, but also the suspension system. The suspension's ability to absorb the impact of driving over bumpy terrain also plays an important part in the main gun's time on target. The M1's sight and gun stabilization systems are very capable, but their limits will be exceeded if hull motions are too great.

The Abrams tank uses a hydro-mechanical suspension system of seven road-arm stations on either side of the hull. The 14 road arms connect to high-hardness-steel torsion bars that run across the vehicle to anchors on the opposite side of the hull. Spindles fit to the lower ends of the road arms to accept two road wheels for each arm. There are 28 road wheels on an Abrams tank.

As the Abrams speeds over rough terrain, the mass of the tank acting against the motion of the road arms causes the torsion bar springs to rotate. The twisting action of the torsion bars pushes the wheels down to keep them on the ground. The torsion bars on the latest-version Abrams provide it with 15 inches (38 centimeters) of road-wheel travel up and down. The high wheel travel combined with the very high mass of the Abrams gives it the extraordinarily smooth cross-country ride for which it is so well known.

Since the pure springing action of torsion bars alone would cause the vehicle to pitch uncontrollably, even on relatively smooth terrain, six rotary hydraulic shock absorbers control the tendency of the heavy hull to oscillate on the torsion bar suspension; the reduction of oscillation is known as damping. There are three shock absorbers on each side of the vehicle. Because the leading road wheels encounter terrain inputs before the rest of the suspension has had a chance to react, the first two stations are damped. The last station also gets a damper because track vibration needs to be controlled before the drive sprocket engages the track stand. Dampers keep

masses (hulls) isolated by springs (undamped suspensions) from oscillating wildly like undamped Slinky toys. Spring-mass systems all have resonant frequencies that can result in uncontrollable oscillation amplitudes. Dampers reduce these oscillations by turning the kinetic energy into heat.

FUEL TANKS AND HULL ELECTRICAL SYSTEMS

From the M1 up through the M1A2, all the Abrams tank variants can hold 505 gallons (1,911 liters) of fuel divided among their four fuel tanks. The lone exception is the SEP version, which has room for only 445.4 gallons (1,680 liters) divided among three fuel tanks.

The SEP has a lower fuel capacity because the fuel tank located in the left rear sponson of the hull was removed to make way for a gas, turbine-powered, under-armor auxiliary power unit (UAAPU) as part of the SEP upgrade. However, the development of this device ended without a production order. Now a set of advanced batteries and a battery monitoring system is going into this unused space.

The Abrams gas turbine engine currently operates most efficiently with kerosene-based aviation fuel (JP-8). It can also burn DF-2 diesel fuel and other fuels, including gasoline. The flexibility of this design was demonstrated as the tanks were originally designed for DF-2, then the army's ground fuel. They were able to switch to JP-8 with little impact.

It is always logistically desirable that a force carry as few different fuels as possible, so a resupply fuel tanker can refuel any vehicle, from a

helicopter to a Humvee. However, in forward areas or when operating with multinational forces, the ability to burn a variety of locally procured fuels is desirable. In fact, the Abrams tank can use almost any fuel that will flow through a pipe and burn.

The maximum operational range of the SEP version at 29 miles per hour (47 kilometers per hour) on a dry, level, paved road is about 220 miles (350 kilometers). This compares to the 289-mile range (465 kilometers) of the M1A1 tank with a full fuel load and its NBC system off. With its NBC system on, the range of the M1A1 tank drops to 279 miles (449 kilometers). In comparison, the last version of the M60 main battle tank, the M60A3, had a maximum operational range of 280 miles (450 kilometers) at 29 miles per hour (47 kilometers per hour) on a dry and level paved road.

The fuel economy of a tank is measured in gallons per mile rather than miles per gallon. During the first Gulf War in 1991, Abrams tanks consumed about 7 gallons of fuel per mile of cross-country travel. Unlike the diesel engines used in other tanks, the Abrams gas turbine consumes almost as much fuel at idle as it does at full power. Some Abrams tank units actually ran out of fuel before their fuel supply trucks could reach them. Adding to this problem was a lack of fuel trucks with suitable cross-country mobility to keep up with the tanks. The difference between the tested fuel consumption figures and the

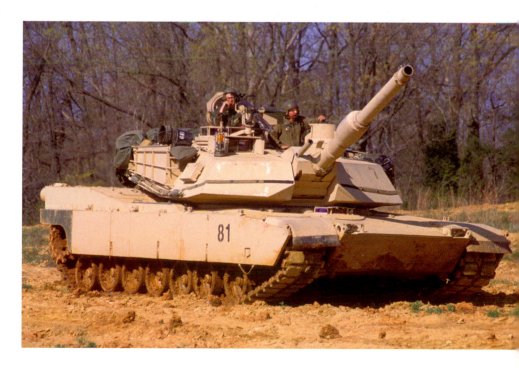

The crew of a U.S. Army M1A2 tank pauses while awaiting orders during a training exercise. Abrams tank drivers learn in training that moving out of a firing position properly is just as important as moving into it, since the enemy has probably sensed the approximate location of your tank from the fire it just delivered. *Michael Green*

actual operational consumption is because combat vehicles seldom move in continuous marches. Units habitually move by bounds, with one part of the unit moving while another part covers by fire from protected positions. Thus, a given element, even in the best of conditions, spends half of its time stationary.

For the second Gulf War in 2003, the Marine Corps fitted every Abrams tank with one or two 303-liter (80 gallons) synthetic rubber fuel bladders—battlefield refueling apparatus (BRA). They were strapped to the sides of M1A1 turrets. The BRAs were dangerous because they were designed only for movements when the units were not in contact with the enemy on long road marches. Most Marine Corps tankers were uncomfortable with this arrangement and discarded the BRAs as soon as they drew enemy fire; however, at least one M1A1 tank was lost when caught in an ambush with its BRA still mounted (the crew was not injured).

The Abrams' electrical power source from the M1 through the M1A2 is a 24-volt, engine-driven generator. Six lead-acid batteries comprise the energy storage capacity. The battery system provides enough electrical capacity to meet critical cold-engine starting and allows the Abrams tank crew to conduct engine-off silent watch for varying lengths of time depending on the amount of electrical power used. A low-battery-charge message will appear on both the driver's and tank commander's display panels when the batteries need charging and will continue to stay on until the vehicle's six batteries are recharged.

ENGINE

One of the most important mobility performance indicators for a tank is the ratio of engine horsepower divided by the gross vehicle weight. This measure is called the power-to-weight ratio. The latest 68.5-ton (62.1 metric tons) version of the Abrams tank has a power-to-weight ratio of about 21.4 horsepower per ton. This translates into a much higher level of agility when combined with an improved suspension compared to older-generation tanks, such as the M60 series. Better agility and mobility increases vehicle survivability.

The AGT-1500 gas turbine engine on the Abrams tank produces 1,500 gross horsepower. Abrams tanks accelerate twice as fast and travel cross-country at speeds three times faster than M60s. The diesel engine on the M60 series tank generated 750 gross horsepower. Gross horsepower refers to the power produced by an engine itself,

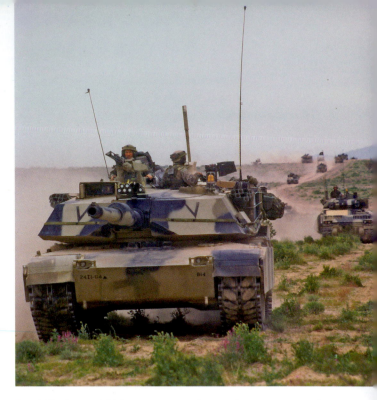

The U.S. Army M1A1 tank pictured is leading a convoy of M2 Bradley Infantry Fighting Vehicles (IFVs) at the Army's National Training Center (NTC). The distance between vehicles in convoys is normally spaced out so that a single shell burst will not cause damage to more than one vehicle. *Greg Stewart*

without driving accessories nonessential to the engine's operation. Power available to the vehicle's transmission is called net horsepower.

The large leap in power provided by the Abrams gas turbine engine made a positive impression on army tankers who were accustomed to M60 tank performance. Army Major Jim M. Warford (retired) describes his personal impressions of the improved performance of the M1A1:

The massive increase in speed and cross-country mobility of the M1 over the M60 tank series could not have been felt any deeper than in my battalion deployed with the 2nd Armored Division (Forward) in northern Germany. This new and previously unheard of performance changed the way we trained, the way we thought, and the way we would have fought had that become necessary. The tried-and-true methods and procedures of combat support and combat service support were suddenly too slow everything was too slow. We now had a tank that was literally as fast as the

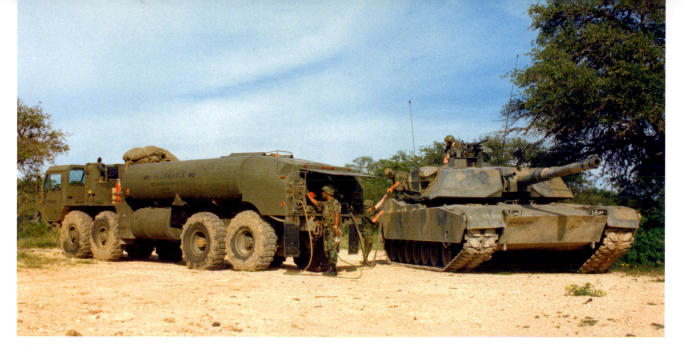

Crewmen from a U.S. Army M1 tank are refueling their vehicle in the field. The army depends on the M978 fuel servicing truck for its refueling needs. It is a very large 8x8 vehicle based on the chassis of the army's M977 series truck developed by the Oshkosh Truck Corporation. *Oshkosh Truck Corporation*

beat-up car I drove in high school. So fast in fact, that my battalion commander seriously considered developing a new go-to-war tactic of jumping tanks (using a series of ramps) over the many small canals that crossed our planned defensive positions. While this new tactic never got beyond the drawing board, it clearly demonstrates how far we had come.

Army Colonel Chris Cardine (retired) explains that jumping the Abrams tanks across obstacles is possible:

When I was a battalion commander at the NTC [National Training Center] I got a new driver just as we laagered [parked tanks in a defensive formation] in the Washboard the first night. I decided to teach him how to drive at high speed in that area by jumping wadis with the tank. The secret is to accelerate the vehicle over a small bump, go airborne, and continue to accelerate the engine while the track is not in contact with the ground so when you land the tank keeps moving at full speed just like a speedboat crossing a wave. Unfortunately, the absolute worst thing you can do is get scared when you are airborne and step on the brake pedal, as the tank will stop moving when it returns to earth. I had my driver [accelerate] to about 35 miles per hour in the Washboard [and

he was] doing just fine until on one bump he panicked. After eating the .50-caliber machine gun in front of me, I managed to get him to drive me to the Battalion Aid Station and get seven stitches in my mouth.

To start the air-cooled AGT-1500 gas turbine engine located in the rear hull compartment of the SEP, the driver pushes the start button on his driver's integrated display (DID) panel that is located to the left of his seat. A signal then goes to a digital electronic control unit (DECU) to begin the startup sequence. The DECU applies battery power to the engine's starter and ignition system. A power management system senses that the DECU has initiated the startup sequence and starts the tank's fuel pumps. As all this is going on, a start-in-progress message appears on the DID.

As the starter turns the Abrams engine and the ignition system produces a pulsating arc at the igniter (spark plug), an electronic fuel management system (EFMS) senses engine rotation and directs fuel and air to the engine. When the engine reaches idle speed, the DECU turns off the starter and ignition and displays an engine started message on the DID. All of this occurs within 60 seconds or less. Once the burning starts with an ignition spark, continuous burning takes place and the engine is ready for action. The whole process is not unlike the familiar startup sequence aboard an airliner or a turbine-powered

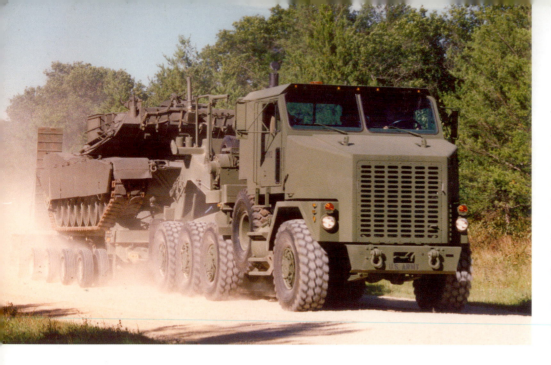

To save fuel and wear on the Abrams' tracks, the preferred method of moving on roads outside of combat areas has always been with large-wheeled tank transporters. The newest tank transporter in service with the U.S. Army is the Oshkosh heavy equipment transporter system (HETS), which consists of the M1070 tractor and the M1000 trailer, seen here hauling an M1.
Oshkosh Truck Corporation

helicopter. The driver controls the engine speed with a power-throttle twist-grip that increases fuel flow to the engine in accordance with load demands.

A gas turbine operates by burning fuel mixed with compressed and heated air. Air enters the Abrams engine through an air-intake port at the left rear of the vehicle just behind the turret. There, it is filtered before flowing through two compressors. Engine exhaust gases heat the compressed air to increase the efficiency of burning the fuel in a mechanism called a recuperator. The hot air is forced into the combustion chamber of the engine, where it mixes with atomized fuel from the fuel injectors.

One of the early problems with the Abrams gas turbine engine was the huge amount of air that had to be filtered efficiently. Depending on dust conditions, the engine filters quickly clogged and required constant manual cleaning. This problem became more acute during the 1991 Gulf War, when Abrams tanks spent much of their time in a dusty environment. During sandstorms, the engine filters clogged as often as four times per hour of operation. A pulse-jet filter cleaning system has now been developed and fielded to most M1A1 and all the M1A2 fleets. This system allows the constant cleaning of the air filters by systematically isolating each of the three filters

The preferred method of shipping Abrams tanks overseas is by large roll-on roll-off ships. The chained-down M1A1 tanks pictured are deep in the hold of the USNS *Shughart* awaiting transport. All the Abrams tanks pictured have the auxiliary power unit (APU) in their rear turret-bustle racks.
Defense Visual Information Center

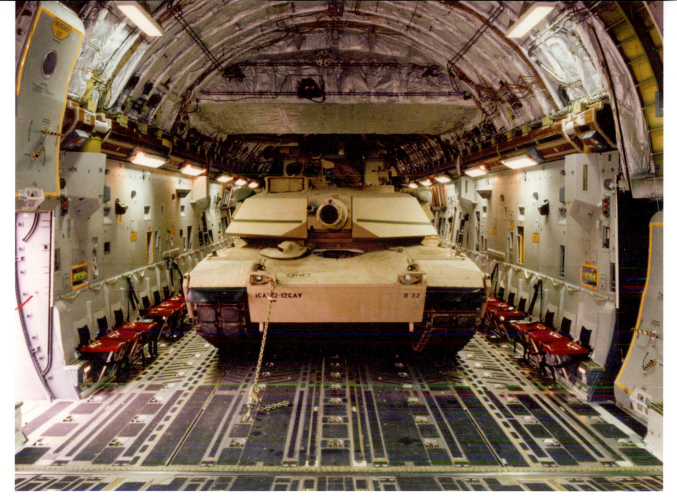

An M1A1 tank is tied down inside the spacious fuselage of a U.S. Air Force C-17 Globemaster III cargo aircraft. The Globemaster III is the newest cargo aircraft in the air force inventory and can carry two Abrams tanks during wartime. Powered by four large turbofan jet engines, the Globemaster III can deliver oversized vehicles, such as the Abrams tank, directly to austere airfields almost anywhere in the world on relatively short notice. *McDonnell Douglas Aerospace*

and pulsing reverse air through them. This process allows continuous operation in severe dust environments. The system has virtually eliminated the need to clean the filters and has substantially reduced engine losses due to dust damage.

The last brand-new AGT-1500 gas turbines were built in 1992. Since then, the army has depended on overhauled AGT-1500 gas turbine engines to keep their Abrams tanks running. Many of the engines have gone through the overhaul process more than once. In an overhaul, only certain high-failure items are replaced. The wear on the engine's remaining components resulted in overhauled engines that failed to achieve the durability of brand-new engines. To rectify this situation, the U.S. Army began a search for a new gas turbine engine suitable for mounting in the Abrams tank.

In March of 2000, the army asked for proposals on a replacement for the AGT-1500 gas turbine engine. In re-

sponse, an industrial team from General Electric and Honeywell proposed a new state-of-the-art gas turbine engine: the ACCE/LV100. It seemed to offer a host of advantages over the 1960s-vintage AGT-1500, including a 30 percent reduction in fuel consumption, 43 percent fewer parts, and a dramatic increase in mean time between failure (MTBF). To the army's great disappointment, the ACCE/LV100 prototypes failed to live up to expectations, and the project ended. The army currently has GDLS, Honeywell, and Anniston Army Depot teamed in a program aimed at completely rebuilding its inventory of AGT-1500 gas turbine engines from the top down.

As an alternate to mounting another gas turbine engine in the army's fleet of Abrams tanks, GDLS has continued to refine the design of the Teledyne Continental AVDS (automotive vee-bank diesel supercharged) 1790-2C, which last powered the M60A3 main battle tank.

Since 1995, GDLS has increased the engine's horsepower rating from 750 to 1,200. In its new and upgraded mode, the 1,200-horsepower Teledyne Continental diesel engine provides the power for the Israeli army's Merkava 1 and 2 tanks, as well as the U.S. Army and Marine Corps' inventory of M88A2 armored recovery vehicles. The latest version of the Teledyne Continental engine boasts a rated horsepower of 1,500 and may be a suitable replacement for the aging AGT-1500 gas turbine engine of the Abrams tank fleet.

TRANSMISSION

The Abrams gas turbine engine drives an X1100-3B automatic transmission through a reduction gearbox. The transmission has a torque converter with an automatic lock-up clutch in combination with a four-speed planetary range package.

The high-capacity, three-element torque converter that forms part of the Abrams transmission multiplies the characteristic high-torque rise of the gas turbine engine and transmits it to the range package. The range package on the Abrams transmission consists of five multiple-disc clutch packs and three planetary gear sets, providing the driver with four forward and two reverse ranges. A planetary gear set makes it possible to provide high gear ratios in a small volume.

To understand the desirable output characteristics of a tank powertrain, torque and power must be defined. Torque is a measure of the engine's ability to apply a twisting force to its output shaft. Power is a measure of the amount of work that can be performed per unit of time. Imagine a motorcycle and a small bulldozer, which might have engines rated at the same horsepower. The motorcycle develops its power by generating relatively low torque at very high rpm. The bulldozer develops its

Crewmen of a U.S. Army M1A1 tank are preparing to remove the power pack from the rear hull of their vehicle. They have opened the armored rear-exhaust doors, exposing the very black engine exhaust duct in the middle. On the right of the exhaust duct is the grille of the auxiliary transmission oil cooler. *Greg Stewart*

Visible on the ground is the removed power pack from the M1A1 tank parked behind it. To the left of the black engine exhaust duct are the grilles for the primary transmission oil cooler and the engine oil cooler. The engine and transmission oil cooling system consists of a fan, fan-drive system, cooling duct, transmission oil cooler, and engine oil cooler. *Greg Stewart*

power by generating high torque at relatively low rpm. Even though they have the same power, the motorcycle is the sure winner in a drag race, while the bulldozer always wins a stump-pulling contest. A tank powertrain has to combine acceleration for battlefield agility with high tractive effort for overcoming obstacles, hills, and soft ground. An efficient transmission provides torque multiplication at low speeds, when maximum pulling power is required, but trades lower torque for higher rpm when the tank needs high speed. Less sophisticated tanks use clutches, but these are inefficient power transmitters when they have to be slipped to allow the engine to maintain high rpm in low-speed conditions. The inefficiency converts to heat and leads to the well known burned-out clutch. Modern tanks, like the Abrams, do away with this inefficiency by using torque converters, which continuously trade torque for rpm to transmit optimal power.

In low-torque operating modes (primarily at higher vehicle speeds), a lock-up clutch in the Abrams tank transmission bypasses the hydraulic torque converter and provides direct mechanical transmission of power to the sprockets. The ability to operate more efficiently in lock-up under a greater variety of conditions is a result of the high torque rise provided by the Abrams gas turbine engine. Torque rise is the ability of an engine to supply torque to a sudden demand without lugging. The high torque rise of the Abrams engine results in part from its high inertia and fast-responding fuel-control system.

Maximum gross torque on the Abrams tank is 3,934 foot-pounds at 1,000 rpm. Maximum net torque is 3,800 foot-pounds at 1,000 rpm, with the 134 foot-pound difference being consumed in the overhead required to run peripherals. By comparison, the 750-horsepower, air-cooled diesel engine of the army's M60A3 main battle tank had a maximum gross torque of 1,710 foot-pounds at 1,800

On patrol in an Iraqi city is a U.S. Army M1A1 tank. The vehicle rides on a hydro-mechanical suspension system, which provides static and dynamic support through torsion bar springs and the smoothing-out of terrain features with six rotary hydraulic shock absorbers. Each shock absorber assembly weighs 41 pounds and is supplied with oil from a reservoir, which is an integral part of the suspension housing. *U.S. Army*

rpm and a maximum net torque of 1,575 foot-pounds at 1,750 rpm. The greater proportional overhead losses of the diesel comes from the two large cooling fans required to pull air through the cylinder cooling fins and the oil-to-air heat exchangers for the engine and transmission.

POWER PACK

The transmission of the M4 Sherman tank was located in the front of the hull. The engine was in the back, with a driveline connecting the two. It would take an entire day to remove and replace the engine and transmission of a typical M4 Sherman tank. In contrast, the engine and transmission of the Abrams tank form a single unit known as a power pack. An experienced crew can remove the 4.25-ton (3.86 metric ton) power pack in less than 20 minutes.

Abrams power packs are complete with air-cleaner system, scavenging blower, and cooling system. The final drives are also a part of the power pack. A tank's final drives connect directly to the sprockets and provide the final speed reduction between the transmission output shafts and the sprockets.

A maintenance crew gains access to the power pack by using a small crane to remove the rear top deck structure. If a large crane is not available to remove the entire power

pack, the crew is able to remove 70 percent of the power pack accessories and components with the engine still mounted in the vehicle.

To ease the number of tools and training requirements for the Abrams tank, fasteners, hydraulic fittings, and electrical connectors are standardized. Only 85 special tools are required for the Abrams tank, compared to the more than 200 needed for the M60A3 main battle tank.

The current maintenance ratio of the Abrams tank is one hour of maintenance for each hour of operation. By comparison, the famous German Tiger tanks of World War II required almost 10 hours of maintenance per one hour of operation. Adding to the Abrams tank's maintainability is the fact that the gas turbine engine consists of only four modules for ease of removal and reinstalling.

Other features on the Abrams that make maintenance less of a chore than in past American tanks include built-in test equipment, warning lights, and audio warning messages. The driver is made aware of low oil pressure, engine over-speed, low fuel, clogged oil filters, and other out-of-range conditions by warning lights similar to those in automobiles. These features help to reduce the burden on maintenance crews and the need for technical training. This translates into more tanks being available for operations.

A U.S. Army M1A1 tank sinks into an Iraqi farm canal after the dirt road collapsed under its weight in May 2004. While the Abrams was a formidable foe if it could get where it was going, crews soon learned to stay clear of certain areas. *Nicholas Moran*

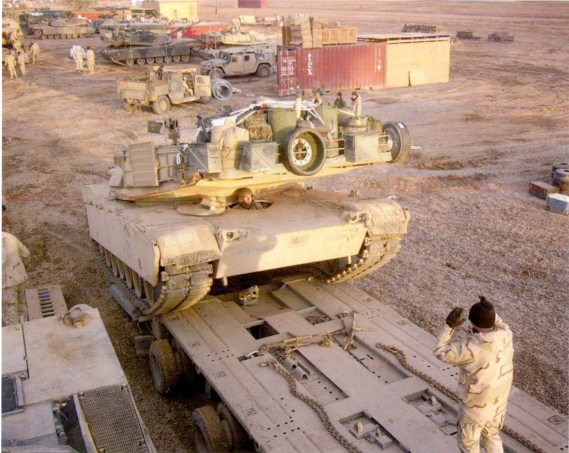

An M1A1 tank is loaded into a heavy equipment transporter (HET) in preparation for a six-week stay in Mosul, Iraq, in January 2005. Everything the crew will need for this period of time is mounted in the bustle rack or jammed somewhere in the turret. The gear is removed at the first opportunity to prevent loss or damage, and to increase visibility. *Nicholas Moran*

INDEX